ar murders,
ar, sexism, ageism,
rorism, the
pe, regular rape,
mps, battered women,
homophobia,
sness.

serial murders, regul

child abuse, AIDS, v

drugs, vandalism, te

environment, gang ra

euthanasia, death ca

sadism, masochism,

censorship, homeles

This is our world,
I dissect it, I assemble it,
I call it art.

Edited by Benjamin Lignel
Introduction by Francine Prose

la maison Red

Ida Applebroog

1976 > 2002 Are you bleeding yet?

RED

Published by la maison Red
Designed by Hartland Villa

Special thanks to Martina Batan

Production consultant - OREP (Paris, France) Olivier Renault & Carole Eveillard
Reproduction - Point (Paris, France) • Printing - Deux Ponts (Grenoble, France)
Hartland Villa (Paris, France) is Lionel Avignon assisted by Klaartje Van Eijk

Published by la maison Red,
198 Douglass Street, Brooklyn, New York 11217
Distributed by D.A.P./Distributed Art Publishers, Inc.
155 Sixth Avenue, 2nd Floor, New York, New York 10013, 212.627.1999

ISBN 1-56466-087-7

Front and back covers:
Modern Olympia exhibition at Ronald Feldman Fine Arts,
New York, January 2002. Photograph by Dennis Cowley

with voices by

Ida Applebroog I.A.
Martina Batan M.B.
David Beytelmann D.B.
Dan Cameron D.C.
John Cussans J.C.
Arthur C. Danto A.C.D.
Katy Deepwell K.D.
Rosalyn Drexler R.D.
Manny Farber M.F.
William Feaver W.F.
Ronald Feldman R.F.
Kathleen Finley K.F.
Grace Glueck G.G.
Charles Hall C.H.
Elizabeth Hess E.H.
Jeffrey Kastner J.K.
Max Kozloff M.K.

Kay Larson K.L.
Kim Levin K.L.
Jean Lignel J.L.
Kate Linker K.L.
Lucy R. Lippard L.R.L.
Carlo McCormick C.McC.
Linda McGreevy L.McG.
Flannery O'Connor F.O'C.
Patricia C. Phillips P.C.P.
Griselda Pollock G.P.
Nancy Princenthal N.P.
Carrie Rickey C.R.
Corinne Robins C.R.
Mira Schor M.S.
Lowery S. Sims L.S.S.
Roberta Smith R.S.
Thomas W. Sokolowski T.W.S.

Abigail Solomon-Godeau A.S.-G.
Patricia Spears Jones P.S.J.
Robert Storr R.S.
Terrie Sultan T.S.
András Szántó A.S.
Amy Taubin A.T.
Marilyn A. Zeitlin M.A.Z.

"Some guy came to my studio for 15 minutes
and wrote something that took 6 hours to read."

de Kooning

Benjamin Lignel

Did you know that Ida Applebroog has been monitoring your home for twenty-five years? While you were *at it*, thinking that no decent citizen would peer in through the curtains at your very own version of domestic bliss, she was jotting down your lines and freeze-framing your scenes and actions for posterity. This, then, is the deal: you remain silent, while she lends a helping hand in the description of what happened last night; she likes to Show & Tell. This seems indeed to have been the driving element in Applebroog's 25-year career. She has been variously described as a social voyeurist, sometimes commentator, or more aptly as the willing witness of the way things work in that mini-theatre we call LIFE.

Applebroog is a relative late-bloomer on the art scene (she started exhibiting her narrative pieces at 45), and this new publication is the first comprehensive overview of her work to date. It is definitive enough to have called for the artist's close supervision, and features, in an effort to portray her approach to 'difficult' subject matter, early works and personal notes previously unreleased.

A total of 20 exhibitions and performances are featured in chronological order to demonstrate both the thematic coherence of her work throughout, as well as her use of every new major exhibition as an opportunity to explore new display strategies. The precision and efforts involved in the installation of each show, in fact, seem to suggest interpretative routes that would consider not only the individual paintings, but each exhibition as a whole; as a species collective, if you will - distinguished by the particular method employed to observe and assemble it. In order to suggest the spatial interaction intended by the artist, an installation shot was thus selected to introduce each exhibition.

Finally, to give an idea of the development of the "critic's voice" alongside the work itself, it was decided to use excerpts from critical reactions to each exhibition to accompany the pieces they discuss. This fragmentary format reflects the variety of critical approaches to Applebroog's work and echoes the artist's own "fragmented" narrative strategy.

This book has been a year and a half in the making; the kindness of all those involved in its production made it seem too short a while, and I thank them.

This book is dedicated, of course, to Ida Applebroog.

Francine Prose

Something about Ida Applebroog's work evokes the wonder, the dreamlike disorientation, the rapt, transfixed fascination experienced by a child riding through the city at breakneck speed, at dusk, on an elevated train line. Streaking past at eye level, dizzyingly nearby, the windows of the apartment buildings are either brightly lit or still swathed in shadow, but - lit or darkened - each of them has only a few seconds in which to present its high domestic comedy, its drama of romance and sex, or, just as likely, its private tragedy of loneliness, fear and violence.

Nothing is, or can be, interpreted or explained. The actors (that is, the ordinary men and women caught in the act of being themselves, of leading their everyday lives) are all strangers who somehow seem hauntingly, elusively, and maddeningly familiar.

Like life itself, these half-glimpsed, enigmatic scenarios rush by so fast that, by the time their most basic elements can be understood or even identified, they are already in the process of being erased and forgotten. Ida Applebroog's work - its mystery, its ability to create a weirdly pleasurable and durable state of anxiety, to offer the promise that everything will be made clear at the absolutely precise instant when that promise is being revoked - reminds us of those train rides, of those windows, those interiors, of those alternate lives slipping past us in the gathering darkness. It suggests that for that child - or anyway, for certain children - that train trip is the first intimation, the first real experience, of art.

Of course, many of Ida Applebroog's paintings make specific reference to the window, or to the theater stage that shares so much with the window beyond the obvious fact of the curtain. Indeed such pieces as "Now then" and "It isn't true" see no need to distinguish between the window and the stage, so that a curtained proscenium also gets its own window shade, just for good measure. In Ida Applebroog's theater of so-called normal life, the most ordinary and even banal gestures - an embrace, a kiss, a handshake, a touch, a moment of abstracted reflection - don't exactly add up the way we think they should. Or perhaps we're so disturbed by what they seem to be adding up to that we would rather not name it, not follow our intuitions to their logical conclusion. Again, there's a feeling of speeding past, of seeing something you aren't supposed to see, something that will change (indeed, that has already changed) the moment you pass by. The work is remarkably cinematic, in a looking glass sort of way; that is, the images and the viewer are fixed in place, and it's the viewer who seems to be in motion.

Even when a constellation of figures initially seems safe or at least neutral, the title forces us to confront (or at least rethink) that scene we were hoping to get past without major psychic damage. For example, those citizens in their nice overcoats returning our gaze could be focused on anything - except that the piece happens to be called "the lifeguards are carrying a still body out of the water." Our view of an impassioned embrace is

altered fairly drastically by its giddy and thrilling threat: "You're rat food." What could be more harmless than a man taking off his jacket while a woman looks up at him? And yet the title, "Sure I'm sure" fills us, strangely, with doubt and dread. Whoever is talking, whatever it means - we don't believe it for a minute. And the truth is, it's not strange at all, it's that repetition of "sure." Ida Applebroog's compressed titles, texts, and brief, unsettling books function like well-aimed darts programmed to administer calibrated dosages of unease and humor the poison and the antidote combined in one neat package.

Part of the experience of speeding past windows on an elevated train is never being able to know for certain whether you have just imagined the scene you are pretty sure you just saw. That same riveting and exciting uncertainty comes through in Applebroog's work, though there are enough demonstrably troubling images here - guns, amputees, hatchets, suicides, people whose heads appear to have been surgically scooped away - to reassure (or alarm) viewers that whatever seems to be bothering us, it's definitely not all in our minds. In fact, the world and its very real horrors are always impinging on, and determining, the dramas of the paintings - which is part of what enables the work to be so interior and so private, so personal in its language, and at the same time, the very opposite of solipsistic and self-involved.

Much about Ida Applebroog's work suggests an especially marvelous passage from Jane Bowles's brilliant novel, "Two Serious Ladies." A woman named Miss Goering is telling her new friend Mrs. Copperfield about looking out a window, staring across the street directly into a half-torn-down building, and watching a man enter a room that is still partially furnished, and covered with flowered wallpaper, though now it is missing an entire wall. Miss Goering describes watching the man walk over to the bed and pick up "a coverlet which he folded under his arm. It was undoubtedly a personal possession which he had neglected to pack and had just now returned to fetch. Then he walked around the room aimlessly for a bit and finally he stood at the very edge of the room looking down into the yard with his arms akimbo. I could see him more clearly now, and I could easily tell he was an artist. As he stood there, I was increasingly filled with horror, very much as though I were watching a scene in a nightmare."

After ascertaining that the man didn't jump, but just stood there looking down with "an expression of pleasant curiosity on his face," Mrs. Copperfield remarks, "I do think it's such an interesting story, really, but it has quite scared me out of my wits and I shouldn't enjoy hearing another one like it."

What's so reminiscent of Ida Applebroog's art is the impression of a certain sort of mysterious information being communicated for mysterious purposes and in a mysterious way. And what resonates equally clearly is the notion of the intimate and quotidian gesture transformed by the removal of a wall, so that a private moment now becomes a species of performance or display, even if the performer is unaware of being watched, and even if no one is watching.

Her more recent paintings have not only abandoned the reference to the window but have been divided and reassembled from parts, worked into more sculptural constructions, all of which serve to remind us that we are looking at a painting. And yet they have somehow managed to retain that sense of showing us, in passing and on the fly, something at once recognizable and baffling, familiar and unnerving, something we almost think we can "get" until, invariably, it eludes us. Partly that's because what we're seeing is in fact so intimate, so hidden; the figures in "Marginalia," "Tattle Tales 2" and "Cul-de-sacs" are pictured in the midst of enacting the duets that they dance, on a daily basis, with their bodies, their underwear, their appetites, their fears, their selves, and with each other. The painter's eye, the painter's vision, is remarkably down-to-earth and anti-romantic, gifted with infinite compassion but with only limited patience for the pieties and the lies, the banalities, the bursts of passive aggression and false reassurance that demarcate a low-water point in the ebbing of our family, our cultural, and our political life.

Throughout the whole of Ida Applebroog's career, the voice that calls out to us from these paintings and drawings and installations resembles an older, wiser version of the voice of the astonished, truth-telling child in "The Emperor's New Clothes." It's a voice that insists on reminding us of what is (or should be) patently obvious, but which we would rather not acknowledge, or have been encouraged to deny. Sly, remarkably unjudgmental, but always with great force and conviction, that voice insists that sexuality does not end along with youth, that human nature is capable of far more than we might wish to imagine, that our bodies and souls are constantly contradicting the untruths that we have been told about them, that our lives will necessarily fail to follow the punitively narrow and restricted paths that our culture keeps telling us to take.

So the "Living" series, which takes off from Martha Stewart's simultaneously helpful and profoundly depressing calendar, addresses the dangerous and surprisingly long-lived lies about what women should - or can aspire to - do with their time. Hilarious and subversive, Appebroog's seasonal "to do" list of household hints illuminates the hopeless impossibility and absurdity of the goals that domestic goddesses like Stewart promote, from the imposition of order ("Organize Switzerland") to the expression of a cramped and heartbreakingly limited form of creativity ("Design aprons for nuthouse"), to charitable "good works" ("Benefit dinner for homeless scrotum"). Finally, in its suggestion that we set aside time to "Restore Mama's coffin," "Living" explodes the falsehood at the very heart of all the rest - that a clean house and a festive holiday table can efficiently sever the unbreakable connection between the passage of time and the world of loss and grief.

Humor is an essential element here, as well as that self-awareness that lifts all of this out of the realm of the self - and keeps the self in perspective. What results is the ability to walk a particular tightrope, a spider web spun, automatically and even at times involuntarily, by the artist who does have ideas and opinions about such

(one would think) self-evident issues as war, racism, sexism, hideous cruelty to animals, violence in general, and against women and children in particular. The challenge is to produce work that integrates and accommodates the promptings of these realities without seeming polemical or dogmatic, without suggesting that ideas are entirely what the work is about. It's impossible not to admire the courage of taking on the range of serious and important subjects that Ida Applebroog has addressed (sex, birth, death, the Holocaust, the Ku Klux Klan, Vietnam, child abuse, environmental disaster, to name just a few and say nothing of all the minor acts of evil and beneficence that constitute everyday life) as well as the panache, the humor and lightness of touch that has kept her work from ever seeming to lecture, or to hector, or merely to tell us what we already know. Her art reminds us that it's possible (if not always easy) to be fiercely, even ferociously moral, without being moralistic.

What comes through all of this is the sense of an artist who has been acutely aware of - and, more important, intensely alive and responsive to - everything that has happened to us over the last decades: what has changed and what hasn't, what has improved and degenerated, what we have triumphed over and what we have allowed to defeat us. And what's especially striking is not only the consistent freshness, but also the broad inclusiveness of this response. Few artists have been at once so stubborn and so subtle in their refusal to make arbitrary distinctions between high culture and low, between the domestic and the global, between the monsters of the psyche and the demons of the daily paper.

The world that Ida Applebroog's art reflects is entirely like our own - that is, a world in which comic books share psychic and physical space with the masterpieces of art history; a world in which high seriousness co-exists with high comedy, a world complex and broad enough to embrace gas masks and girdles, crucifixes and clarinets, television and tranquilizers, baseball bats and birthday cakes, gun-toting tots and homicidal polar bears. And the abundant life contained here is exactly like life - elusive, elliptical, filled with non sequiturs that (it may take us years to realize) turn out to make perfect sense. What it makes us realize is that those windows we have been rushing past were always, simultaneously, windows and mirrors, in which we were invited or allowed to see others' lives - and our own.

From her earliest works to the most recent, Ida Applebroog tells the truth about that world, and yet it's impossible to reduce that truth to mere words, to summarize what it is, or to explain how it communicates so allusively - and so lucidly. It reminds you of Emily Dickinson's suggestion: "Tell all the truth, but tell it slant." Looking at this body of work, this lifetime's worth of art, you can't help feeling that the truth - if the truth could somehow choose - would choose to be told exactly as Ida Applebroog tells it.

red notebooks

1974-78

Galileo works

1976

Vellum stagings

1977

"It's no use Alberto"

1978

Illuminated Manuscripts

1979

Dyspepsia

1981

Past Events

1982

Current Events

1982

"Life is good"

1983

Inmates & Others

1984

16

51

71

83

91

105

121

125

137

141

Sign on a Truck

1984

Cul-de-sacs

1986

Magic Kingdom

1987

Nostrums

1989

Safety Zone

1991

Tattle Tales 1

1992

"Everything is fine"

1993

Tattle Tales 2

1994

Prurient Interests

1995-96

Living

1996

Modern Olympia

2002

159

167

185

215

239

265

273

279

303

311

339

red notebooks

Is this a triumph?

I will be a legend
 (become a legend)
I will be a nobody from
the Bront who made it ~~so more~~

They will be loyal to me
It will be embarrassing
to be so rich

" Ida has made it!"

they will say

~~They~~ . I will dazzle everyone
 surround myself w.
I will ~~have~~ an air of
graciousness & grandeur

you think I should?
I accept
I didn't think
I stop being sex symbol
I make myself ugly
I become a reluctant goddess
I have mixed feelings
about my mother

I egg him on

You're not God.

You get what you pay for

I shudder with admiration
I squash him like a bug
I could be wrong
I fail (too)
I look amused
(is good)
Being alive feels good
(isn't)
Being dead doesn't
They stare at me
I'm a little scared
My hands tremble

x cut into dialogue of
 tiny sculpt.
 ——— repeat same again
 again

———

? use zig zag pcs.
 maybe other pcs.

———

Caruso pc.

———

ha ha
 I've gone crazy
 they put me in the
 looney bin

——— ~~Check Alice in wonderland~~

——— take her phrases
 repeat. one again +
 again

I let God touch it
" " " hold it

I touch his

He lets me hold it

I smile Knowingly

I show him

I am ready

I talk only to God

God find a minute!
God finds a minute

I see what God is doing

God & I don't speak any more

I egg him on

you're not God

I need permission to think?

Oh God take away my lunacy

I enjoy my lunacy

hat on head reading newspaper
→ other (me) leans forward
 anxiously ; holds a closed
umbrella tightly w. both hands

Eventually I become ~~Jewish~~

I call him stupid creep

Did I have my baby yet ?

I forget to say good - bye
 The Trouble is

1583 G : I discover uniformity of pendulum
 vibrations (1583)
 (Set is carnival)

1604 I announce law of falling bodies
 I am correct in result but defective (wrong)
 in theory

1609 I arrive at correct theory of
 falling bodies

1611 I am feted by Jesuit mathem-
 aticians

1614 Both dtrs. enter convent (at
 Arcetri)

1618 I hold discussion of comets w. friends

1630 · I leave Rome w. "complete
 satisfaction"

1637 Both my eyes irretrievably lost

1638 I publish first great work of
 modern physics

1642 I die
 I offend the reputation of the
 Church

Intermix w. other
our lives
leave out dates

I want a baby
I make a deal
why am I so cruel?

Don't be scared, baby
I hand him the "kill-me" pill
I (He) really mean business
I am catching on
I say "goodbye, baby"

She's no use to me dead
I (do) pull the please-kill-me-now
routine
I take my enemies alive
I feel his nails cut into my flesh
He could cut my throat with-
in seconds
I'm already ahead (of) in the game
I know whom I'm dealing with
I get rid of those closest to him

I drop names
I become a street-trained /killer
It is in the cold steel of my eyes

Another party
I feel uneasy
I was tough all right
am

A hot drop of sweat rolls down his
forehead
Panting heavily
I keep my cool
I obey willingly
His brow ~~was~~ is damp w. perspiration
His nerve ends twitch
He makes throaty noises
His muffled sounds reach a peak
~~His~~ He is spent
I can ~~almost~~ feel it
My eyes flash ~~xx~~

Beverly ~~was~~ is now doing it w. fervor

My voice rises w. excitement
I close my eyes
I let it happen
I loose all control
My pulse starts racing
I don't fight it
I moan from deep within
burst, after burst, like a
machine
~~(He)~~ I can't get ~~enuf~~ ~~machine gun~~
A ~~lusty~~ lusty smile creeps
over my face

I am differently developed
~~A~~ you are mentally ill
yes, it is so
my object is in your cleansing
I love you
I hate you
My object is to establish woman's rights
Are you human
I am human, you pig
Now then
Shall I get well again
Not according to the plan
I only want to help you
You are not mentally ill
~~For~~ God's sake, you ~~made a note~~ memorize
~~of~~ everything I ~~could~~ say
No, in the middle of ~~your~~ my head

Too bad
I think you're sick (you stink)
who's that?
I'm not deaf
what for?
How tiny?
That's adolescent
That's too much
who's that?
Think so?
Especially now

I am what I am

I Know what nothing means

I'm pregnant or something

("He says," you pregnant or something?")

I'm getting there

where?

where I am

I tell him something funny

Don't tell me no

I also love Christmas / Christians

"You started it", I whisper

go ahead

you can't hurt me

why should we / I?

I can't take this

Stop it

I'm all right

I don't tell him who I am

Can you hear me?

(me)
He orders a Cuba Libre for both of us

yes that is art
I tell an enormous lie
He used to be a stockbroker
my teeth smile like a knife
I am about to forget you

A 9yr. old Bronx boy is falling from
a fifth-floor window.

~~An 82, They discover~~ An 82 yr old
man is lying & bound, ~~and~~ gagged ~~and dead~~ on the
kitchen floor.

The Police Dept's. methods of
measuring corruption ~~is~~ are
grossly inaccurate

~~A hidd.~~ somewhere Aa handsome Congressman
talking about how
is battling to preserve ~~the~~ civil liberties

the a 5 million dollar ~~winning~~ lottery tickets ~~are~~ is being
allotted
The winner of a million $ lottery ticket
is being announced

you are beating a woman

take it away

There are no heads w.o migraines
here

a hundred lilac trees ~~around them~~

~~She~~ She tells me,
"your avocado tree has also
died"

And you?

All of a sudden?

Mating person

a ~~horse~~ is being born w. only one ~~kind~~ leg
baby

within 2 days his entire body will be
teeming w. maggots

I'm big w. child
what do I get out of it? }

Immortality
Yes that is art

The smell of lilacs ~~blossom~~ enters the ~~night~~
room

I'm going to the morgue, sir —
This is a dead lady, sir

 I am also Jewish
 I don't tell anybody I'm Jewish
 How come I wasn't told?
 I see I'm scaring you
" we think your father died ", ~~they~~ he says
" It is our opinion that he is dead " ... "
 Death is very final
 Go ahead & ~~smoke~~
 I have something to tell you
 I have bad news for you
 nothing is happening
 you killed her? yes. poison

I agree to have a baby
 I say yes to everything
 Not to me
we must not shake hands —
while people are slipping out of my body
 Panting heavily, I keep my cool
 He is spent
 I can't get enuf
you blow your nose
I blow mine
who is right? you or me?

Stop doing that
Don't call me that
(Never)
It'll do you good

Hilda is my name
My mother & father gave it to me

Yes, once, a long time ago
What's that got to do w. me?

I can't take it anymore
you must Know (me)

Don't sit in it

Are you deaf too?
You're a bunch of cripples
 mother
your father wants you to come home
~~Don't call~~

I've got news for you, girlie

I've got the bible in one hand
and a 38 gun in the other
Save America
Power is God

I'm very worried I hope you are,
too

If I told you they were made up, you'd feel deceived; if I told you they were true, you'd be embarrassed

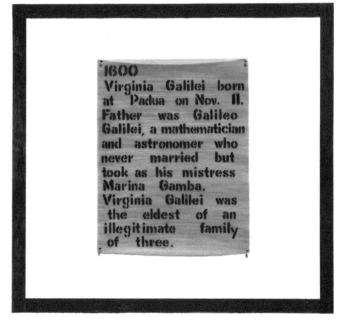

**Galileo Chronology:
I too am of the male race**

1975 > ink and rhoplex on vellum & ink on mylar,
4 panels, 21 3/4" x 57 1/4"

1600

Virginia Galilei born at Padua on Nov. 11. Father was Galileo Galilei, a mathematician and astronomer who never married but took as his mistress Marina Gamba. Virginia Galilei was the eldest of an illegitimate family of three.

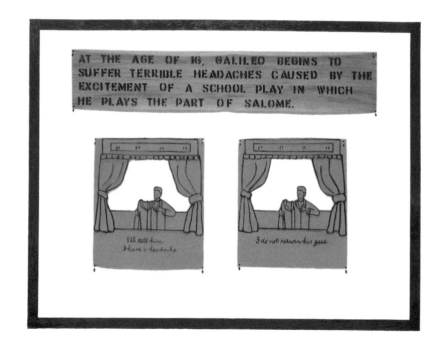

**Galileo Chronology:
At the age of 16**
1975 > ink on mylar,
3 panels, 2B 3/4" x 37 3/4"

AT THE AGE OF 20, GALILEO IS OFFERED UNION WITH A VIRGIN ON NEW YEAR'S EVE. HE ACHIEVES THIS WITH THE GREATEST POSSIBLE DIFFICULTY, EXPERIENCING THE MOST ACUTE PAINS OF THE BLADDER.

I'm offered union with a virgin

But we haven't met yet

I drink in every sob like wine

Eros has shafted me

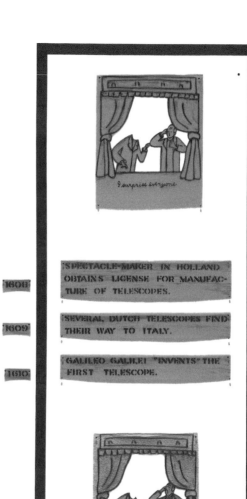

I surprise everyone

1608

SPECTACLE-MAKER IN HOLLAND OBTAINS LICENSE FOR MANUFAC- TURE OF TELESCOPES.

1609

SEVERAL, DUTCH TELESCOPES FIND THEIR WAY TO ITALY.

1610

GALILEO GALILEI "INVENTS" THE FIRST TELESCOPE.

Everyone smells it and no one believes it

Galileo Chronology: At the age of 20
1975 > ink on mylar,
5 panels, 60 3/4" x 34 1/4"

Galileo Chronology: I surprise everyone
1975 > ink on mylar,
8 panels, 49 1/2" x 20 1/4"

55

I'm hearing voices

God, is that you?

Collect yourself, this is a serious moment.

I accept reality. I dare not question it.

I'm suffering

I haven't suffered enough.

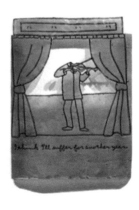

I think I'll suffer for another year.

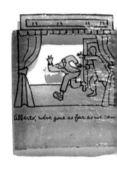

Alberto, we've gone as far as we can.

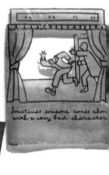

Sometimes someone comes along with a very bad character.

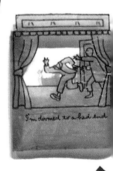

I'm doomed to a bad end.

GALILEO GALILEI SUPPORTS THEORY THAT EARTH MOVES ROUND THE SUN.

1625

INQUISITORS ORDER GALILEO TO ABANDON THIS THEORY.

1632

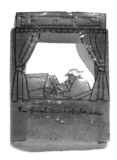 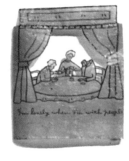 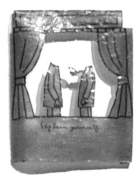

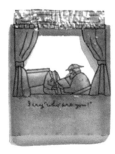 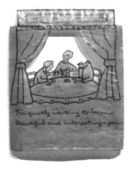 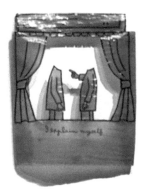

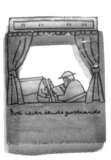 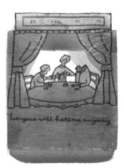

GALILEO GALILEI
IS IMPRISONED
AFTER HUMILIAT-
ING ABJURATION.

Galileo Chronology: I'm hearing voices
1975 > ink and rhoplex on vellum & ink on mylar,
24 panels, 82" x 148"

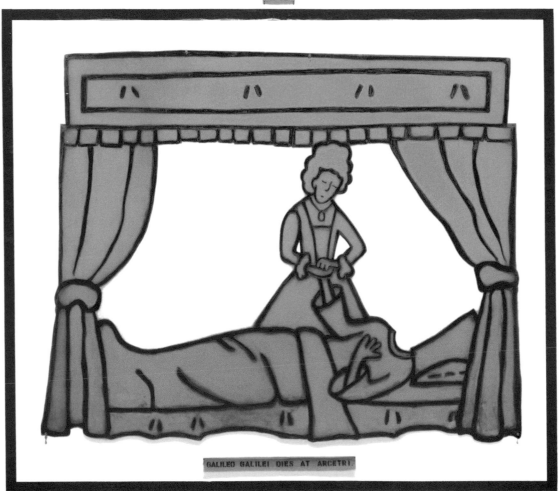

Galileo Chronology: I'm dying

1975 > ink and lacquer on mylar,

3 panels, 69 1/2" x 79 1/2"

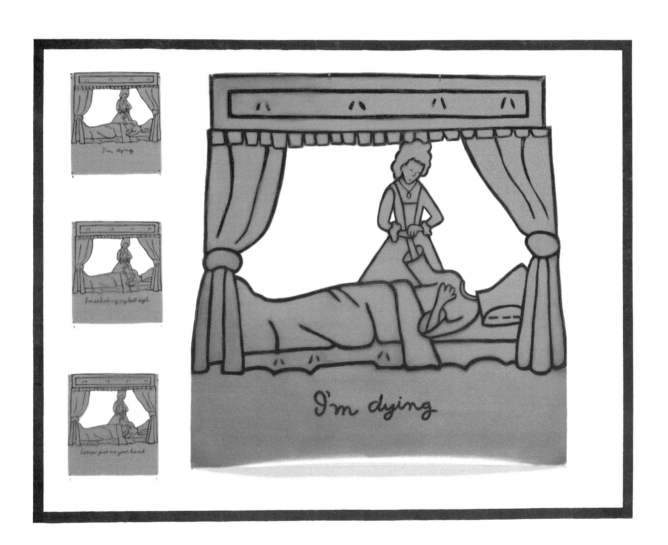

I'm dying

Galileo Chronology: I'm dying
1975 > ink and lacquer on mylar,
4 panels, 67 1/4" x 86 1/2"

Dearest Father,

Now that the tempest of our many troubles is somewhat abated, I will no longer delay telling you all about them. The fact was, that I was half out of my senses with fear, at the furious behavior of Livia, who during these last few days has twice endeavored to kill herself. The first time she knocked her head against the floor with such violence that her features became quite monstrous and deformed. The second time she gave herself thirteen wounds, of which two were in the throat. You may imagine our consternation on finding her all over blood, and wounded in this manner. At present we are all well, thank God, and she is tied down in her bed, but has just the same frenzy as ever, so that we are in constant terror of something dangerous happening. I hope, please God, this will be the last time I shall trouble you.

I conclude with affection,

Your devoted daughter,

Virginia Galilei

If you have collars to be bleached, Sire, you may send them to me.

**Galileo Chronology:
Virginia Galileo letters**
1975 > ink on parchment,
3 panels, 28 3/4" x 37 3/4"

Dearest Father,

Truly I have never resented living cloistered as a nun, except when I hear that you are sick, because then I would like to be free to come to visit and care for you.

Of the preserved citron you ordered, I have only been able to do a small quantity.

I feared the citrons were too shrivelled for preserving, and so it has proved.

I also send back the rest of your shirts which I have been working at. I cannot begin working on the dinner napkins till you send the pieces to add on.

Your most affectionate daughter,

Virginia Galilei

Dearest Father,

Pray, pardon me but there are signs which seem to tell me that your affection for me is not so cordial as it was in the past. For now you do not pay me a visit once in three months.

For more than a month I have suffered day and night from headaches, and can get no relief. Just now, the Lord having mercifully mitigated the pain, I seize my pen to write you this long lamentation. Meanwhile I send a few preserved fruits which were given me. I beg that the dish in which it is sent may be returned, as it does not belong to me.

Your devoted daughter,

Virginia Galilei

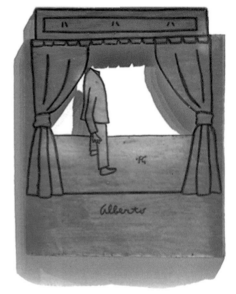

Alberto
1975 > ink and rhoplex on vellum,
6 panels, 12" x 9 3/4" each

 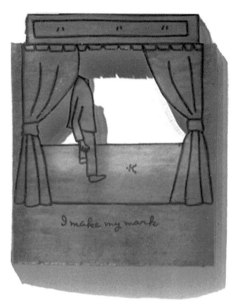

I make my mark

One of the persistent issues of Ida Applebroog's work is the hazardous uncertainty of personal communication. It is about the gaps, lapses, and communication breakdowns that can make life almost unlivable. She builds her world on a base of misunderstanding, a world from which meaning is perpetually hemorrhaging. It is a world where the answers insistently cast doubt on the questions; where communication divides much more than it unifies; where the messages are undermined by their meanings. From the early dramatic vignettes to the later assemblage paintings there is the recurrent sense that the viewer and the actors will never ultimately understand anything for sure. And in this doubt, paradoxically, there is certainty. Ultimately, Applebroog's is an œuvre without an ending.
J.C.

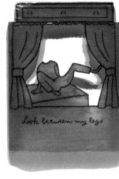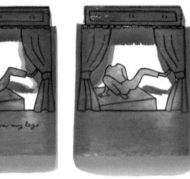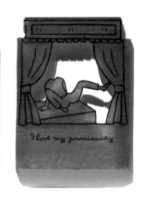

Look between my legs
1975 > ink and rhoplex on vellum,
5 panels, 10 3/4" x 8 1/4" each

**I am adrift in a medium deprived
of significant boundaries**
1975 > ink and rhoplex on vellum, 11 3/4" x 9 12"

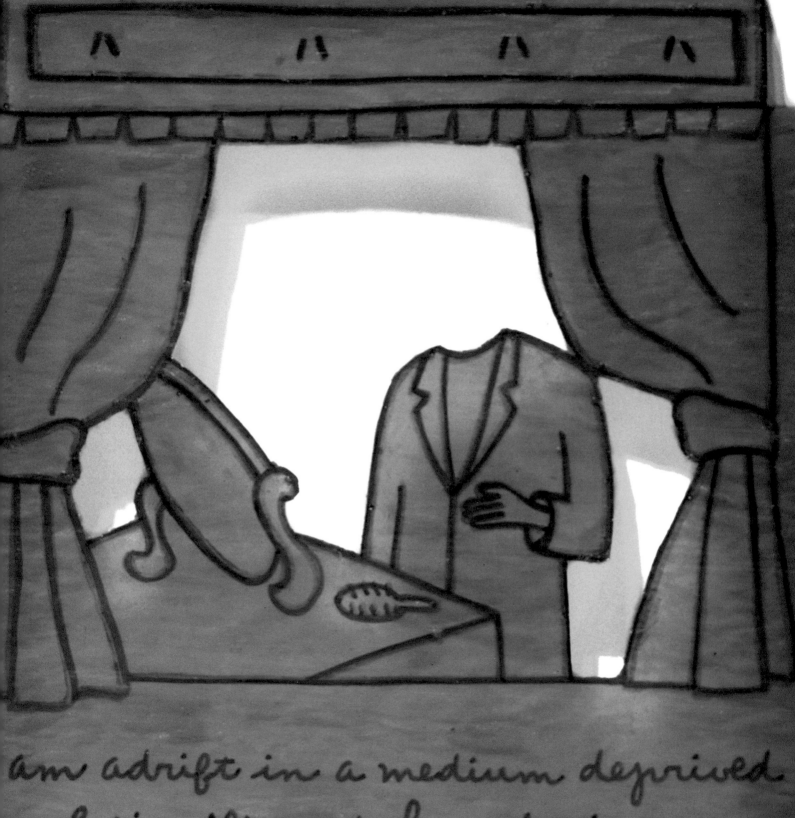

am adrift in a medium deprived
of significant boundaries

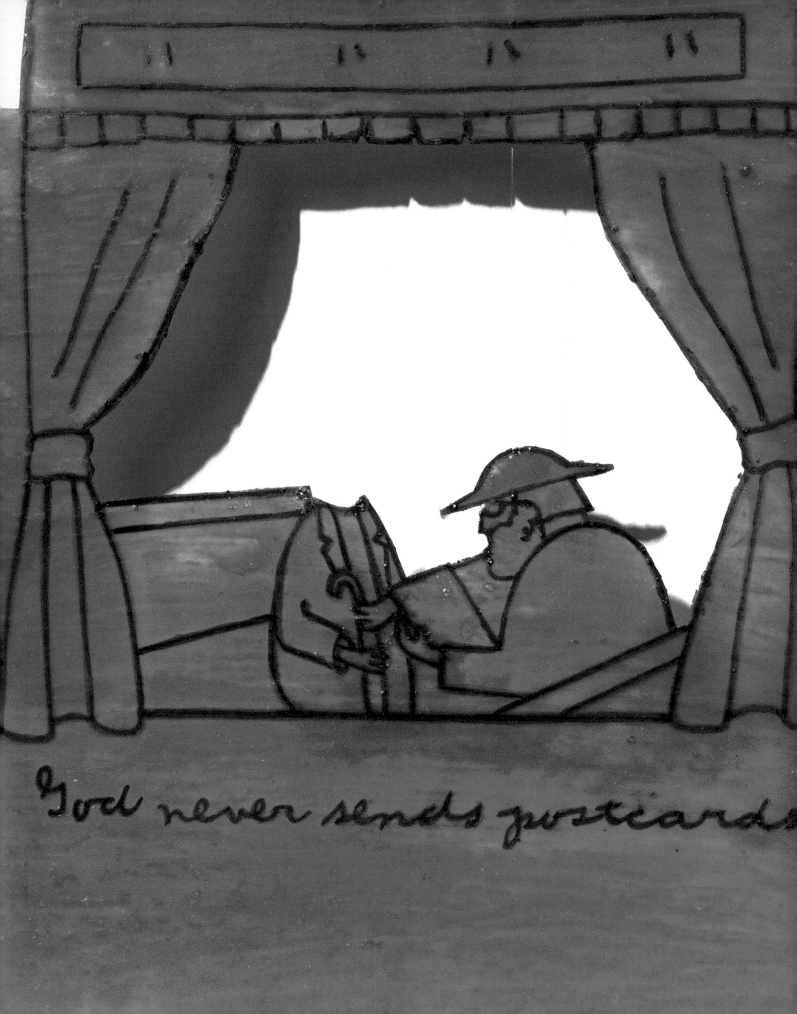

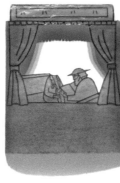
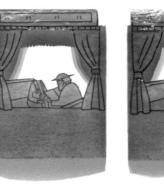
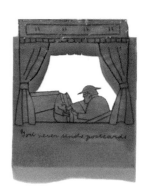

I'm frightened of old men

I cry "who are you?"

God never sends postcards

God never sends postcards (detail)
1975 > ink and rhoplex on vellum,
5 of 6 panels, 10" x 8" each

By the late 1970s, it became clear that ultimately there was no criterion for how a work of art had to look - and hence that art could look any way at all. This effectively sundered art from aesthetics, and opened possibilities for art beyond those of simply prompting visual pleasure. This meant not the end of painting, but the end of painting as the paradigm of art. Painting now had no greater claim to the status of art than a piece of chicken wire, some felt scraps, a length of cheesecloth impregnated with latex, a two-by-four leaning against a wall - or a plywood box stenciled to look like a carton of Brillo scouring pads. Painting became merely one member of an indefinitely expansible array of ways of making art, leaving it possible that graffiti, lists of sayings, postcards - or booklets - should be among the other disjuncts.

...

And if the artworld was a site of experimentation and exploration, expressed in the ephemerality of its most characteristic products, the performance was perhaps the defining genre of the time, involving an immediacy of engagement between artist and audience that aimed at the transformation of consciousness rather than the embellishment of walls. That Applebroog appropriated the term for her books implies that they were not to be looked at but worked through by interactive rather than passive readers.

A.C.D.

I CAN DO ANYTHING

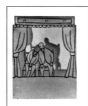
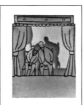

SEX IS LIKE A CARNIVAL

2

3

A PERFORMANCE

IDA APPLEBROOG

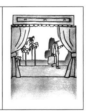

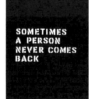

SOMETIMES
A PERSON
NEVER COMES
BACK

1 Alberto is gone

2 I can do anything

3 Sex is like a carnival

4 The lifeguards are carrying
a still body out of the water

5 Sometimes a person never
comes back

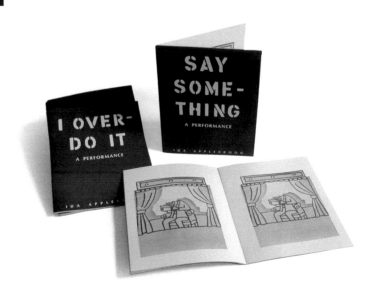

SAY
SOME-
THING
A PERFORMANCE
IDA APPLEBROOG

I OVER-
DO IT
A PERFORMANCE
IDA APPLE

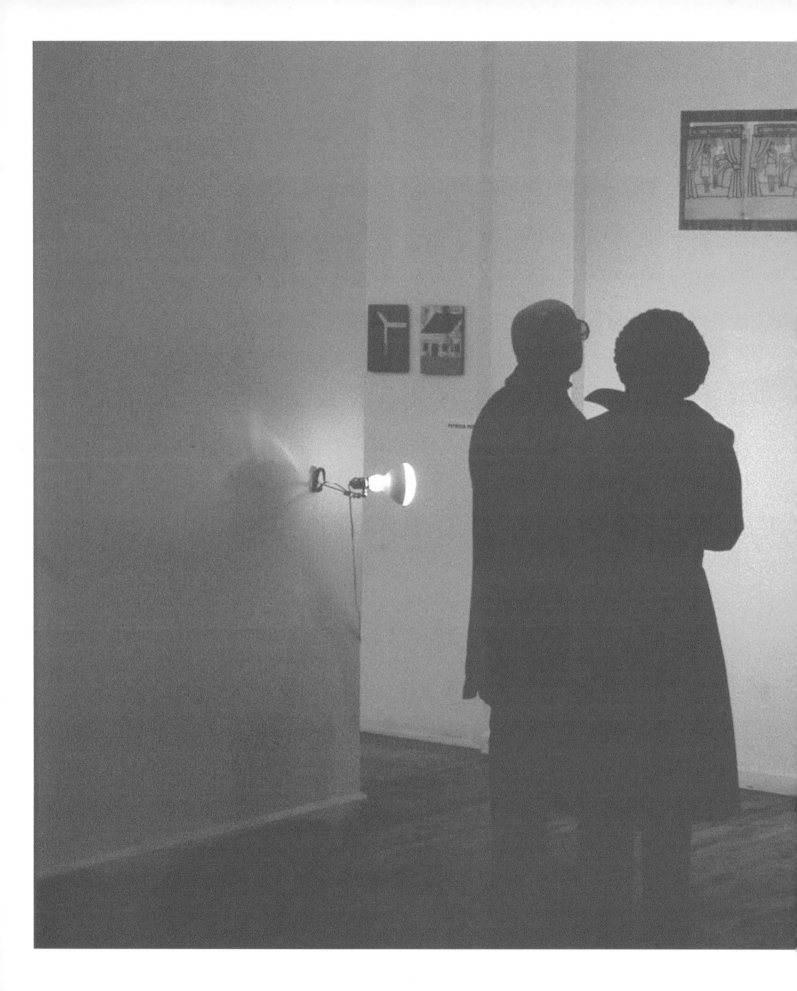

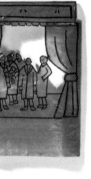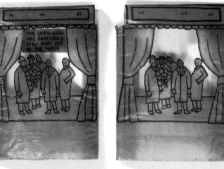

**The lifeguards are carrying
a still body out of the water**

1977 > ink and rhoplex on vellum,

5 panels, 12" x 9 1/2 each

**Sometimes a person never
comes back**

1977 > ink and rhoplex on vellum,

5 panels, , 12" x 9 1/2 each

There is something mechanical about the repetition of the frames, players and stage-directions of Applebroog's dramas, evoking the serial duplications of mass culture and the repetitive patterns of life in the metropolitan machine. Small dramas of routine existence, captured momentarily from a neighboring window, the habitual déjà-vu of daily events replayed, again and again. There is a numbness here, a lack of affect, something vaguely catatonic. Here the mundanely obvious is haunted by the sinister evocation of latent sexual violence and loss. The linear sequence of repeated frames is like the walls of a haunted house into which the memory of trauma has been recorded.

Each phase, section, and work within the oeuvre is one more amputated sequence from a story which has neither beginning nor end. It is as if between the parts which make up the whole, between each new act in the infinite drama, the thread which binds the components together has been severed, the storyline lost. Frozen frames of neutralized intensity have been set adrift from the narrative base that might have given meaning to the actions they depict. Now the actors are trapped in the endless repetition of dramatic instants. They are suspended in time by the lost memory of their action's meaning, a meaning perpetually on the verge of being remembered. The players in these dramas have lost the plot, and the viewer is helpless to assist. Deprived of a narrative context which might clarify and substantiate their meaning, the viewer, like the players themselves, is set adrift in this autistic and amnesiac space of meaning's absence. The present has been sealed off from the immediate past and imminent future. The actors have forgotten the meaning of their lines, whose lines are whose, and to whom they are addressed. But still the ghost of meaning haunts them. And in the space emptied of meaning there resounds the echo of some generalized trauma, the memory of some unbearable pain.

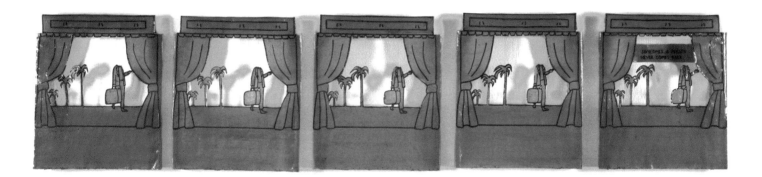

The flattening of emotional affect in these vignettes suggests the splitting of the personality which occurs as response to trauma. In order to neutralize the pain to which their memory perpetually returns them, the subjects position themselves as detached observers of the drama of their life. In the process, their emotions begin to take on an artificial quality, as if drained of some authenticating essence. The defensive mechanisms which protect them from further pain also put an unbreachable distance between themselves and others. Their capacity for empathy has been neutralized, and they observe the world with frozen affect, as if they were witnessing the events from outside their bodies.

But perhaps this is all TOO dramatic. Perhaps, on the contrary, the players in these dramas are just normal people, whose emotions have been so automated and neutralized by the serial rhythms of everyday life that events of real dramatic significance pass through them without affect. One is never sure.

Perhaps this is why their meaning always addresses the viewers tangentially. The viewer is left to guess as to which player in the frame the caption refers. To do so, he is obliged to invent the story that would make sense of his interpretation. Ida supplies the image sequence and the caption; the rest is brought by the reader. In so doing, the work confronts the reader with his own preconceptions and projections about the relationship of the characters in the scene. There is trauma, but whose is it?

J.C.

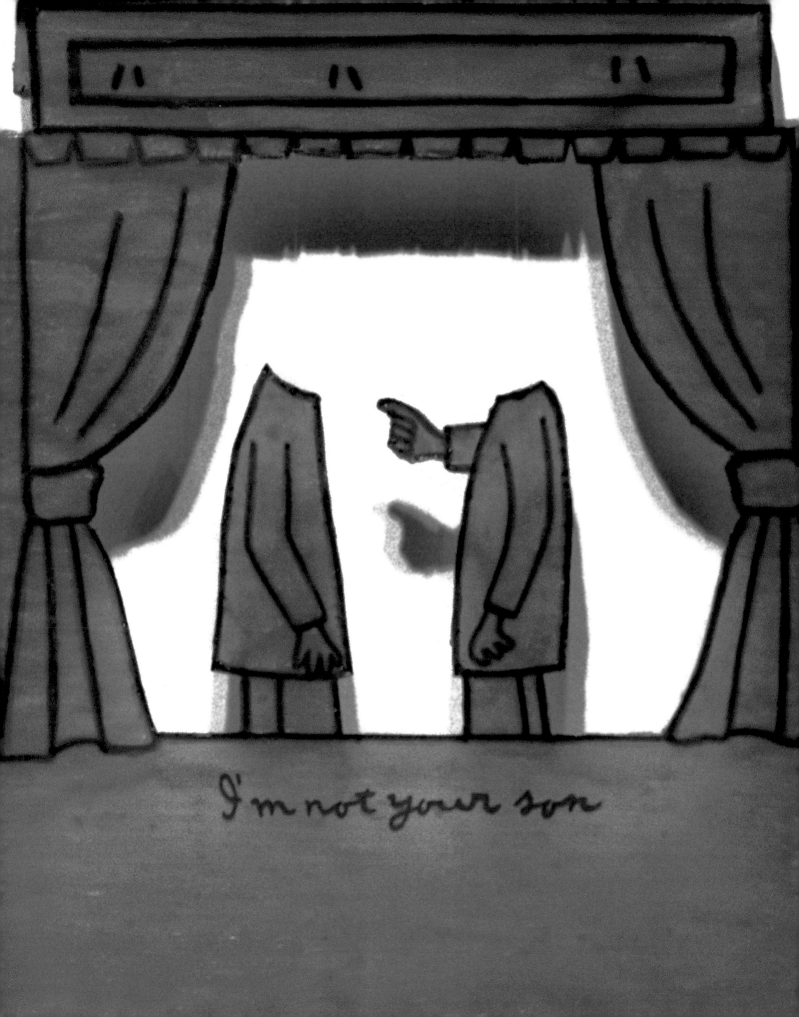

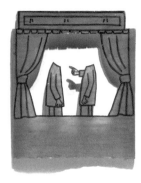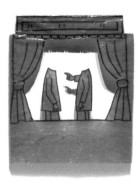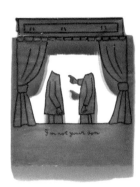

I'm not your son, Act 2
1977 > ink and rhoplex on vellum,
3 panels, 12" x 10" each

The stage sets that typify Ida's early works suggest an awkward incompatibility between those events of a life worthy of dramatic significance and the monotonous repetition of everyday banality which surrounds them. The heroic and the everyday intersect in these minor dramas, but they never meet. The self splits at the intersection where art and life coincide, where the normal person finds himself in the uncomfortable role of a dramatic persona. The profound sadness of these works stems from the double tragedy of human subjects alienated from themselves, yet desperate to communicate with others; actors whose words are forever missing each other at precisely the same point.

Sometimes this is funny.
J.C.

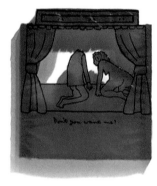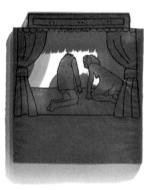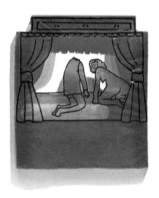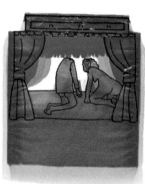

Say something
1977 > ink and rhoplex on vellum,
7 panels, 10 1/2" x 9 3/4" each

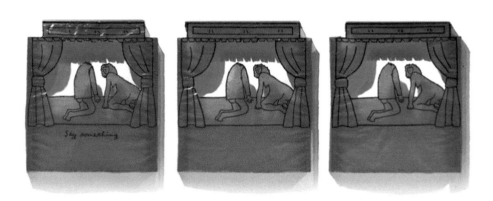

There is no linear narrative… usually one expects that if you start at the beginning and enter each scene one after the other, surely you will understand it at the end - but there is no beginning, no end - you enter into the middle of it. I.A.

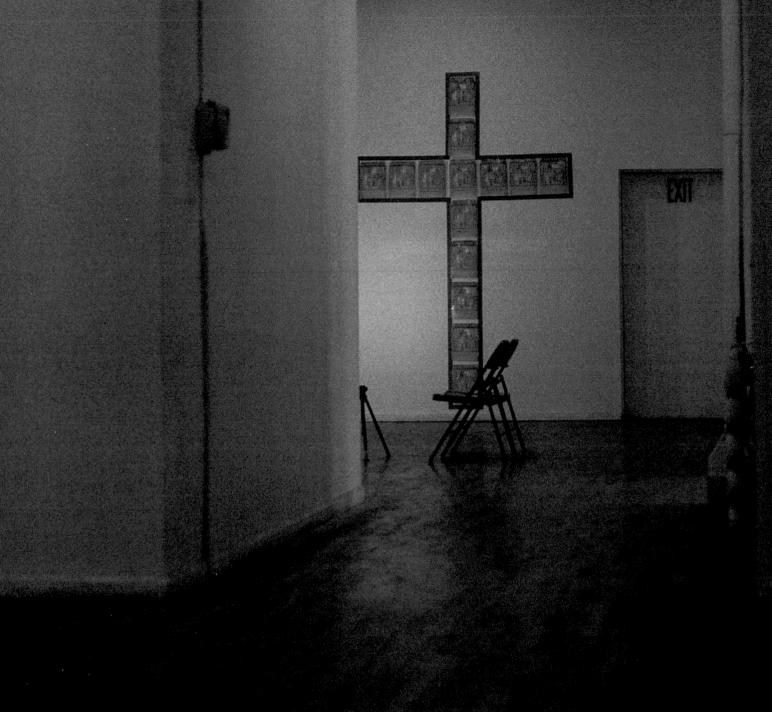

The Applebroog installation is a highly personal magical world of puppet theaters, small illuminated stages on which potent human dramas take place and speak of the endless, repetitious, and absurd conditions of life on this planet in 1978.
The whole setup has the charm and mystery of a lantern show run by a laconic puppet master who puts together very simple cartoons on the human condition with a sinister use of silence against the snatches of conversation.
M. F.

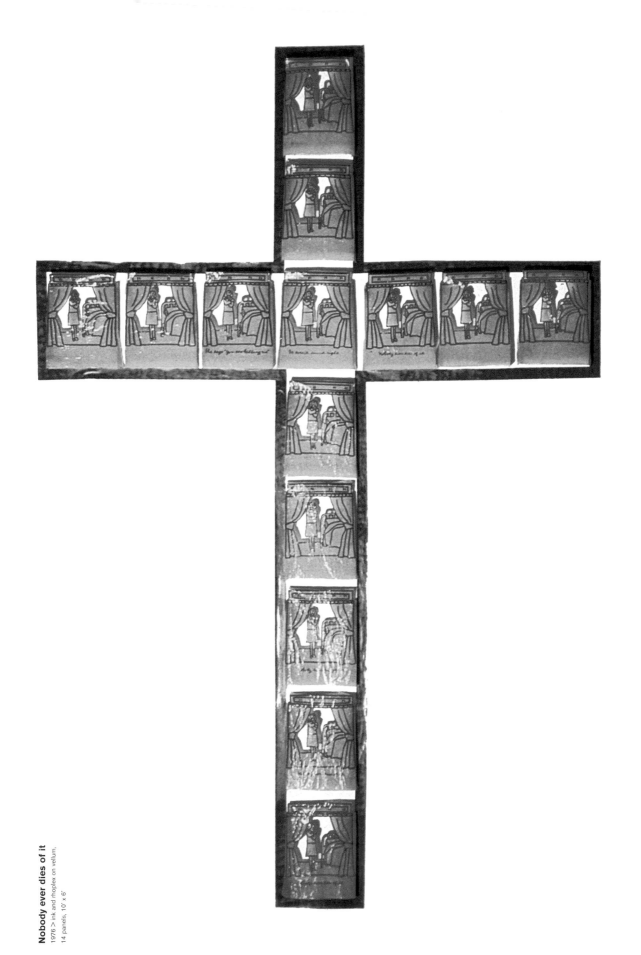

Nobody ever dies of it
1976 > ink and rhoplex on vellum,
14 panels, 10' x 6'

once

I was beautiful

like a porno

star

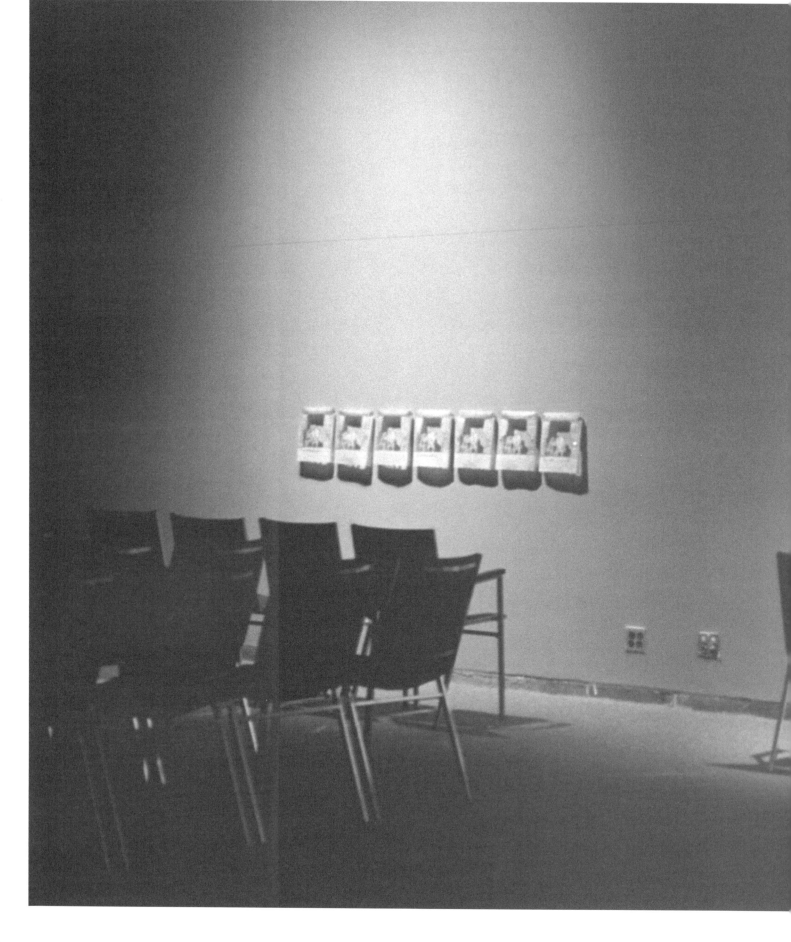

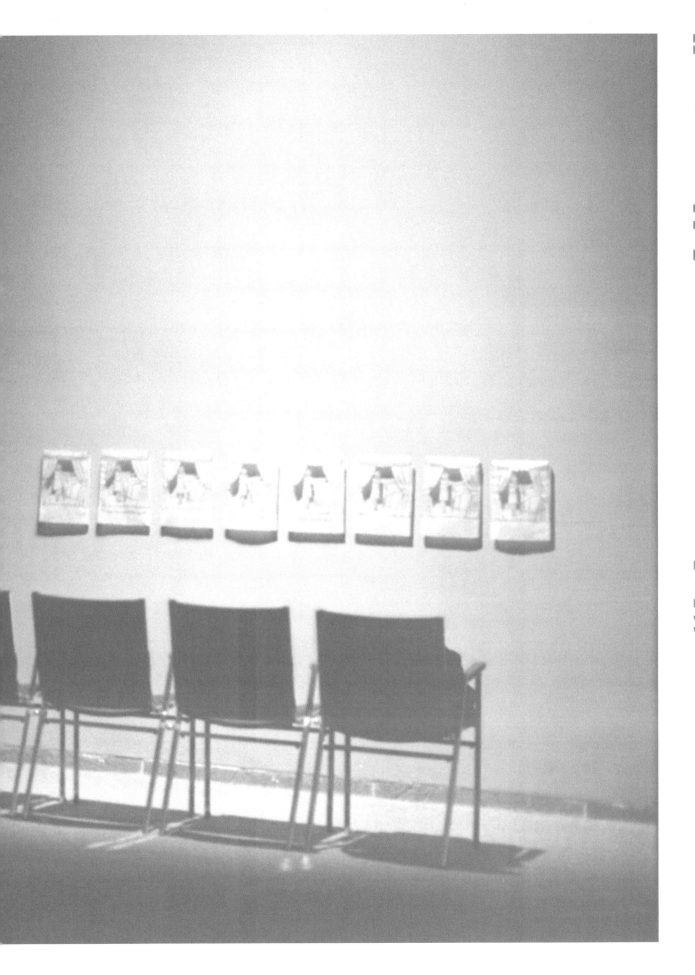

"It's no use Alberto"

1978 > Whitney Museum of American Art (Film & Video Dept.)

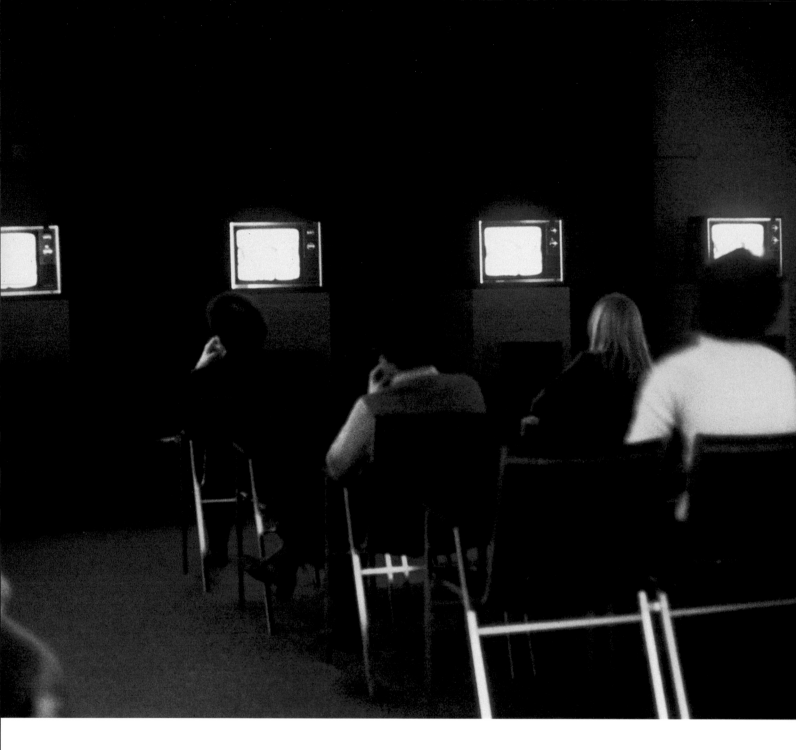

Always present a given situation which remains to the end substantially what it was at the beginning by the time you arrive on the scene - the story is over - what's left is the situation which is being recalled.
I.A.

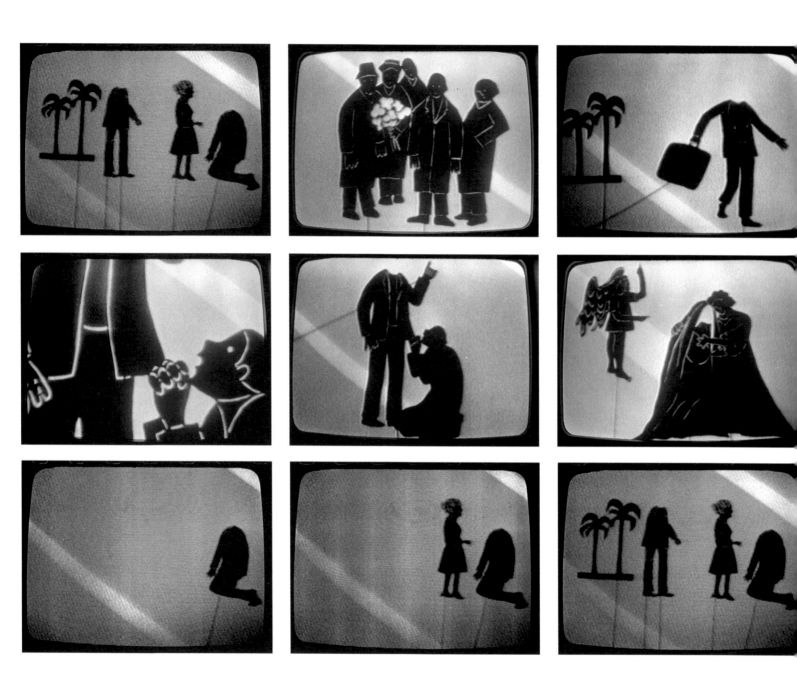

It's no use Alberto (stills)
1975 > black and white video, 21 minutes

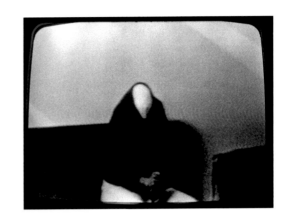

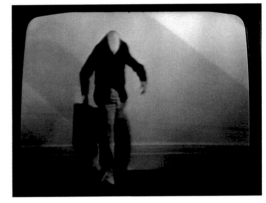

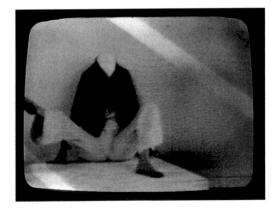

Lunch hour Tapes (stills)
1977 > black and white video, 25 minutes

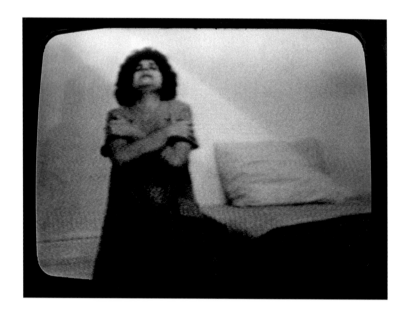
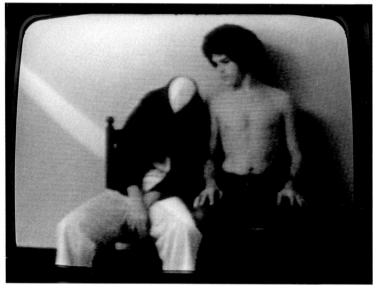

In that other thing called "television" the idea is to make everything as real as possible; for me video was a way to cut through all that reality by leaving in hums, scratches, edits, audio distortions, incoherent dialogue - I tried very hard to evoke the "wrong" effect.
I.A.

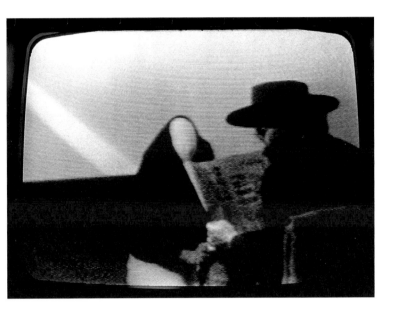
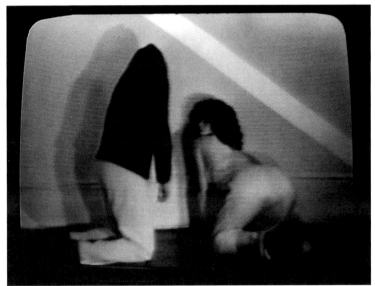

Lunch hour Tapes (stills)
1977 > black and white video, 25 minutes

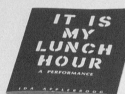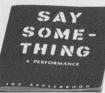

SOMETIMES
A PERSON
NEVER COMES
BACK

I CAN
DO
ANY-
THING
A PERFORMANCE
IDA APPLEBROOG

THE LIFEGUARDS
ARE CARRYING A
STILL BODY OUT
OF THE WATER

A PERFORMANCE
IDA APPLEBROOG

Codex n°2
1976 > ink and rhoplex on vellum, 18" x 14"

Codex n°9
1976 > ink and rhoplex on vellum, 18" x 14"

Codex n°10
1976 > ink and rhoplex on vellum, 18" x 14"

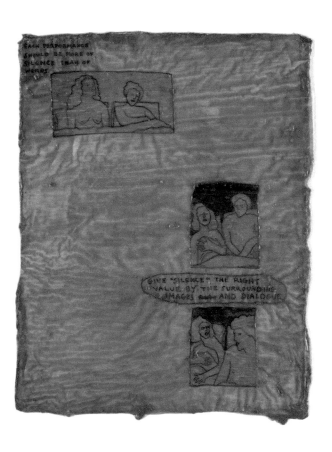

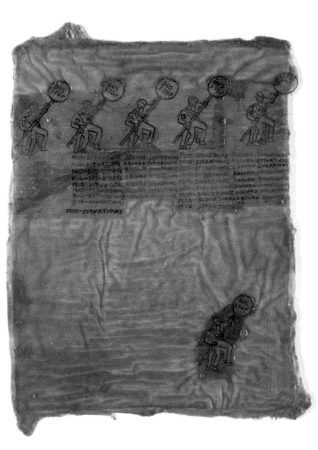

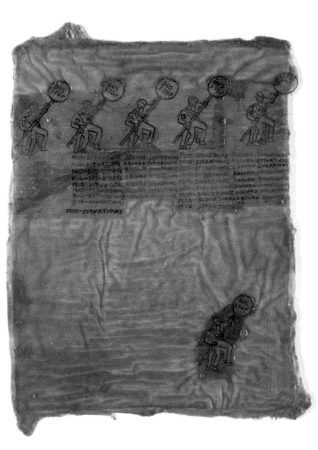

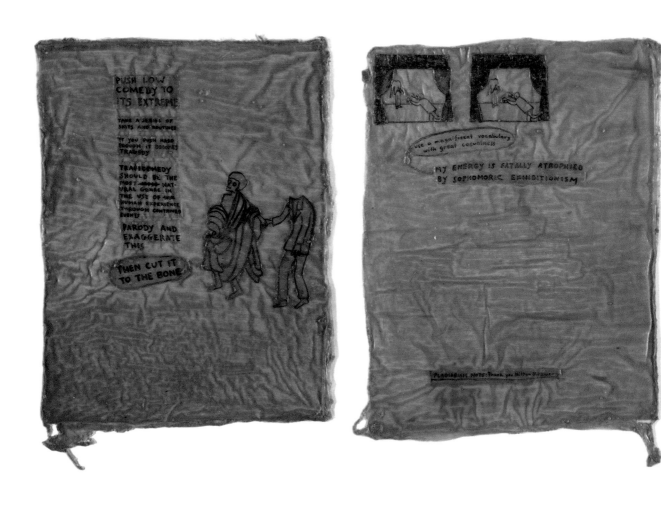

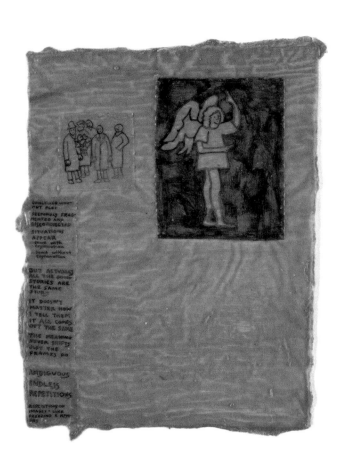

Codex n°3
1976 > ink and rhoplex on vellum, 18" x 14"

Codex n°8
1976 > ink and rhoplex on vellum, 18" x 14"

Codex n°7
1976 > ink and rhoplex on vellum, 18" x 14"

95

Applebroog's silent "stagings" sometimes seem like pages from the secret diary
of a deaf mute - that is, they "speak," but in forms devised by a person not used
to eloquence.
K.L.

Codex n°1

1976 > ink and rhoplex on vellum, 18" x 14"

EACH PERFORMANCE

1 where nothing really happens
2 where puppets hide behind their clichés
3 where the situation is ~~the~~ the condition of being human

TRY TO KEEP A KIND OF OBSCURE REALISM WHICH CAN'T BE EXPLAINED BY WHAT WE'RE USED TO SEEING— BUT NOT SO HIDDEN THAT IT CAN'T BE READ

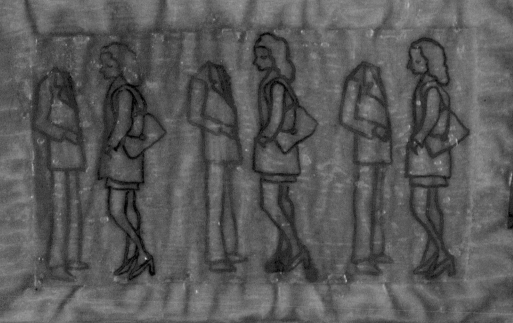

REDUCE LANGUAGE TO THE CORE

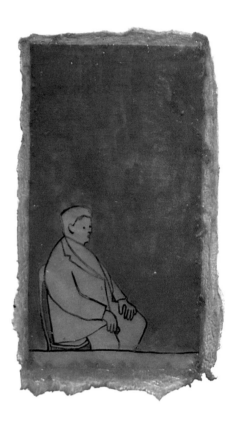

Untitled (birth)
1979 > lacquer, ink and rhoplex on vellum,
6 panels, 9 1/2" x 5" each

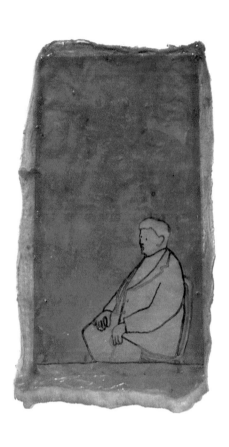

pif

paf

pof

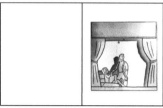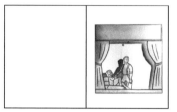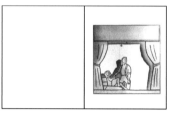

3

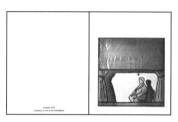

5

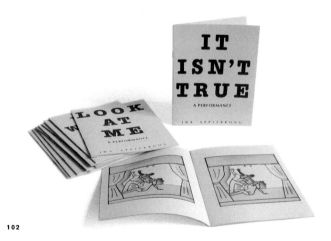

When I first started putting out these images, especially the ones including text, some people were uncomfortable: I was hitting too close to some of their experiences, feelings. The drawings were about situations that people don't talk about. They were very private, personal thoughts, and in art, one just didn't do that. Think of the work that was out there in the 70's: minimalism, performance, very cool conceptualism. When I started sending out the drawings as books to a lot of different people, I got a varied response. Some loved the books; from some, I got hate mail. I have an inspiring file of hate mail.

I.A.

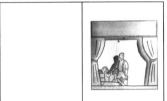

1

2

LOOK
AT
ME

A PERFORMANCE

IDA APPLEBROOG

4

6

1 It isn't true

2 Your hair will grow again

3 Look at me

4 We are drowning, Walter

5 Now then

6 Take off your panties

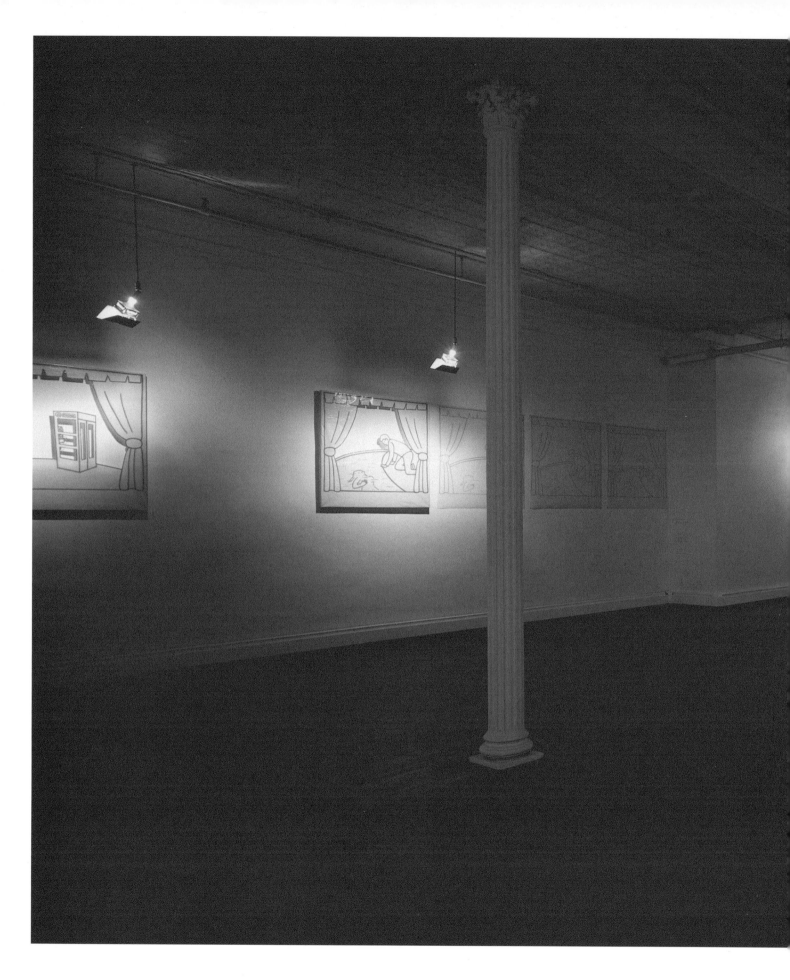

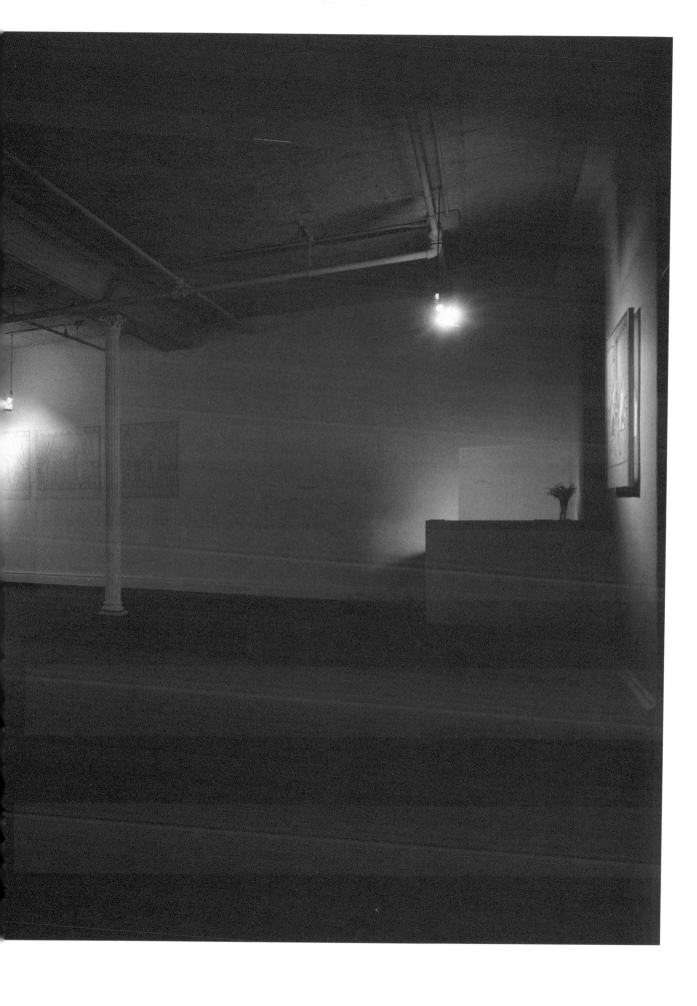

Dyspepsia

1981 > Ronald Feldman Fine Arts

Mute family traumas and moronic formalities take place between proscenium curtains or behind window-shades in her provocative *Staging*. These unfunny cartoons stick in the gullet and repeat like records stuck in a groove. They are less narrative events to be understood than psychological imprints fixed in the voyeuristic memory like scar tissue. K.L.

Now then
1978-79 > ink and rhoplex on vellum,
5 panels, 11 1/2" x 9 3/8" each

Shake
1980 > ink and rhoplex on vellum, 48" x 48"

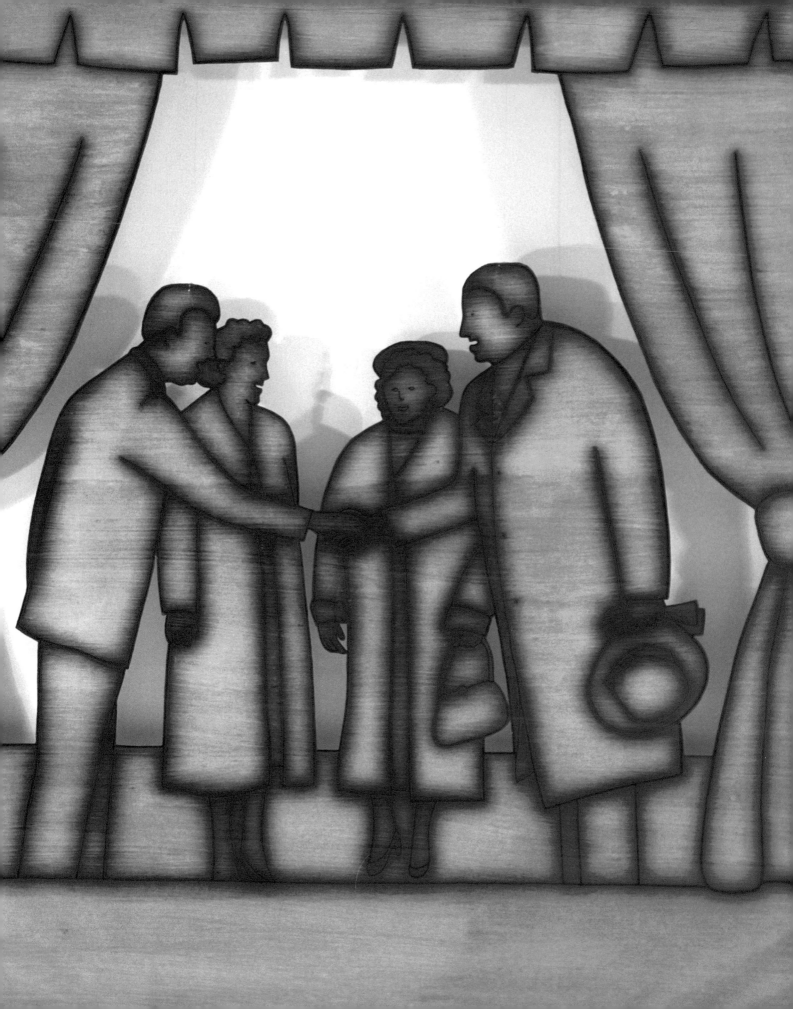

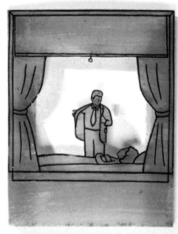

I threw it away

Sure I'm sure
1979-80 > ink and rhoplex on vellum,
6 panels, 12" x 9 1/2" each

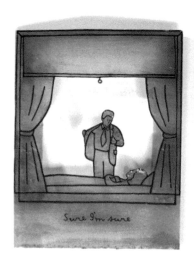

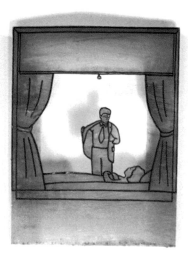

She uses a cinematic effect - a sequence of the same image - to lock her exquisitely drawn caricatures into their misbehavior. It's a nightmare that's in an infinite loop, the characters repeat their awkward gestures, their inauthentic emotions.... no matter what the situation, these contretemps have no beginnings, or end - they just continue.
C.R.

Applebroog's canvas is a window through which we peek at our neighbors and, in turn, see ourselves. In the Hitchcock tradition, the artist feeds us information through a half-raised window shade, and we become voyeurs.
E.H.

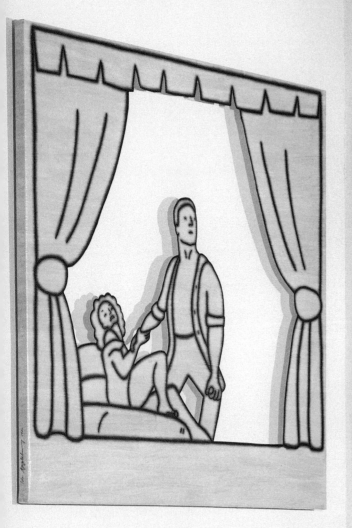

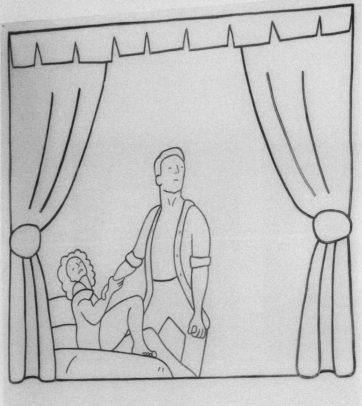

**Look at me
(installation view)**

1981 > Ronald Feldman Fine Arts

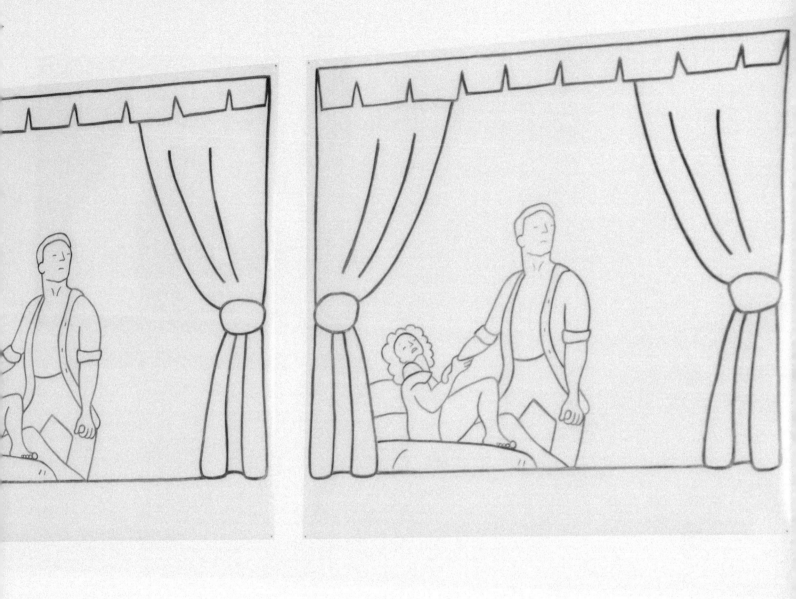

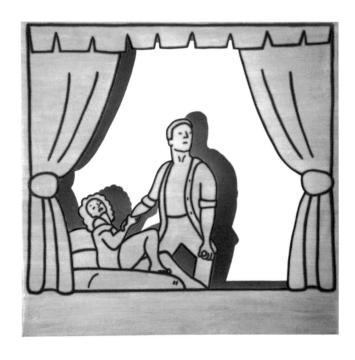

J.L.　So Ronald, when did you meet Ida for the first time?

R.F.　I met Ida sometime in the mid 70's, not long after I opened my uptown gallery in 1971. She did not call herself Ida Applebroog at that time. Her name was then Ida Horowitz. I remember meeting her and her work was outstanding, but it looked very much like Eva Hesse: Ida really stretched it, and it had new edges, it was definitely her own but it paid this enormous homage. I lost track of it over the years, but then small artist's books began arriving in the mail every couple of months from an Ida Applebroog, and I loved them.

J.L.　You didn't figure it was the same artist?

R.F.　No, I had no idea. And then a few dealers and curators started to mention the name of Ida Applebroog, as a good artist whose work I should see. Even then, I don't think I related the name to the books that clearly. One day I met Ida Applebroog again at the gallery. Her work had totally changed; it was representational, textured, extraordinarily well executed and her ideas were first rate. It was everything you would want to find in an artist, so I decided that this was somebody I definitely wanted to work with, and she was willing, and so we began to work together.

J.L.　When was this?

R.F.　This was probably in the late 1970's. The gallery then moved to Mercer Street in 1981. Ida opened the gallery for us downtown: she was the first exhibition in that huge unaltered space. She was nervous, like all the other artists when they saw this huge space, but she installed an absolutely incredible show that fit the space perfectly.

J.L. And Ida's name?

R.F. She invented it for herself sometime
after our first introduction, and it probably
released her to really begin to explore who
she was, the deepest part of her being,
which I think is really what her work is about.
It's probably what I appreciated most when
I saw the earlier work and I appreciate to this
day. Ida relentlessly records what is happening;
we can observe ourselves through her work.
It doesn't look cosmetic; it has all the warts,
all the horror and all the good things of being
human. So it's not a judgmental artwork in any
way, she's presenting life as it is: this is what
we are like, what it's like to be human. And
that always seems to be timely.

I wet my pants

no one knows

SO?

A PERFORMANCE

IDA APPLEBROOG

WHY ELSE DID GOD
GIVE US THE BOMB?

2

3

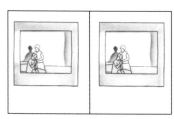

4

5

A PERFORMANCE

IDA APPLEBROOG

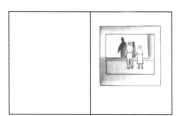

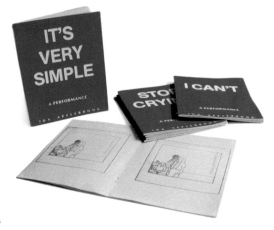

IT'S VERY SIMPLE

A PERFORMANCE

IDA APPLEBROOG

STOP CRYING

I CAN'T

A PERFORMANCE

A cursory analysis of Applebroog's tone would be that it is cynical; yet, while the tone may be cynical, the work itself is not. Cynicism, like jealousy, is nonproductive. Applebroog's mysterious domestic dramas, however, force upon the reader an analysis of their situations. Her characters -paralyzed, sexless, decapitated- are locked into vicious cycles. They're not interacting, they're acting. Their communication is strictly monologue, never dialogue. The installment form reinforces this repetition. As one of the recipients of her books pointed out, "Each time I'd receive a book, I'd leaf through it, gulp, put it on the shelf with the others, and then realized she'd implicated *me* in the goddamned performance..."

C.R.

I CAN'T

A PERFORMANCE

IDA APPLEBROOG

LET'S ALL KISS MOMMY GOODBYE

6

7

8

the end.

Mailing Blue Books

1981

1 He says abortion is murder

2 So?

3 Why else did God give us the bomb

4 I can't

5 Please

6 I can't

7 Let's all kiss mommy goodbye

8 Life is god, isn't it mama?

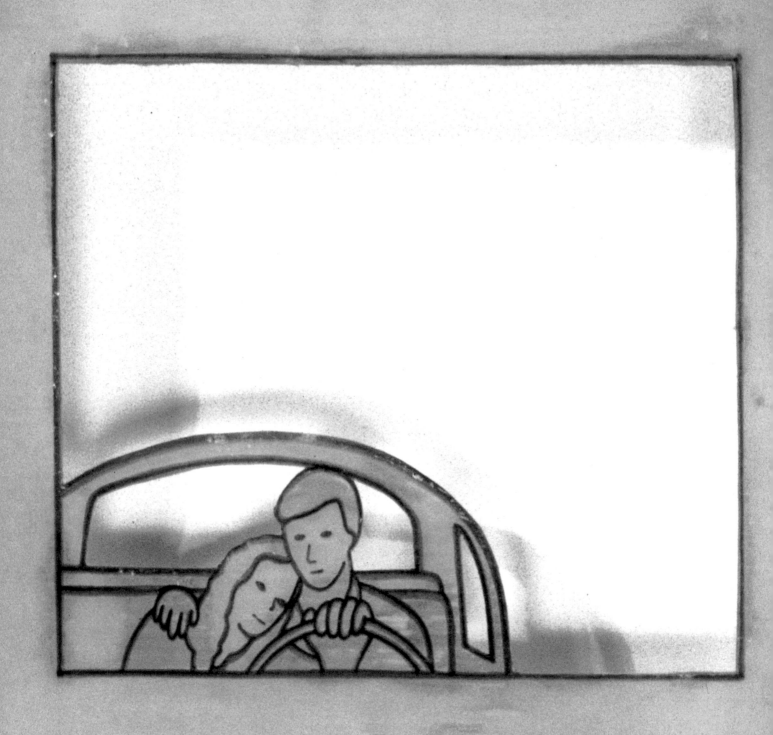

It'll cost you twenty bucks

I mean it
1981 > ink and rhoplex on vellum.
6 panels, 10 1/2" x 9 1/2" and 9 1/4" x 9 1/4"

Applebroog's themes are multiple: isolation, alienation, racism, sexism, homophobia, memory, anxiety, fear, time, nostalgia for good old days that weren't good at all... violence. The violence is rarely pictured (a boy hangs himself, a woman held at gunpoint), but it lurks behind the melancholy of the ordinary. It has happened to these resigned figures, or it will happen to them, and they know it.
L.R.L.

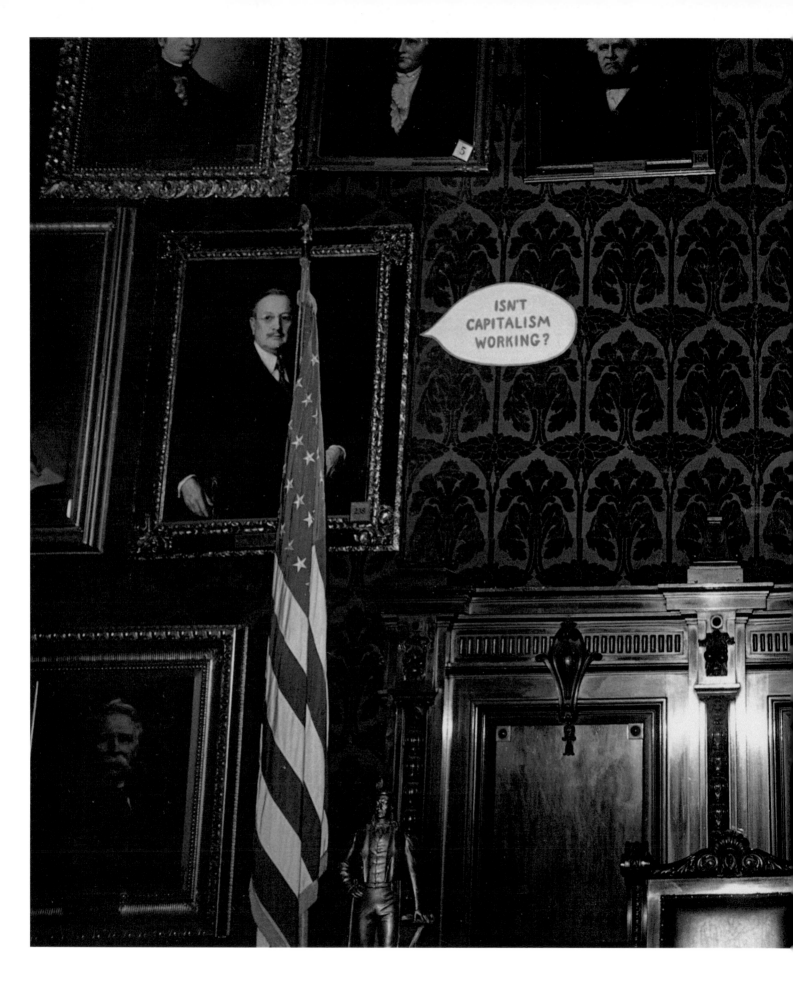

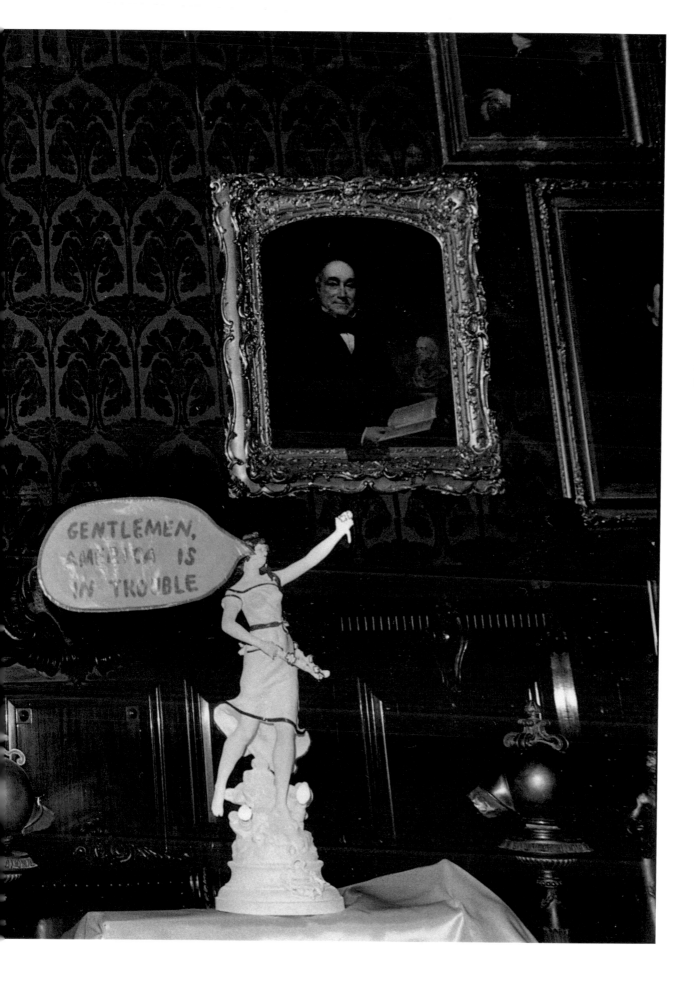

Some artists just don't know their place.... Applebroog, in her *Past Events* installation, invaded an ornate chamber of marble, polished wood, and gold frames by sending in a surrogate — an under-life-size painted metal girl, curly haired, innocent, and garlanded — a 19th century flower child whose message (emitted through a cartoon balloon) was: "Gentlemen, America is in Trouble." The gentlemen, represented by a panoply of self-important portraits of Andrew Mellon, John D. Rockefeller, and pals in the Great Hall of the New York Chamber of Commerce on Liberty Street, replied through balloons with their own brand of innocence: "Isn't Capitalism Working?" "It's a Jewish Plot," "You are Differently Developed," "I am Hot Stuff. I am Also Rich," "You Can Never be too White," and "Underneath I'm Naked."

Ironically, Applebroog's experience with *Past Events* proves yet again that American artists are in fact more feared than they have been led to believe. The piece was censored by public inaccessibility after being commissioned and sponsored (though not exactly supported) by Creative Time. *Past Events* was installed at the Chamber of Commerce Great Hall at 3 p.m. November 9; at 4 p.m. the artist was informed that it would be de-installed immediately after the opening at 7 p.m. because some sort of Board met there the next day. The piece was then laboriously re-installed at 3 p.m. the next day only to be de-installed again from November 16-22 (a schedule previously agreed on by all concerned, because the space had been rented out then).

But on November 23, de-installation persisted. (I can vouch for it; I was there for the second unsuccessful attempt during supposedly open hours; I never did get to see the work in situ). After more Kafkaesque maneuverings by the Chamber of Commerce, which Creative Time, despite a contract, couldn't forestall, Applebroog withdrew the work on November 24, moving it to her *Current Events* show at the Ronald Feldman Gallery. Thus, significantly, *Past Events* joined *Current Events*. Taken out of its den of plutocracy into a Soho gallery, the piece was of course totally disarmed. Thus the invasion could be said to have failed.
L.R.L.

What did they think a woman was going to do in that space?
I.A.

I'm a woman artist with feminist concerns - and so naturally that comes into my work - it's interesting that male artists never have to worry about gender as a creative negative. Essentially, I guess I'm trying to present humanist concerns from a different perspective.
I.A.

Gentlemen, America is in trouble
1982 > site specific installation, the Great Hall,
New York Chamber of Commerce

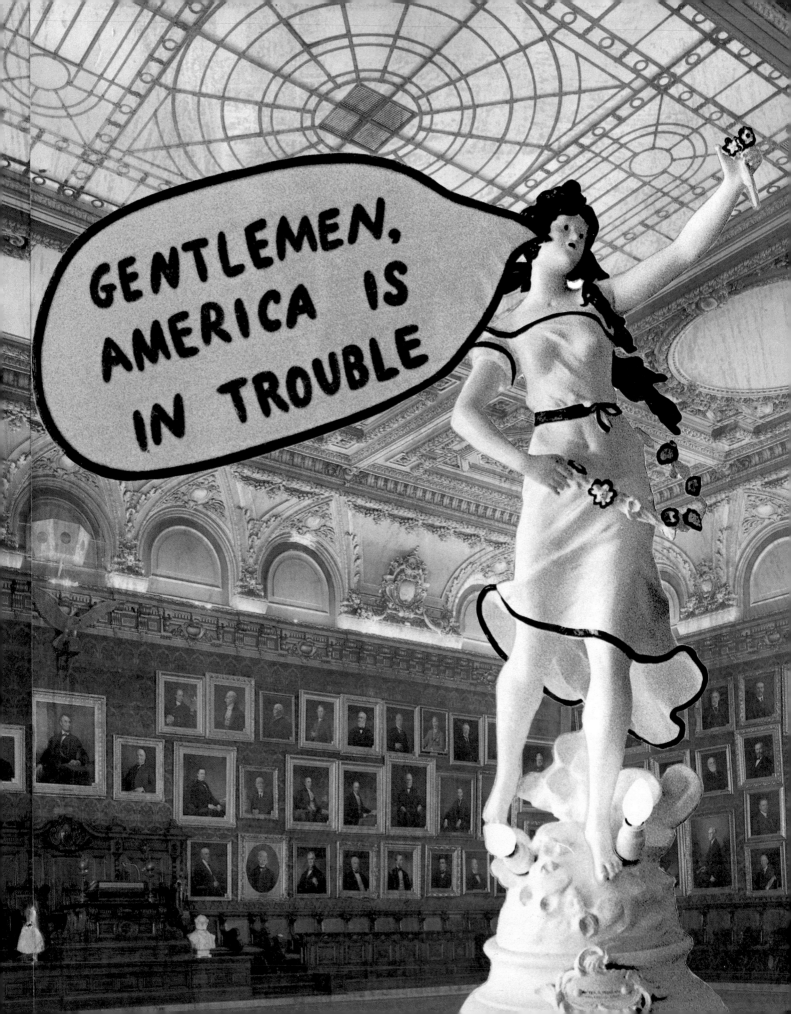

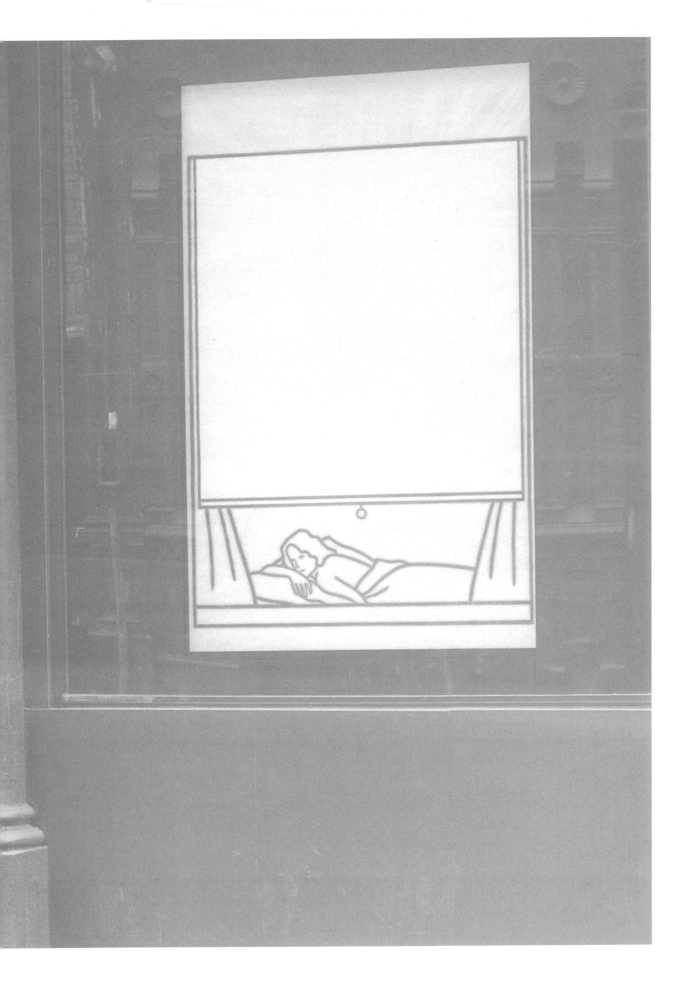

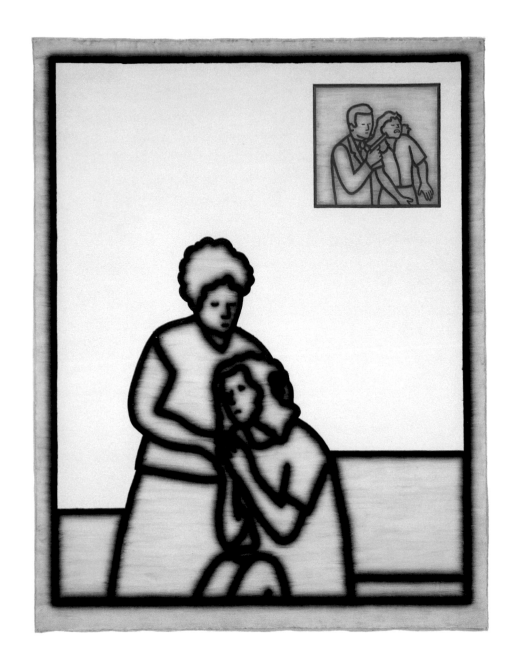

I can't
1982 > acrylic and rhoplex on canvas,
83" x 66"

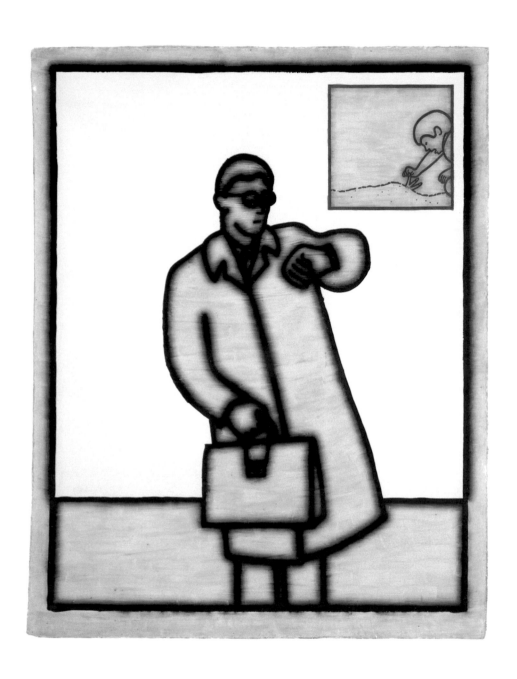

Untitled (time)
1982 > acrylic and rhoplex on canvas.
83" x 66 1/4"

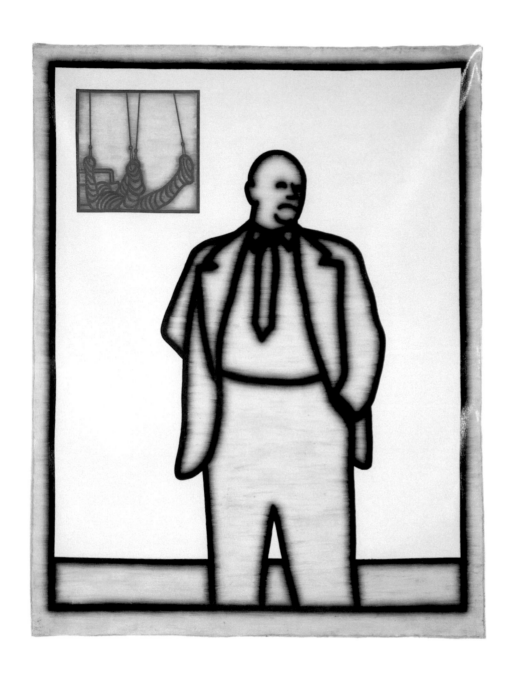

Yes, twice
1982 > acrylic and rhoplex on canvas,
83" x 65 1/2"

Happy Birthday to me
1982 > acrylic and rhoplex on canvas,
83" x 66 1/2"

Thank you very much
1982 > acrylic and rhoplex on canvas,
83" x 89"

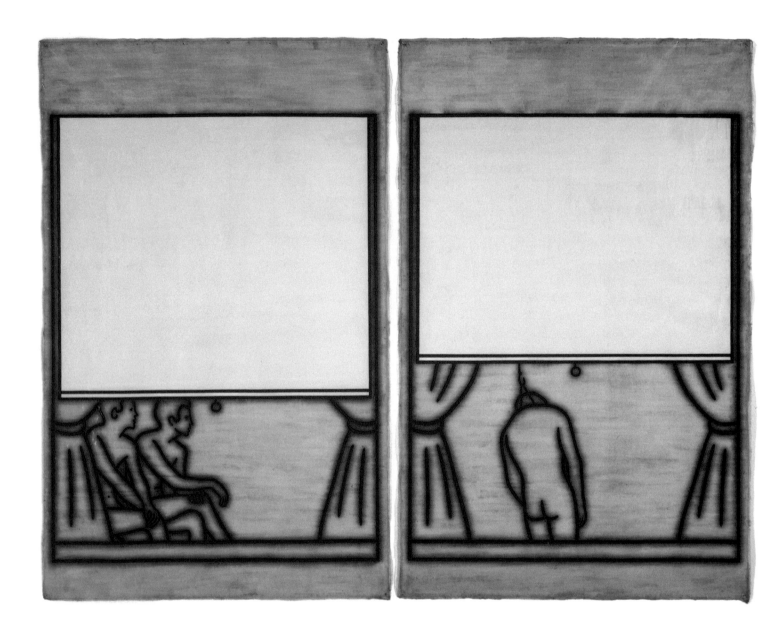

"Violence is as American as cherry pie," black activist H. Rap Brown declared in the heat of the 1960's. Heard against the background clamor of widespread civil unrest, Brown's remark was an instant political cliche [sic] but the juxtaposition upon which it was based has a meaning larger than the polemical one he intended. Violence doesn't put the lie to the cloying image of themselves that some Americans prefer. Instead violence and cherry-pie domesticity are inseparable components of the same reality. Most of the violence that Americans experience or perpetrate, moreover, is intimate rather than public. Cruelty as much as charity begins at home or zeros in upon it. Inside the metaphorical cherry pie is a malaciously [sic] placed cherry-bomb - if not worse. Inside the doughy matrons who bake them and plump patriarchs and blandly smiling children who consume them as sacraments of average contentment are concealed monsters of frustration and vengeance.
R.S.

Trinity Towers
1982 > acrylic and rhoplex on vellum,
diptych, 85" x 55" each

Mercy Hospital
1982 > acrylic and rhoplex on vellum,
diptych, 85" x 55" each

 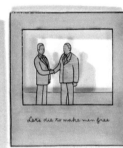 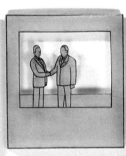 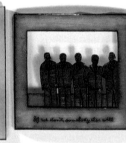

It's very simple
1981 > ink and rhoplex on vellum,
6 panels, 10 1/2" x 9 1/2" and 9" x 9 1/2"

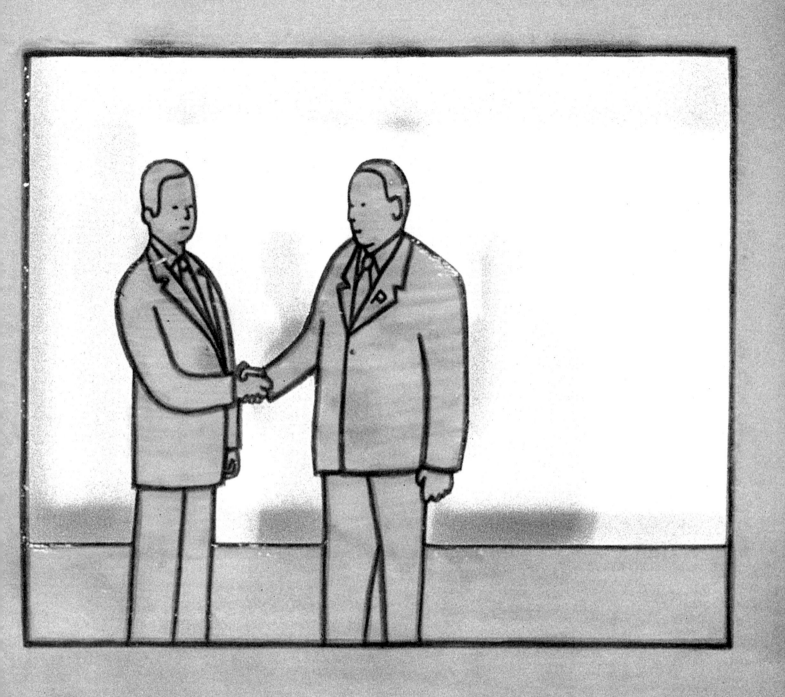

Let's die to make men free

Ocean Parkway:
Five more minutes (top)
1982 > painted lead, 2" high

Ocean Parkway:
101, 102, 103, 104, 105, 106, 107
1982 > painted lead, 2" high

Ocean Parkway:
Priapism? What's priapism (top)
1982 > painted lead, 2" high

Ocean Parkway:
I was beautiful once
like a movie star
1982 > painted lead, 2" high

135

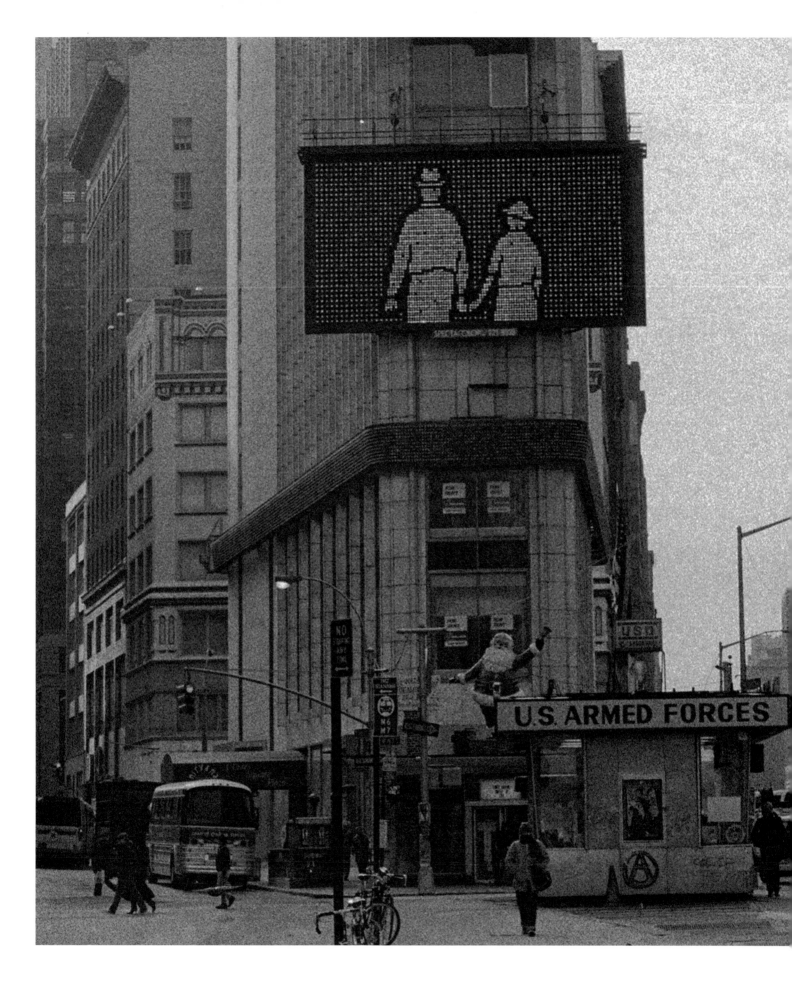

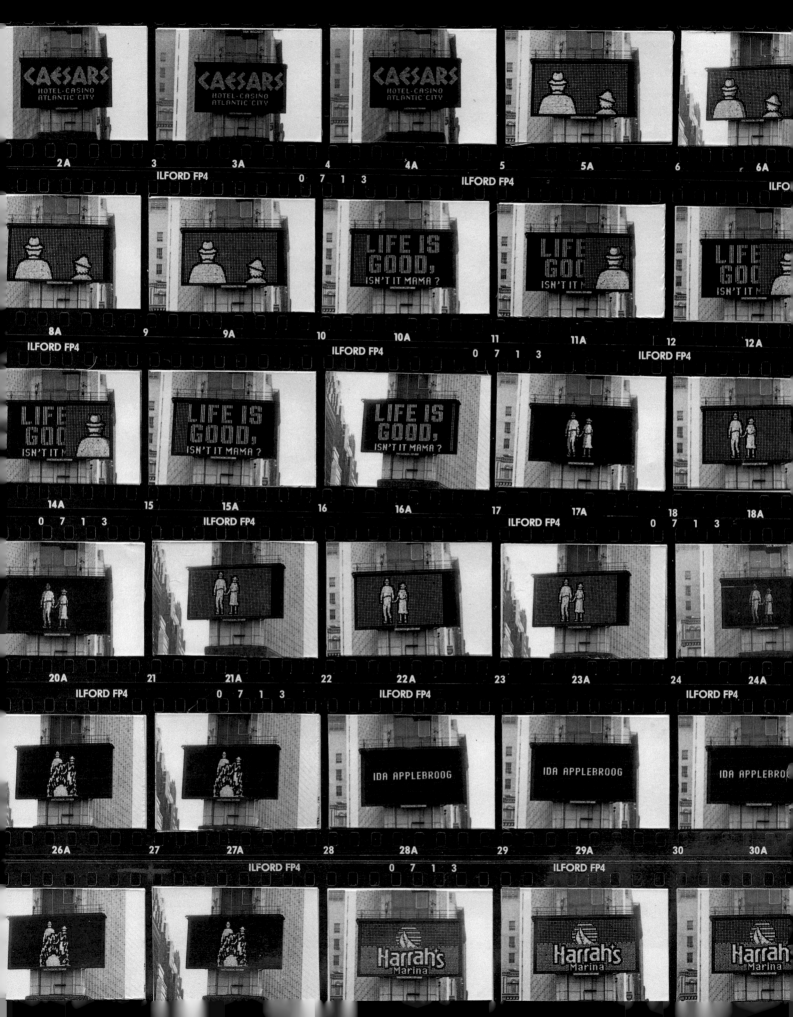

Applebroog's next brief appearance came last New Year's Eve, when another of her situations flashed from Times Square's Spectacolor Billboard. The elderly couple who form the core of her untitled book of 1981 walked off together into a hypothetical sunset, dad saying to mom, "Life is good, isn't it, Mama?" Mother's answer, absent in the book, never appeared on the computerized board either, but was interrupted by an atomic flash that sent their hats rolling in opposite directions. Feeding her mordant message into a computer flashing over the crowd which filled the Square on the eve of 1984 was typical of Applebroog's sense of humor.
L.Mc.G.

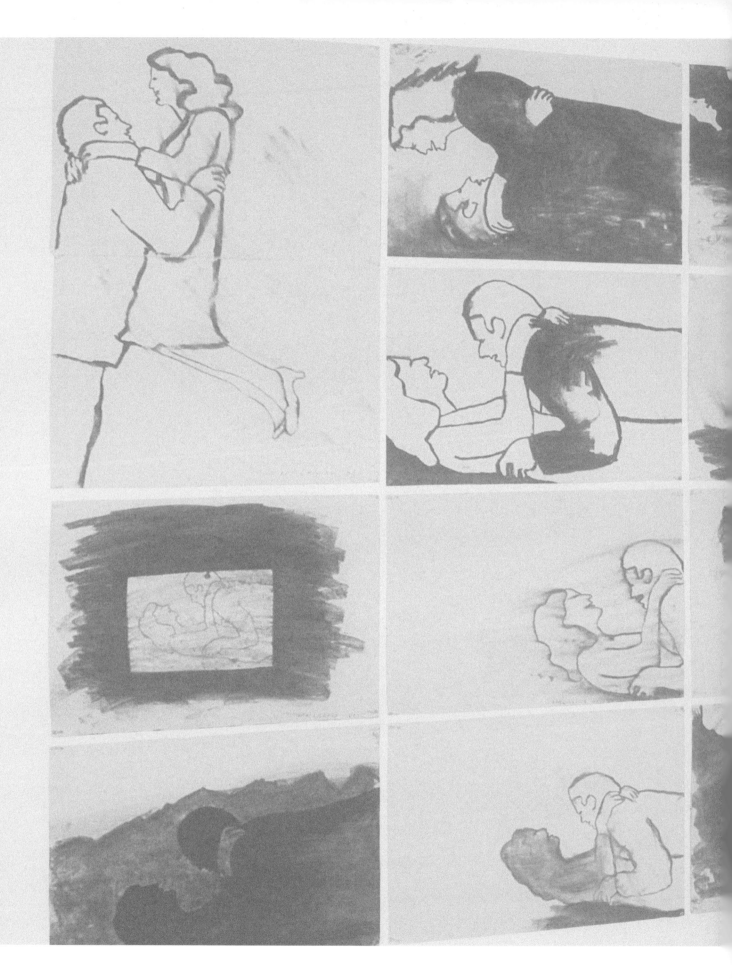

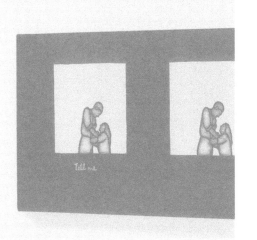

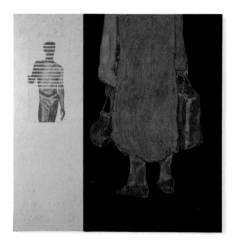

Riverdale Home for the Aged
1984 > oil on canvas, 2 panels, 100" x 100"

Wentworth Gardens
1984 > oil on canvas, 2 panels, 100" x 100"

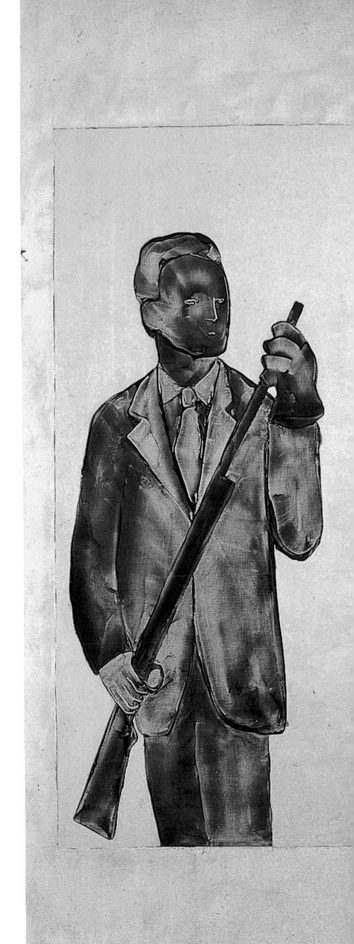

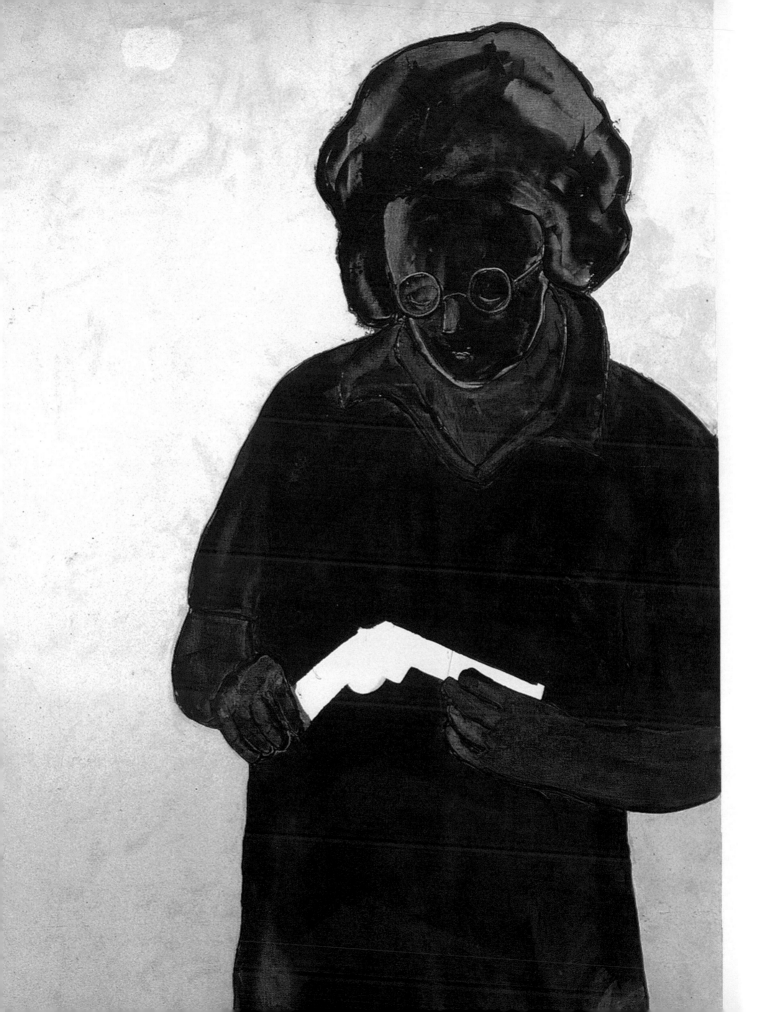

This is my rifle,
And this is my gun
This is for fighting,
And this is for fun.
Anon.

Thank you, Mr. President
1983 > rhoplex and enamel on canvas, 12" x 60"

Tell me. Does your condition have a name?
1983 > rhoplex and enamel on canvas, 12" x 60"

Your eggs are getting cold
1983 > rhoplex and enamel on canvas, 12" x 60"

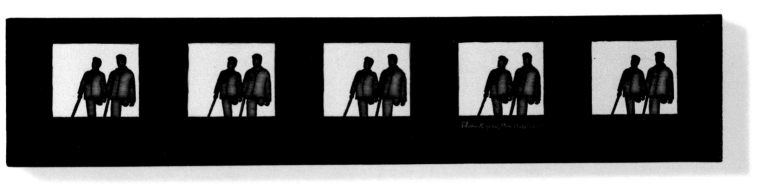

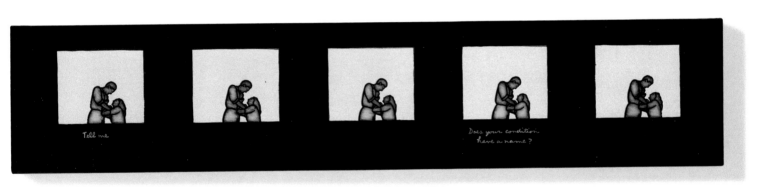

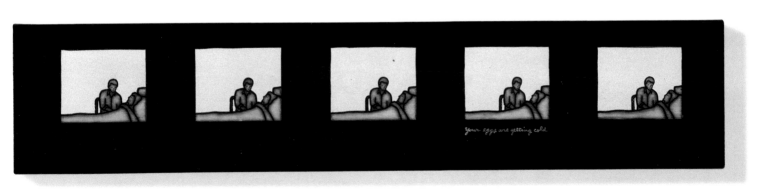

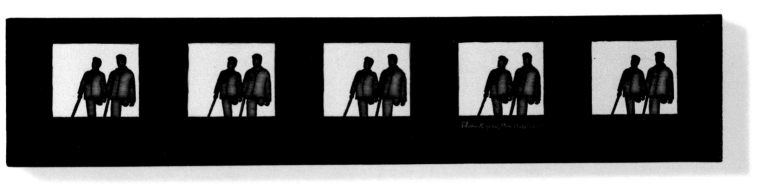

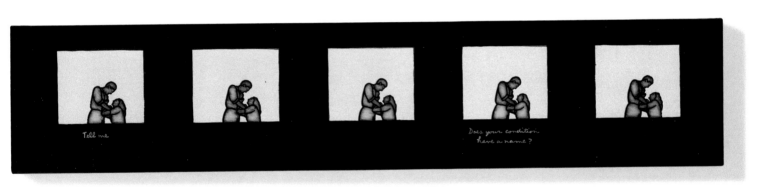

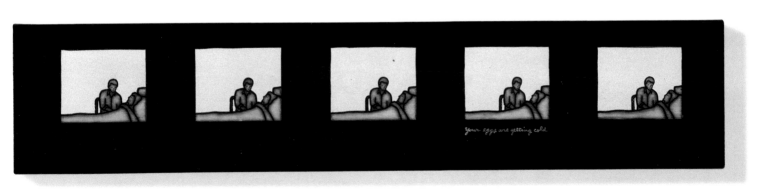

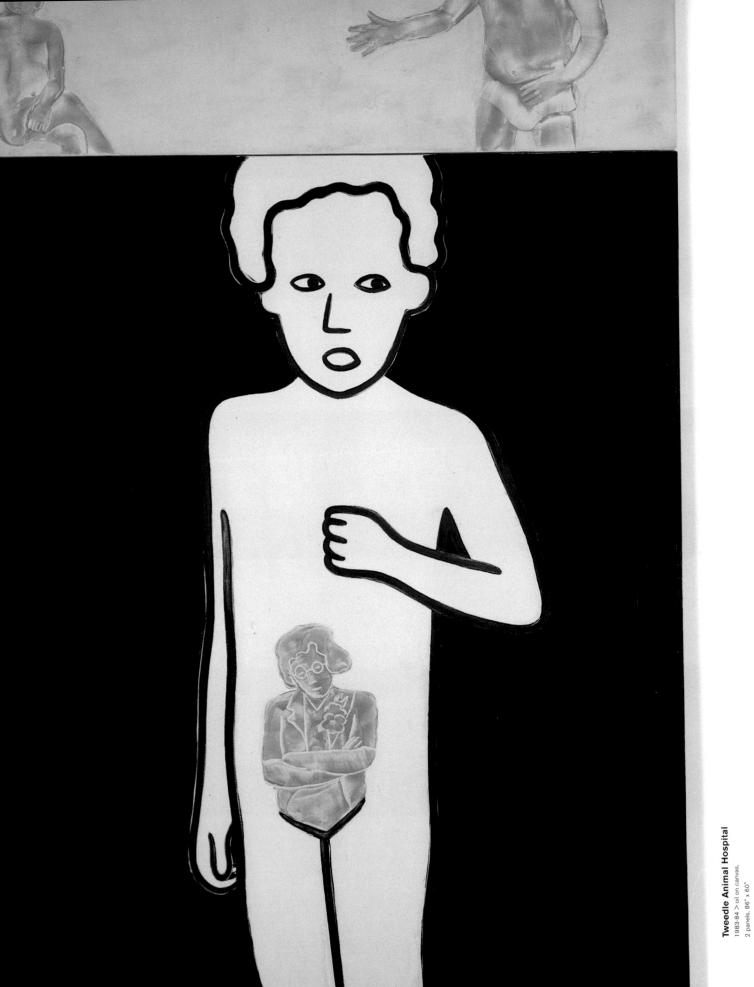

Tweedle Animal Hospital

1983-84 > oil on canvas,

2 panels, 86" x 60"

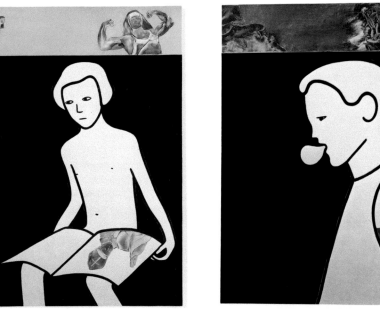

147

I wet my lips
I shut my eyes

my belly
soft as jelly

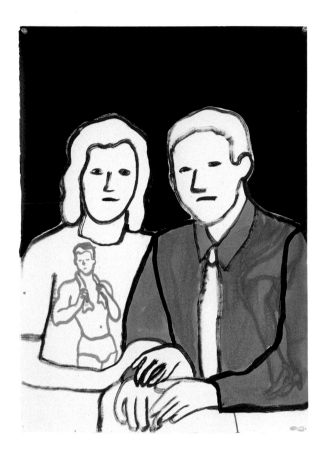

Any person who has survived childhood should have enough material to last them their entire life.
F.O'C.

Come on, look happy
1983 > oil on paper, 30" x 22"

You're leaving? For good?
1983 > oil on paper, 4 panels, 98" x 30"

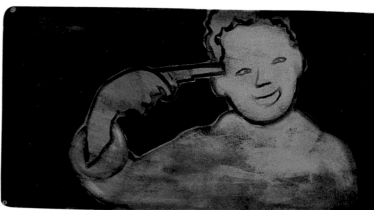

Triple triptych
1984 > oil on paper,
9 panels, 56 1/2" x 57"

Hers is an art that substantiates Freud's argument that our experience of the frightening and disorienting phenomenon called the uncanny - the *unheimlich* - is both contiguous with and integrally linked to its obverse - the *heimlich* - the homey, the domestic and the familial.
A.S.-G.

Bite
1983 > charcoal on paper,
2 panels, 47" x 30"

Thank you for the two rose bushes (top)

1983 > charcoal on paper,

2 panels, 47" x 30"

Dancers

1983 > charcoal on paper,

2 panels, 30" x 47"

Couple I
1983 > charcoal on paper,
12 panels, 91" x 92"

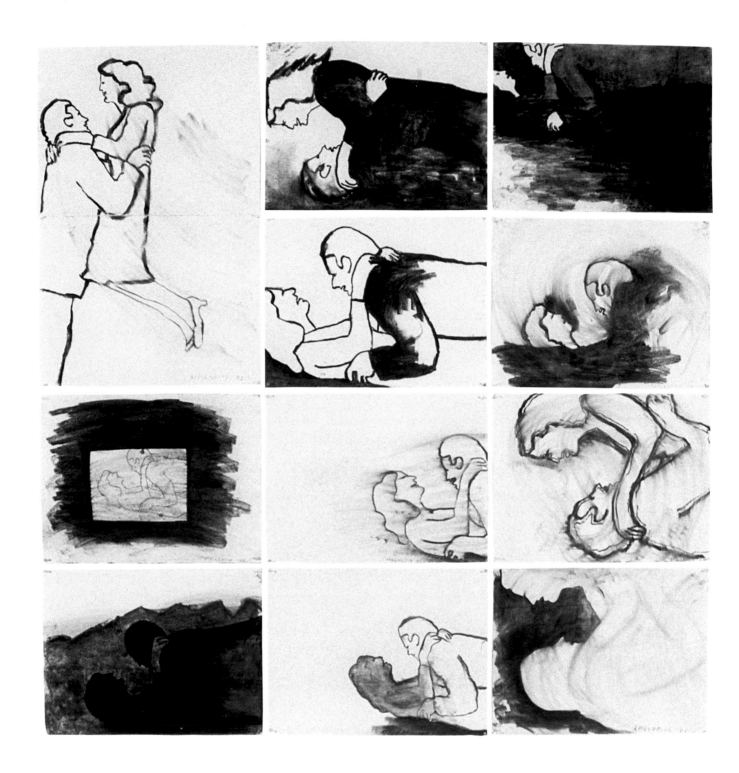

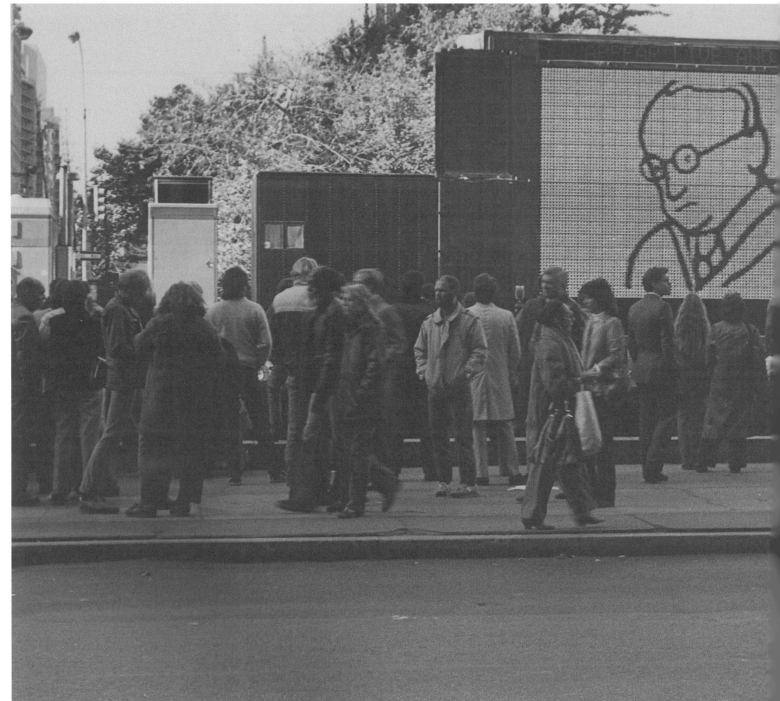

Love war? Vote Reagan.

On the eve of the 1984 Presidential election, Jenny Holzer and 21 other artists employed the giant screen of a Diamond Vision Mobile 2000 to convey a strong anti-Reagan message to the public, who were invited to contribute their own "thoughts, hopes and concerns" about election issues. Jenny Holzer conceived the *Sign on a Truck* during the summer of '84, inviting artists and others to contribute work dealing specifically with the upcoming election. With sponsorship from the Public Art Fund, cooperation from the New York City Department of Parks and Recreation, production assistance from Fashion Moda, and funding from Collaborative Projects, the New York State Council of the Arts and private sources, the 7O-foot-long, 18-wheel semitrailer was parked all day Saturday, November 3 in Grand Army Plaza (across from the Plaza Hotel) and Monday, Nov. 5 at Bowling Green (in lower Manhattan). The program consisted of artists' videotapes intercut with prerecorded "man-on-the-street" interviews. At regular intervals passersby were invited to appear on the 13-by-18-foot screen to express their opinions about the candidates.

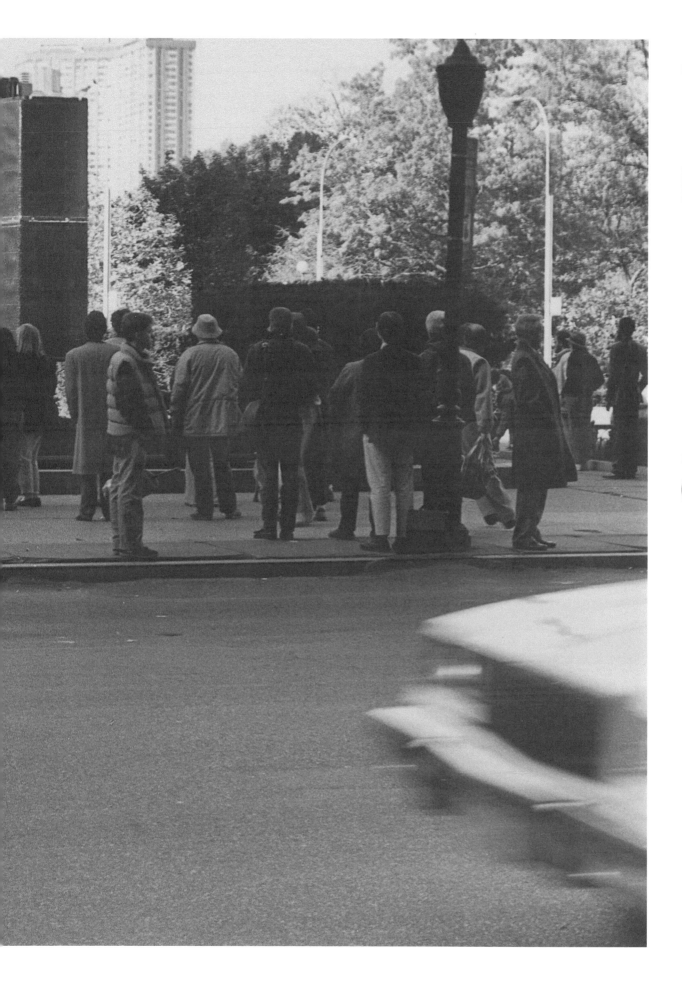

Sign on a Truck

1984 > Grand Army Plaza, Brooklyn

A.S. Tell me about how your career started and what the major turning points were?

I.A. I was born in New York and I had gone into graphic design as a young artist. I didn't go into fine art - I had to make a living, but I really hated it. I went back to school in the sixties at the Chicago Art Institute. From Chicago I went to California, where I was making art and teaching at the University of California at San Diego. I did not want to spend my life being a tenured professor, so I went on back to New York in 1974.

I came into the New York art world as a woman, an older woman. I was much older in that scene than artists that were being seen in the galleries. But my work related to their work more than to artists who were around from my generation.

I had done a lot of soft sculptures in California, large modular pieces. Coming to New York, I really didn't know what I wanted to do. Since drawing came very easy to me, I just did a lot of drawings and also started to make objects, which I photographed and made books out of. I sent these out through mail distribution. In a way that started my career in New York. The books were very small books, about 6 x 6 inches, and I sent out about one a month. Each book had a series of repeated images, with a single line of text or two, which acted as a punctuation. I just sent them out to friends and artists whose work I liked but did not know. I did about 3 sets of books until 1980.

In the 70's the art world was different. The books made art ordinary. It was a cheap object. It was mass produced for mass consumption. I kept on making art, but the books enabled me to decentralize the art system. It was a way of not knowing anyone, of being able to do work all the time. Then people got to know the work, and people started to write about that work.

A.S. Were the themes you dealt with different back then, or was there a continuity?

I.A. The books, like my current work, were ambiguous, open-ended. My pieces are like projective tests. When you are looking at them, they deal with how the viewer interprets the meaning. With each person the meaning shifts, so that no matter what you think you see in that piece, the next person will see something entirely different. It doesn't matter if it is what I wanted to say, or what I thought I was saying, or what it is that was built into that piece.

A.S. What do you mean when you say that the 70's art world was very different?

I.A. It was very activist. It was a political era. It came out of Vietnam, the Feminist movement, student activism, and resulted in minimalism, conceptualism, alternative spaces, feminist art, book-works. Whoever thought about money in art? Artists went into art without ever expecting to make a penny out of it. You knew you were going to be an artist, and you knew you had to have another job. In those days, I was teaching and editing. The male artists did construction or teaching. The women artists did teaching or whatever else was around, like waitressing. That was the art world in the seventies.

A.S. What was the most influential in your success in showing the work?

I.A. In those days I was really not interested in being a part of the establishment. My books were out there. I was out there. I am not a social person, so I was not involved in doing the scene. But I was involved in making my art. The establishment meant that you were attached to a gallery; you were with a dealer. Those were the days when I was much happier in alternative spaces, being out there on my own, being able to just do the work. Being with a gallery was just not something that really interested me very much.

A.S. When people in the art world say "the eighties," what do they mean?

I.A. The eighties was a time when suddenly artists became business people. When suddenly to be an artist was not so much the making of the work, it was to be able to deal with it in a monetary sense. I remember in the 70's, when I did lectures and studio critiques, I always had to deal with giving young art students permission to be an artist, because their parents thought that was no way to make a living. In the eighties, when I went around as a visiting artist, not only did their parents want them to be artists, but a lot of the students that I met were not even interested in being artists. Their parents wanted them to be artists, because this way the parents could buy them a loft in New York, have an investment with their son or daughter being in the art world, and they would make money off their art. They were seeing Jean-Michel Basquiat on the front cover of *The New York Times Magazine* in an $800 paint-splattered Armani suit.

A.S. When did the eighties begin for you?

I.A. I had a show in Germany. And there was lot of neo-expressionism suddenly coming around. It was very hot. Everything was happening in Germany. It was interesting that there was a lot of this big, heavy, male, heroic painting going on, which was not taking place in the United States. I had met a lot of people in the scene and that was all they were talking about, that's what the magazines were full of. And then came the American version -Schnabel. Schnabel was suddenly making the same heroic paintings. The big macho man. The Germans were also big German male artists, quite Teutonic. That was my first sense that something different was happening. Mary Boone was showing Schnabel in this little gallery. I went in to see the Schnabel show, and people were not really looking at the paintings, because next to each painting it was indicated that this particular painting was from the collection of... Very large paintings. And everything - obviously - was sold out in this show. That was rather bizarre. Everyone commented on that, more so than they were commenting on the paintings. What did that mean? That for me was the beginning of the eighties.

I was very involved with feminist activities at the time, and still am. It was the end of feminism as we knew it then. Mary Boone said, "It is men now who are emotional and intuitive. The females are more structured." That was the point at which everything got turned around. The women artists had shown so much work in the seventies, they had turned the art world around with the work they were showing. The women had opened up a lot of taboo subjects. And suddenly the men were picking it up, and the women were sort of shoved under the rug.

A.S. Was there a broader story, something bigger behind all this?

I.A. Oh, absolutely! It was very broad. It was very political. It was the Reagan era. We were back to basics. It was again back to tradition. Everything changed, and the art world went with it. Money. The marketplace. There was a lot of money being made. People were toying with their toys. Art became a commodity. It was a commodity mentality. Art became a toy.

A.S. Why did you choose the Feldman Gallery, and in this context, what did it mean for you to be there?

I.A. Konrad Fischer, a dealer in Düsseldorf was very connected to my work. He said to me, "Why don't you call Ronald Feldman. That should be the gallery you're with. He's much more European." Ron's is a very European kind of gallery. He is much more interested in outside things. He does not operate the way American dealers do. He himself prides himself on that too. Any European that I know, they always love Ron because of that. Maybe the Joseph Beuys connection might have been a part of that, I am not quite sure. He is very connected to Beuys in Europe. I just asked Ron to come over to see my work. He came, looked at the work and asked me if I would like to have a show. And that was it.

A.S. Where was Feldman on the map of the art world?

I.A. It was a very conceptual gallery. He did not have objects that were marketable. I never expected to make money, so when I went into the gallery and nothing sold, I never even thought about that. I was making my money outside. And all the artists were making money outside. If you gave me a choice of what gallery I would have liked to be in, his was the gallery that I would have wanted to be in at that time. I was able to connect to just about every artist in that gallery.

A.S. When did you see the eighties impacting on the gallery?

I.A. The eighties gave a lot of artists a lot to think about. We were suddenly hit by the fact that artists were opening up their own galleries in the East Village. There was a lot of marketing going on by the artists themselves, and the artists were their own best dealers. Suddenly you realized that work was being sold continuously. Very young work. It was the time of Keith Haring and Kenny Scharf. These young kids were out there with a whole different way of being in the art world. It had nothing to do with what I knew about, or any of us knew. It was rather interesting to watch. I didn't quite get it at the beginning.
I did not do the social scene. I did not do the club scene, where you knew that's where you met people. That's how the deals were made. I chose not to do that. That was not my way to be in the world, and I wasn't about to change at that point. Nevertheless, my work began to sell.

A.S. Let's look at your work in the last couple of years. Despite all you've said, your career has taken a tremendous turn for the better. What thoughts does it lead to when one's career does take off like that? How does it change your art, your feelings about the art world?

I.A. Fortunately for me it didn't change my art. I feel that I am always telling the same story. Originally I was using Rhoplex, but it was pulled off the market because it was supposedly carcinogenic. I wanted to continue working in this way, so I tried to simulate the kind of brush stroke that I was using before. For women, it was the time of technology - Barbara Kruger, Jenny Holzer, Cindy Sherman; in my perverse way, I did paintings.

I have always had a lot of media coverage. That has never been a problem for me. But in 1987, after I was in *Documenta*, the Museum of Modem Art included me in the *International Survey of Painting and Sculpture*, and the interest grew. There were only fourteen women in that show, and I was one of them. A lot of museums were suddenly interested in buying my work. I was not a darling of the Collectors Circle. I couldn't be. In fact, when I had done a lecture at the Museum of Modern Art and was sitting at a table with a very well known collector, she turned to me and said, "Oh I just love your work, but I couldn't dream of living with it." I was very flattered.

A.S. I would like to talk just a little bit about what you think about the art world since the boom. What was the net result?

I.A. Everything got turned around. Clinton came in. Everything political suddenly became the "in" thing. It sort of came back to the seventies mentality, like you see kids in bell-bottom trousers. It's just history repeating itself, reinventing the sixties and seventies. I look at the work out there, and I am shocked because many of the young kids don't have a clue that the work they are doing has all been done in the seventies. I like it. It's refreshing for me.

A.S. You are a political person, a feminist. What is your feeling about the new political art that has come out of the art world?

I.A. The politics of art means that political art is really salable art. Political art is like this collector told me - you can't live with it. It's not going to match the couch. It's not pretty art. That to me feels good.

A.S. But if in the seventies political art was escaping the gallery system, isn't there a feeling that today's political art doesn't attempt that?

I.A. The *Whitney Biennial* (1993) has momentarily said that political correctness is in. It's politically correct to show political work. For the first time in the history of the Whitney they made a very conscious choice to include that kind of art. You might like it or dislike it, or hate it, but it's a drastic change. Actually, that show was so demonized, that it might also mark the end of political art. We are seeing a pronounced backlash.

It's problematic. I am often asked by students if I think I am changing the world. I hear it all the time. They want to change the world. That is a most naive idea: that you can change the world doing "political" art. The only way that I even have a fantasy of changing the world slightly is by being out there and being an activist. What I am doing in my art is saying, "That's who I am and this is what I am doing." I am not doing it to change the world.

A.S. Does operating inside the art world automatically raise issues which lead you into activism, or is it just a question of personality?

I.A. Look, in the sixties and seventies there were many artists who were very activist. But then again there were some who wouldn't raise a hand to do anything. There are those who do, and those who don't.

I have my own philosophy, which is that if you don't go out there and do something, the schmucks will inherit the earth. And that's my big worry - that maybe they already have.

it's alright

i'm out of my mind

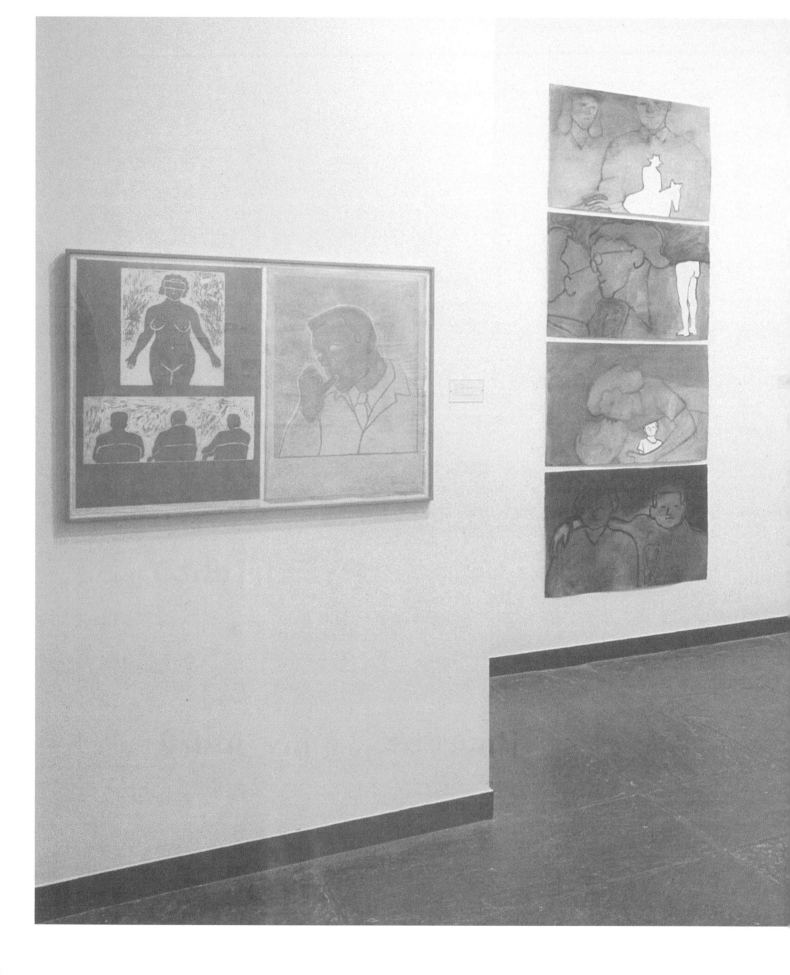

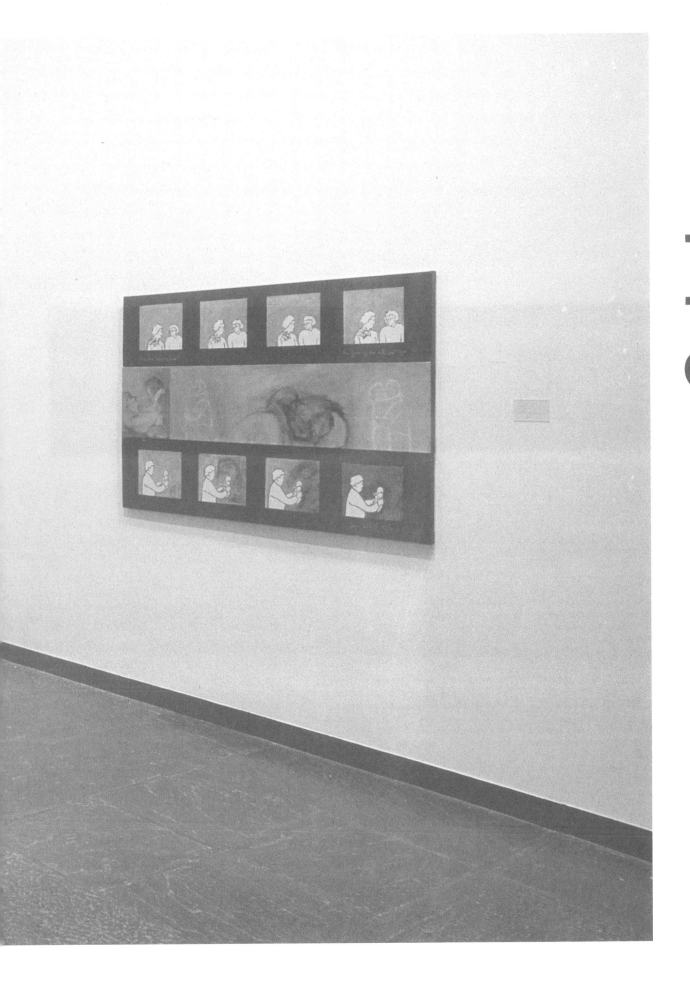

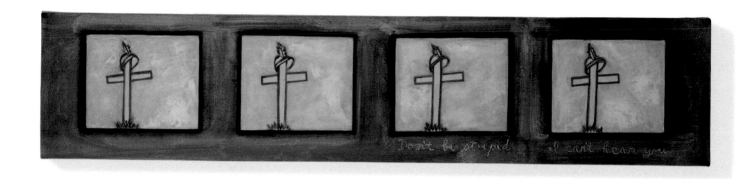

J.L. You once told me a story about the painting *Don't be stupid*.

R.F. Yes. Ida is thinking about what will happen to her work when she's no longer here. It's very important to her that there is an audience for her work, that it resonates in the world. It answers the philosophical question, "If a tree falls in the forest and no one hears it, did it fall?"
I think Marcel Duchamp's answer would be no, it didn't fall and it doesn't matter. Ida is also very clear and specific about this, she wants recognition in her lifetime. She made a painting that I saw after Hannah Wilke's death. This gray painting is of a mound at a cemetery, a freshly dug grave that's just been filled in. There's a cross on top of the grave and there's a woman's bonnet hanging on it, a very simple bonnet.
This work is one of her serial image strip paintings, in which the four repeated frames are exactly the same. Beneath two of the frames she writes "Don't be stupid"; "I can't hear you."

J.L. I love this painting.

R.F. It leaves the viewer a lot to think about. It could mean that a mourner is at the grave confessing, "I'm sorry, I didn't mean to make you angry," or "I didn't pay enough attention, I didn't show my love enough." What Ida is saying is, "Tell me now because I need to hear it. Don't tell me when it's too late that I'm a good artist; tell me before I die." I think Ida was saying this for Hannah as well, for all artists. Because when an artist makes tough work that brings an audience face to face with itself, the audience very often shies away and denies the work its value.

Don't be stupid
1985 > oil on canvas, 14" x 66"

Yes, that is art
1985 > oil on canvas, 14" x 66"

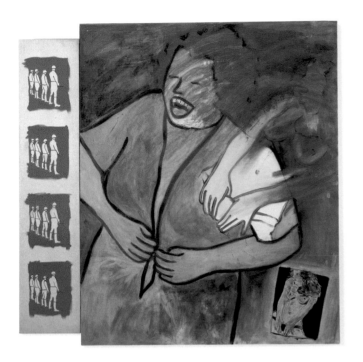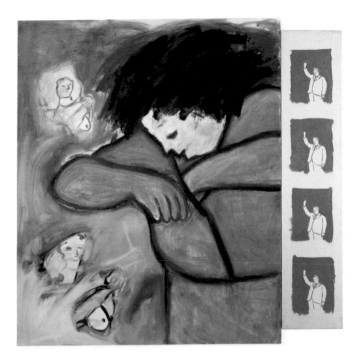

The major advantage in her seductive, painterly approach is a literal one. In these canvases - the larger serial images like the four *Women*, the paintings carrying street-names, or the bitter *God's white too* - she has relinquished the distance of her former panel scenes, replacing their quickly scanned messages with ones which must be read, literally, "between the lines." Applebroog has begun to construct a complex web around her simple themes, depriving the viewer of the "quick read" she formerly allowed.
L.McG.

Willem de Kooning's *Woman I*, 1950-52, becomes an afterimage in Applebroog's *Two Women III*, 1985, a blurred echo hovering over the shoulder of a fat, girdled woman screaming past de Kooning's *vagina dentata* in counterpoint to a repeated predella image of male beauty queens whose rather foolish lumpiness suggests the Other's Other.
M.S.

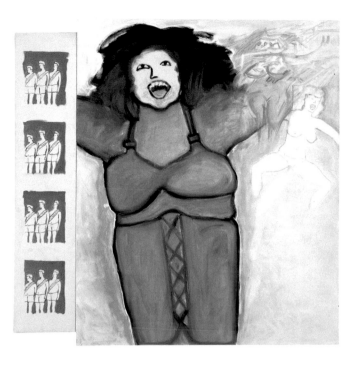

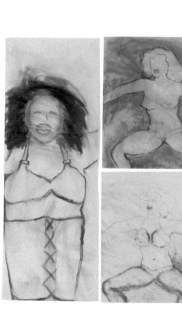

Two Women II (after de Kooning)
1985 > oil on linen,
2 panels, 72" x 74"

Two Women I (after de Kooning)
1985 > oil on linen,
2 panels, 72" x 74"

Two Women III (after de Kooning)
1985 > oil on linen,
2 panels, 72" x 74"

**Two Women III (after de Kooning)
(study)**
1985 > charcoal on paper,
4 panels, 60" x 44"

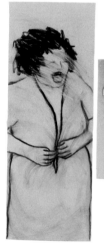

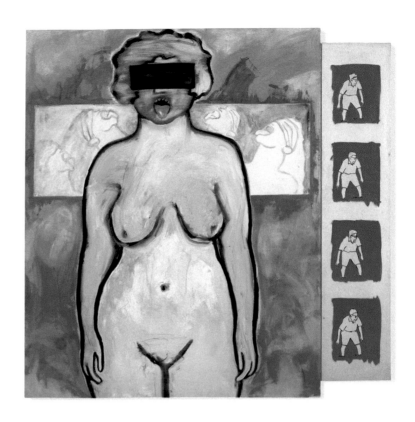

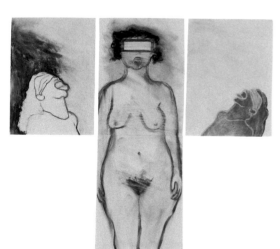

Two Women II (after de Kooning) (study)
1985 > charcoal on paper,
4 panels, 60" x 66"

Two Women I (after de Kooning) (study)
1985 > charcoal on paper,
5 panels, 60" x 88"

Two Women IV (after de Kooning) (study)
1985 > charcoal on paper,
4 panels, 60" x 66"

Two Women IV (after de Kooning)
1985 > oil on linen, 72" x 74"

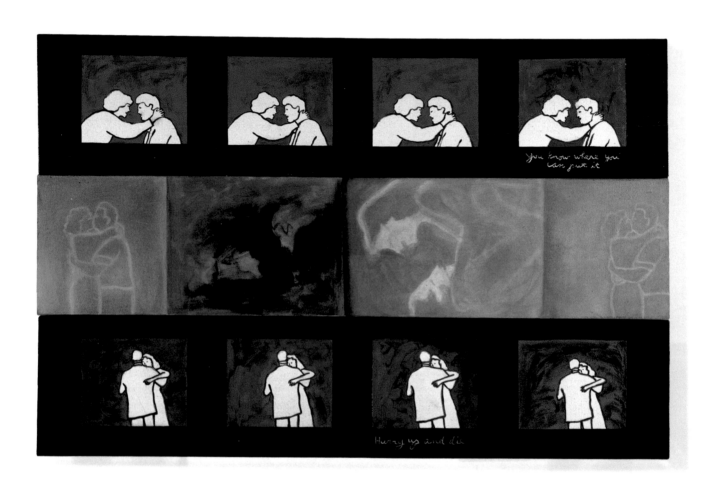

Hurry up and die
1985 > oil on canvas, 3 panels, 42" x 66"

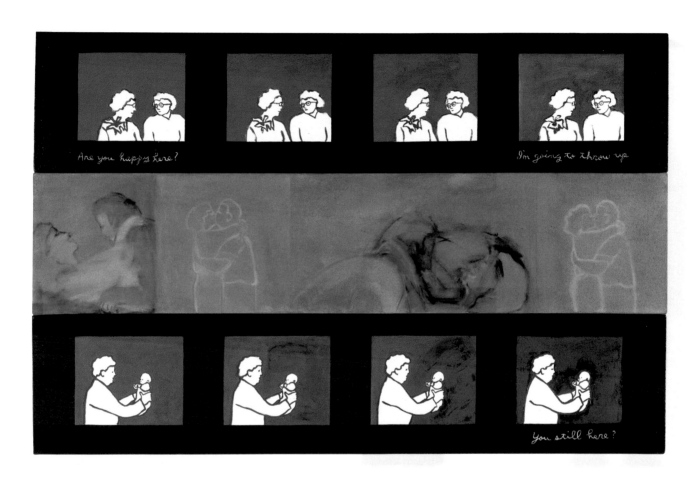

You still here ?

1985 > oil on canvas, 3 panels, 42" x 66"

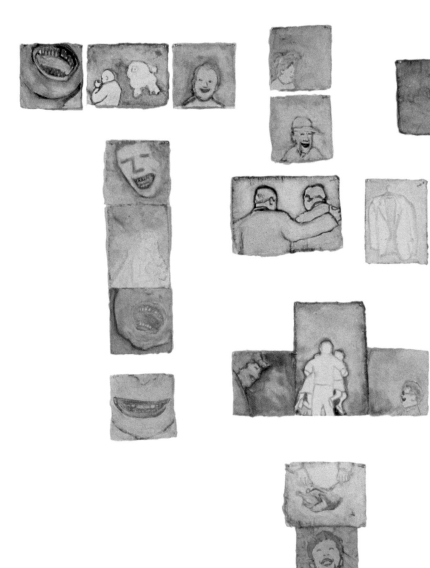

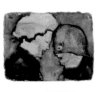

Is everything ready?
1986 > watercolor, gouache on treated paper
17 panels, 112" x 81"

Promise I won't die ?
1985 > watercolor, gouache on treated paper
14 panels, 97" x 95"

For the critic and historian enamored of narrow stylistic definition, such an artist - concerned with states of mind and spirit which elude such boundaries - presents insurmountable difficulties. Applebroog's careful self-positioning between formal and contextual styles relegates her to categorical confusion. No mold quite fits ; she has only the slightest affinity with Longo, Kruger, or Sherman, being *somewhat* distanced, media-oriented and Pop-influenced, but despite an often deceptively "populist" approach (chiefly in the story-board panels), she is neither distant nor slick enough to fit the mechanistic mode. On the other hand, her content (and intent) is more closely aligned to the Neo-Expressionists, but again she utilizes the wild brushstroke and acidic color only in the occasional image and never projects the inflated persona unfortunately common among the breed. It is easy to detect in the artist a stubborn defiance of categorization, of the critics' desire to corner her. No cul-de-sacs for Applebroog - she remains outside current critical contexts.
L.McG.

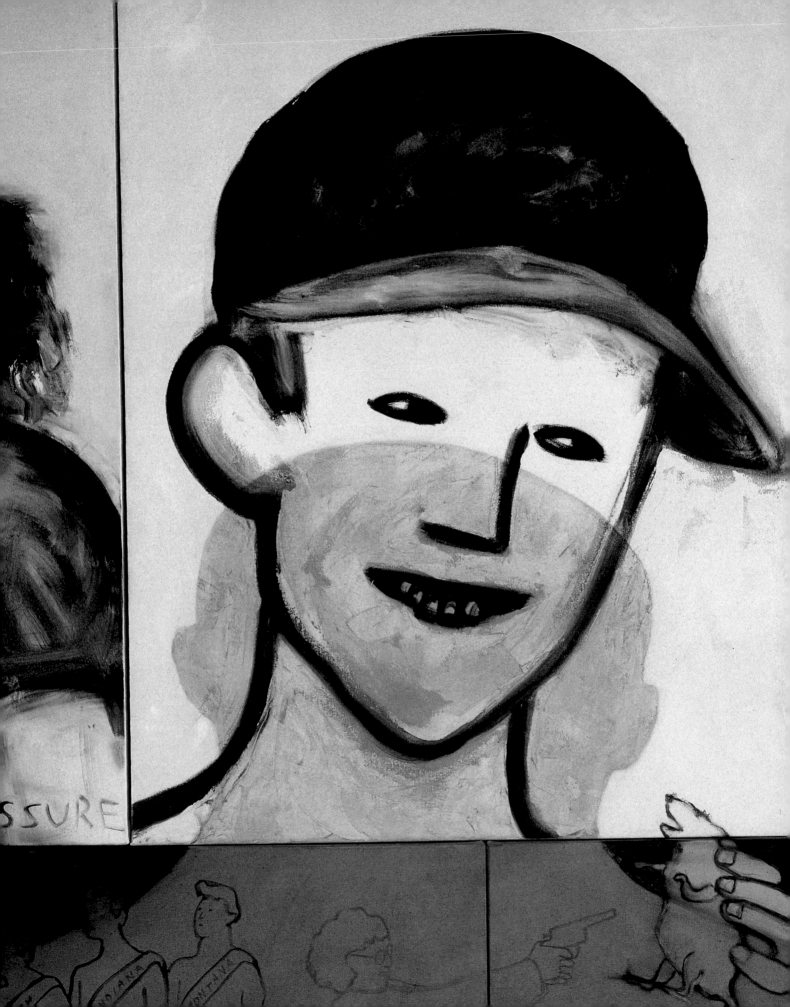

I've chosen cyanide (detail)
1985 > oil on canvas

Life is a Jacuzzi
1985 > oil on canvas, 4 panels, 62" x 120"

I've chosen cyanide
1985 > oil on canvas, 5 panels, 62" x 132"

something unequal is about to

happen

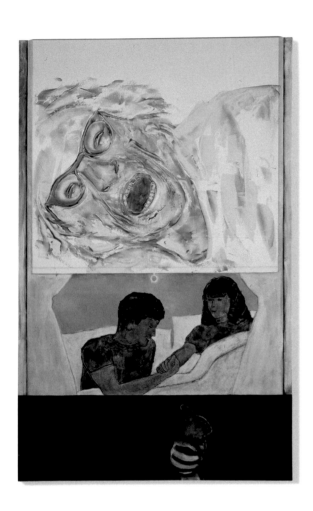

Sunflower Drive
1985 > oil on canvas, 84" x 54"

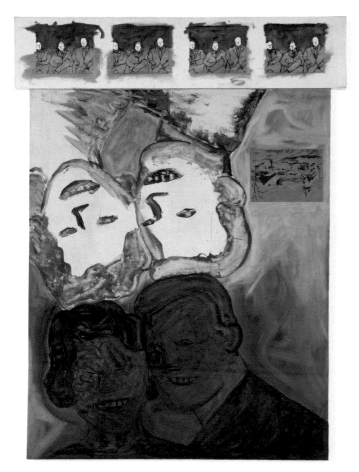

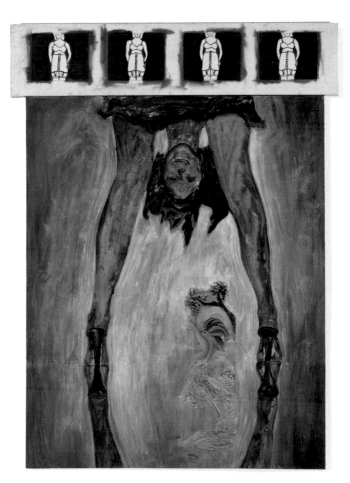

Applebroog portrays women as parodies of pin-ups, clichés of male desire, who grow increasingly strident, finally screaming in hilarity at the edge of hysteria. In *Peel Me Like a Grape*, Applebroog shows a woman bent double, her head peering under her crotch. Her legs are hyperextended, elongated by spike heels, made even longer by the mirroring image of a slick floor. She is a chorus girl posing as a human wishbone. She invites you to violate her. Make a wish. Break a leg.

M.A.Z.

God's white too
1985 > oil on canvas,
2 panels, 86" x 60"

Peel me like a grape
1985 > oil on canvas,
2 panels, 86" x 60"

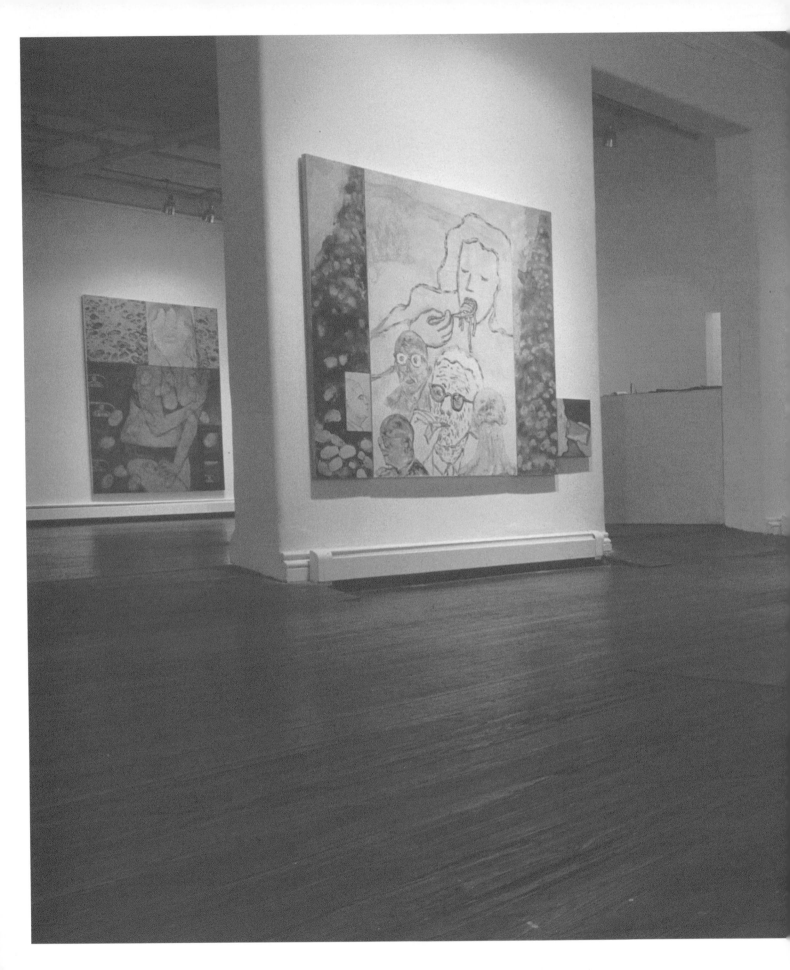

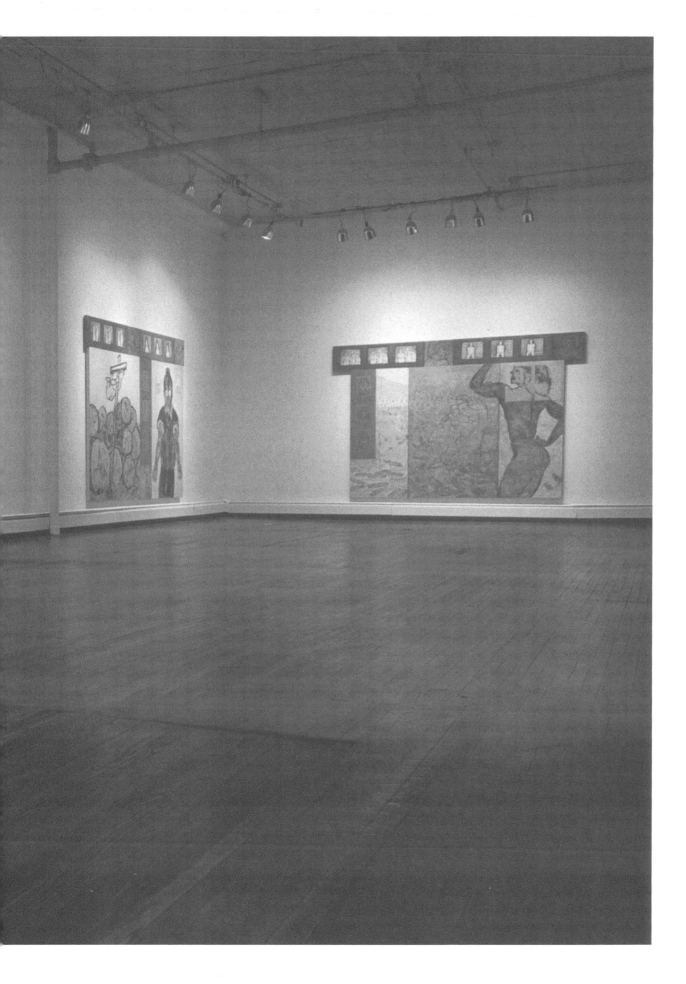

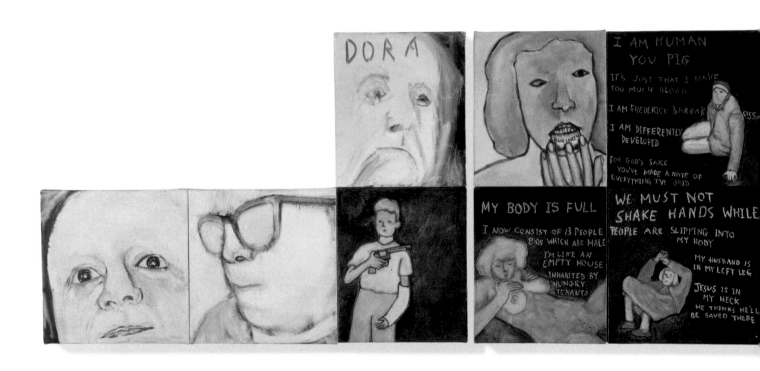

Jesus loves U
1987 > oil on canvas,
8 panels, 32" x 78"

Applebroog understands the deeper meaning of the 1970's feminist motto "The personal is political": the goal was to release individual women from the bondage of isolation, from self-destructive delusions of unique abnormality, to provide a sense of commonality, to illuminate the existence of a determinative patriarchal system of difference, and to focus anger away from the self towards the culture to achieve *voice* and *agency*.
M.S.

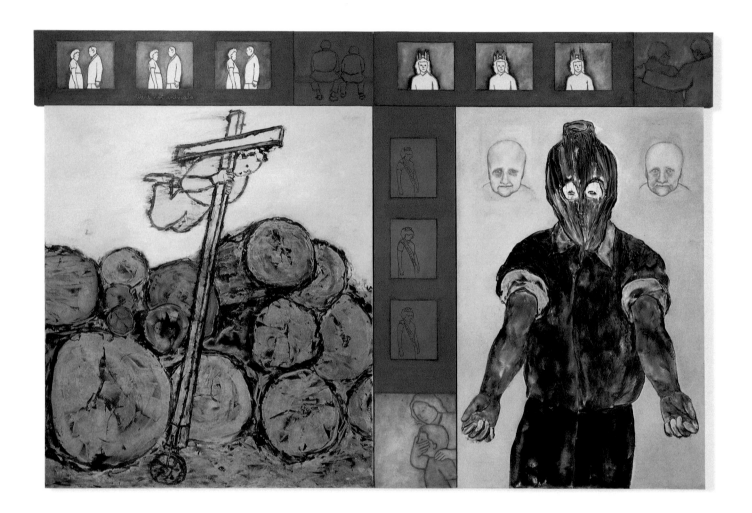

Church of St. Francis Xavier

1987 > oil on canvas,

5 panels, 86" x 136"

Boboli Gardens

1987 > oil on canvas,

5 panels, 86" x 132"

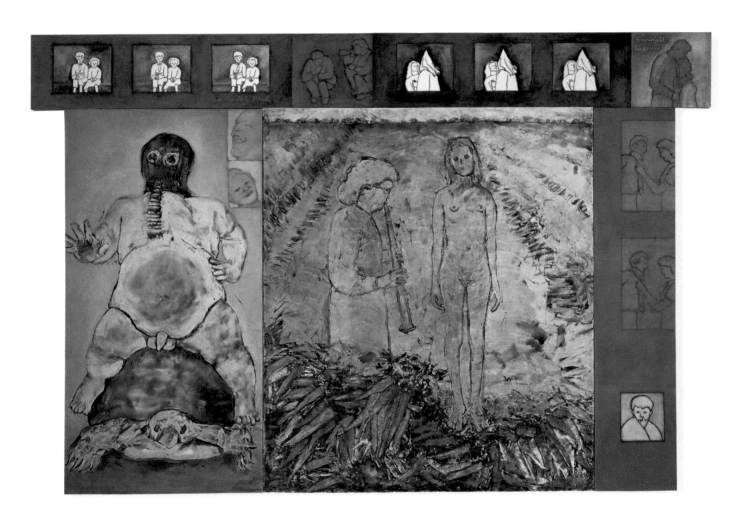

Critique of realism depends on the use of montage, disruption of narrative, refusal of identifications with heroes and heroines, the intermingling of modes from high and popular culture, the use of different registers such as the comic, tragic as well as a confection of songs, images, sounds, film and so forth. Complex seeing and complex multilayered texts [are] the project.
G.P.

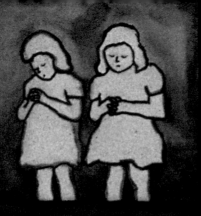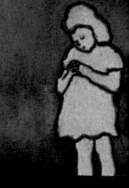

Are you bleeding yet?

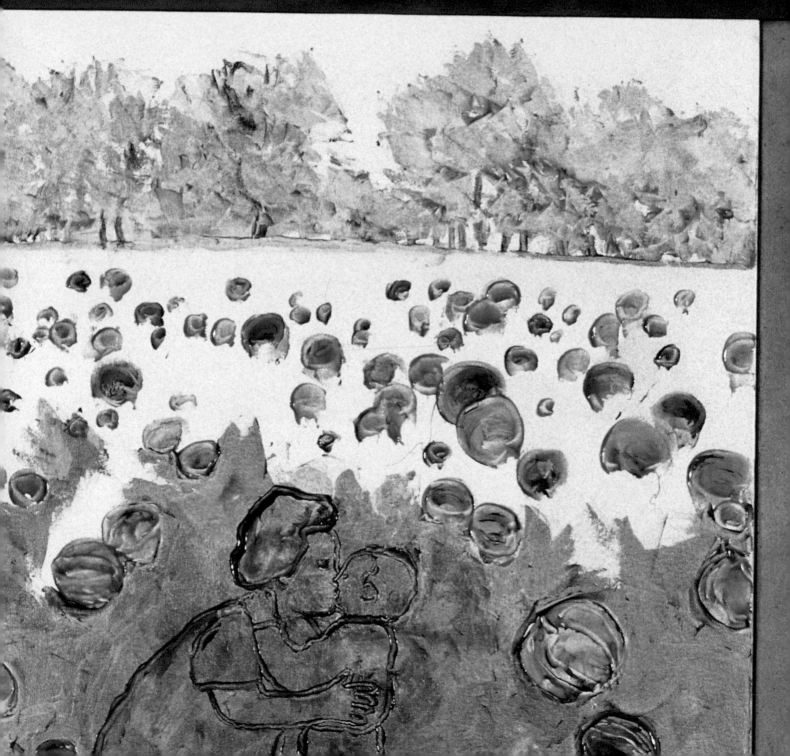

Tomorrowland
1986 > oil on canvas,
5 panels, 86" x 132"

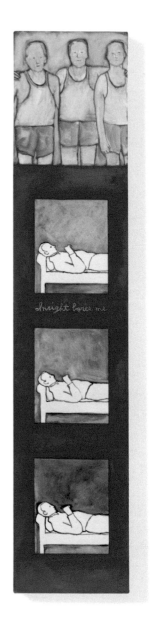

Applebroog hallucinogenically depicts the triumph and the decay
of Oedipus, the de-inscriber of woman, in her representation of the return
of the repressed female, the prescient child, and the ancient monster.
M.S.

Insight bores me
1987 > oil on canvas, 66" x 14"

Don't call me mama
1987 > oil on canvas, 66" x 14"

You got balls, Steven
1987 > oil on canvas, 66" x 14"

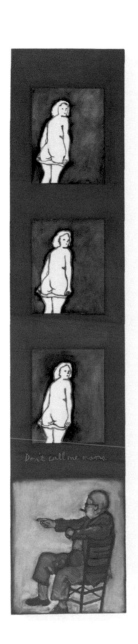

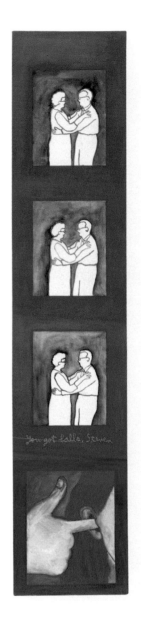

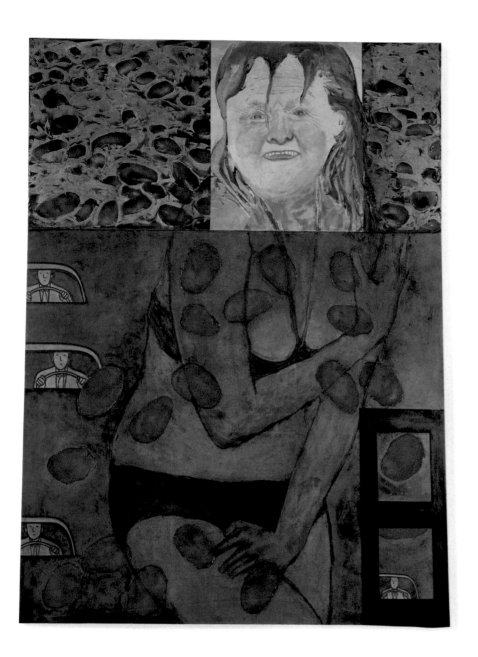

Beulahland (for Marilyn Monroe)
1987 > oil on canvas,
2 panels, 96" x 72"

Almost thirty years after her death, Monroe continues to fuel the imagination of the public and the flacks of illusion that make up Hollywood. She died in 1962 at the age of thirty-six. Never comfortable with the idea of old age, she once ruefully observed, "Gravity catches up with us all." One wonders, then, what she would have made of Ida Applebroog's depiction of her as a middle-aged woman - without lipstick, hair disheveled, plump body threatening to exceed the bounds of her bikini. She stands, one arm across her chest, the other at her crotch, as if hiding from public scrutiny that which is already hidden. Around her float mysterious disks that seem to accumulate on the beachhead at the top portion of the painting. In repeated frames, men appear seated at steering wheels behind disengaged windshields. This Marilyn relives past glories: the pose and the swimsuit recreate a photograph of Monroe, taken in 1960 by Eve Arnold in Reno during the shooting of the film *The Misfits*, when Monroe was thirty-four years old. Monroe would have been sixty-one, had she lived, when Applebroog painted her image.
L.S.S.

My whole life had to do with media. I am an image scavenger, taking images from famous photographs, newspapers, recycling from old magazines. I take all kinds of events and put them together.
I.A.

mr. kelly
had a pimple
on his belly

his wife
cut it off
and it
tasted like jelly

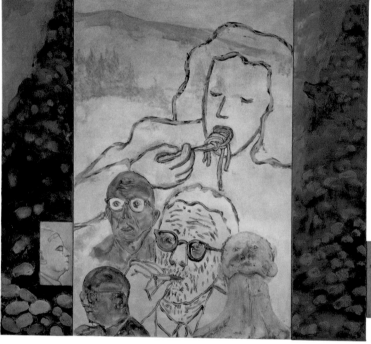

Goya Road I
1987 > oil on canvas,
4 panels, 72" x 94 1/2"

Goya Road II
1987 > oil on canvas,
5 panels, 82" x 62 1/2"

Goya Road III
1987 > oil on canvas,
7 panels, 88 1/4" x 75"

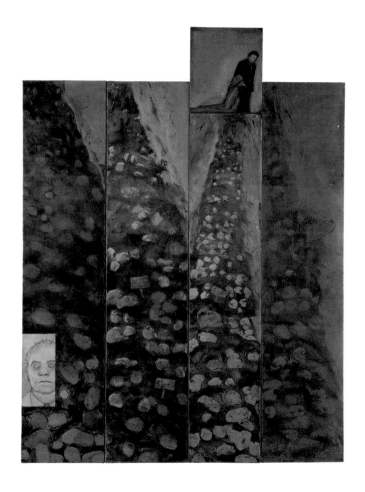
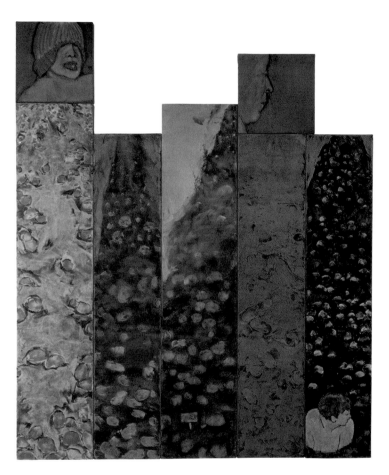

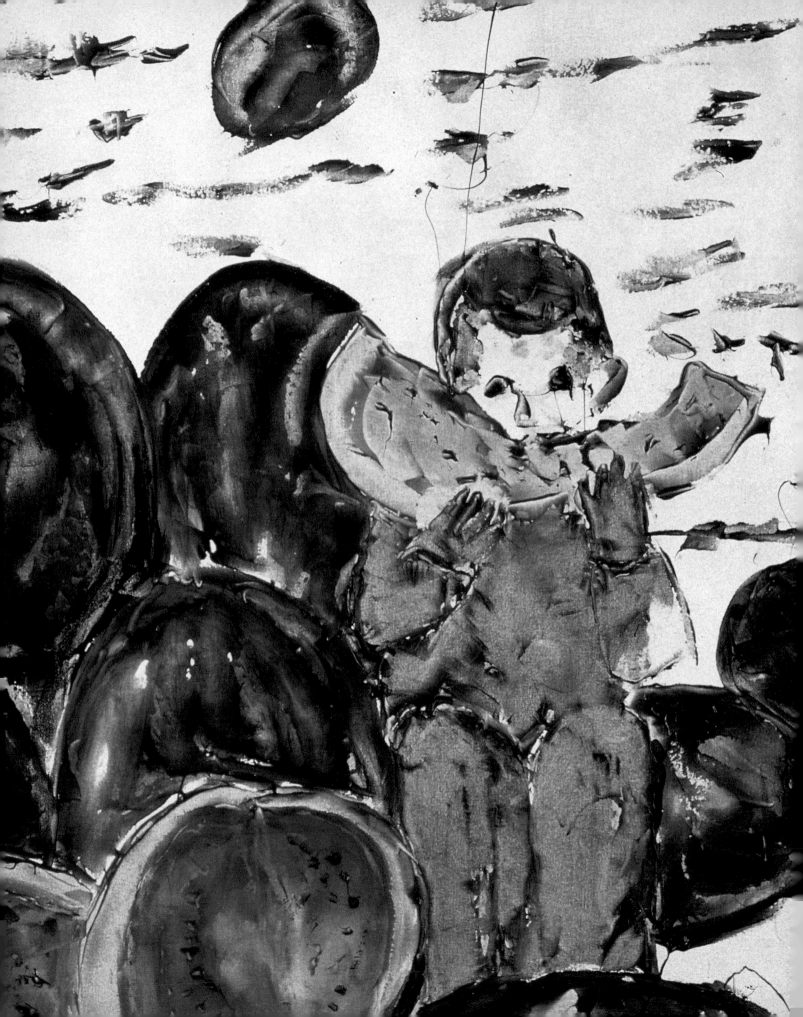

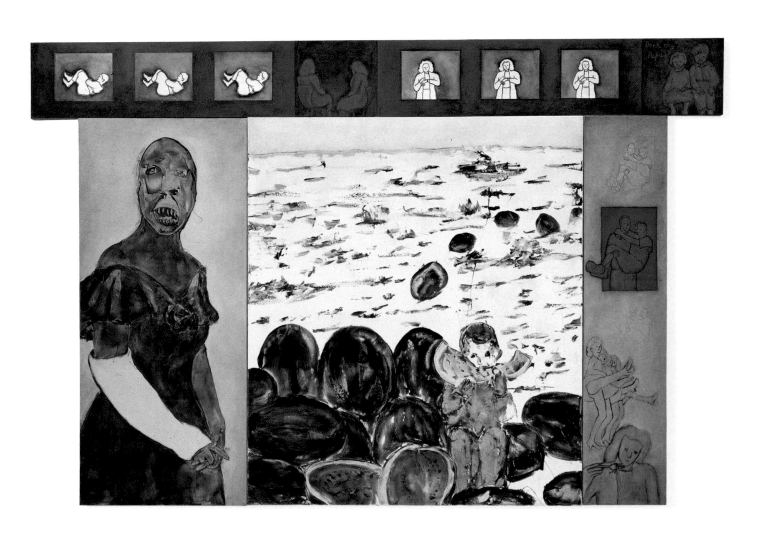

To this viewer, Applebroog's own vision of suburban, familial horrors in the field bears a disturbing relationship with that crepuscular world seen close up in the grass under a white picket fence in the movie *Blue Velvet*.
C.R.

Noble Fields
1987 > oil on canvas,
5 panels, 86" x 132"

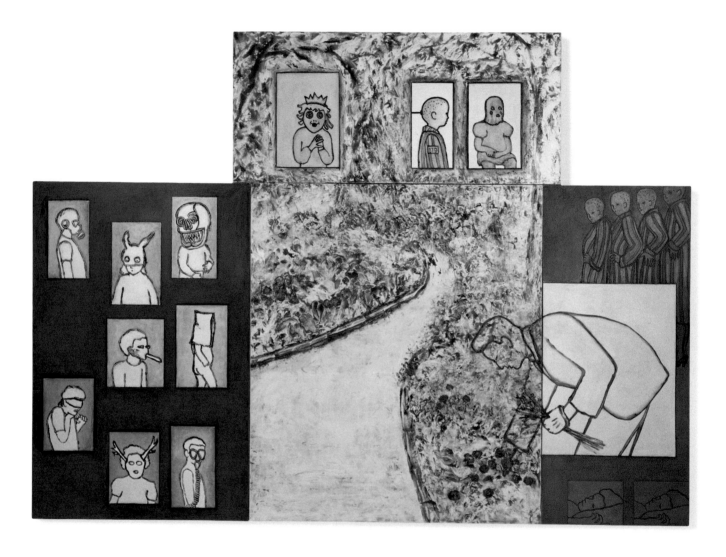

R.F.　There is a collector who always comes to Ida's shows. One day she told me "Ida is without question the best artist working today, but I can't buy it. I can't live with it, and I will never be able to live with it."

J.L.　So what are your feelings when you look at Ida's paintings?

R.F.　They speak to me very directly; Ida is continually re-inventing and stretching the language she has developed. They always have my attention. I appreciate that in any artist, the ability to change what you're doing, to add and subtract from it, to twist it. She's not doing it because she's afraid of history, because she feels that damn it, she has to make something that looks new. She's doing it because each time she finishes a cycle of work she starts afresh, trying again to find a way to present what's on her mind. Ida is never afraid to do that; it's an intense confrontation, a very natural one.

J.L.　Do you see any struggle or fight in her works?

R.F.　Great struggle. There is a great struggle just to make art today, even more so when the approach is somewhat old fashioned - by hand - about serious subject matter - with loads of figures - very representational. Even her survival as a human being, her physical self, is part of her struggle. Her hand, her elbows, her shoulders, her whole body is involved in making these paintings. To survive attacks on her body and still produce this remarkable recent body of work, demonstrates her resiliency and determination.

J.L.　You speak of her fight to make art, but I also see peace.

R.F.　In what way?

J.L.　When I look at Ida's paintings I see stillness, the quiet after a conflict. Perhaps because you are more willing, Ron, to see what she had to go through to make the painting, and I am more satisfied to see the results. Which is the fact that in doing this painting, she did resolve something.

R.F.　What do you find resolved? For example, take the painting *Crimson Gardens*. What in that do you find resolved?

J.L.　I just see it like this: that there was a fight, but the fight is over when the painting is done. I see what she meant, I see what she wants. What do you see?

R.F.　The painting *Crimson Gardens* was once titled *Auschwitz Gardens*. So, many of the people are wearing striped uniforms. Someone is picking red flowers, which lose their color once they have been cut. The flowers have to do with the terrible circumstances that occurred there. The inhumanity that occurred there. The humanity that occurred there. And I have difficulty coming to a peaceful place looking at that painting. I feel a great sadness and compassion for the events that took place. So it's hard for me to think of it as restful. That you can do so comes as a surprise to me. I find solace in the fact that Ida overcomes sentimentality and makes a brilliant record of such heinous events.

J.L. This is the difference: although I see the same painting you do, I see hope - the flowers in it may stand for the life that goes on in some altered way.

R.F. A great tradition in art is the witnessing of events. Ida does this in the most superb, mature way. The fact that she is able to speak in such a profound manner for the deceased or surviving witnesses that find they cannot speak or are unable to do so, for the people involved there, being killed, watching death, administering death - that's what sets her apart. Really, it's a great painting, a huge painting, that portrays the conflict for power and survival. That there are such artworks is a comfort, but also a reminder that this could happen, might be happening now, somewhere, to some people.

J.L. I agree. Somewhere Ida is saying to be careful, this could happen again. If you asked me for a word to define Ida's work, I would choose "love." When someone is giving everything, I see that as a gesture of love, and no other word can describe it.

R.F. Well I think "tough love" is good. Because I can't deny, I wouldn't deny - there is a great deal of love in Ida's works. She's not casting great blame; she's not flogging us to death. She's just saying this is what we did - we've done this - we can do better. Seeing it through her eyes, I feel some sense of hope, that whatever occurs next in the world is within our control.

J.L. La rivoluzione siamo noi, as Beuys once wrote.

R.F. Ida is so intelligent about it. She presents the facts with some sympathy, but leaves it unclear whether we will do better; she intentionally leaves it wide open. And I don't think she would want to make a work where you could identify only her feelings. She doesn't want us to do that, she wants us to use the work.

In a disconcerting manner edges do not meet, walls show through segments, narrative strips do not coincide with the larger canvases or images they abut. The peculiar flow of narratives through these different spaces and scales, and the locking and unlocking of time and space in these disjointed scripts and scapes, serve to disembody the very evident physicality of these architectural paint-things.

In Applebroog's work, as in television, "the global village" tunes into an unhierarchic toxic waste dump of places, images, and events. Earthquakes and ball games, assassinations, space walks, the "Love Canal" and **The Love Boat**, Donahue in a dress, the inside of a human ovary, serial murder, plastic surgery - you are there, you are they, they are here.

. . .

It is the tumult of these spaces that animates the architectural elements of her paintings, transmuting archaic post-and-lintel construction into filmic space and montage. Yet Applebroog's call to the visual-narrative techniques of both old high art and recent low art builds on film's capacity to intercut unrelated images and actions. The narrow bands that horizontally or vertically frame most of the larger paintings have often been referred to as "predellalike," linking these works to medieval and early-Renaissance altarpieces. In these, the predellas were the narrative scenes painted on small panels, usually at the bottom or side of the central, larger image. While the main scenes might contain a static and symbolic portrayal of the principal iconography and be painted in a refined, "advanced," highly finished style, in the High Church Latin of visual language, the predellas were painted in the vernacular. They often appear more "primitive," as they tell a story in vivid movement and detail. But in Applebroog's work, the predella narrative is reduced to simple repeating images that function as cell animation and as frames from a silent movie with titles.

. . .

Predella or cartoon? Applebroog reaches back to a very old technique and a very low-brow, "infantile" form of story-telling, not to instruct us on the life of a saint, however, but to offer us only ciphers of modern life. These images are previews for a film run through a Super-8 projector while the main screen may be in Cinemascope, and fragments float around like "smart window" television.

M.S.

Delmore Arms
1987 > oil on canvas,
4 panels, 58" x 44"

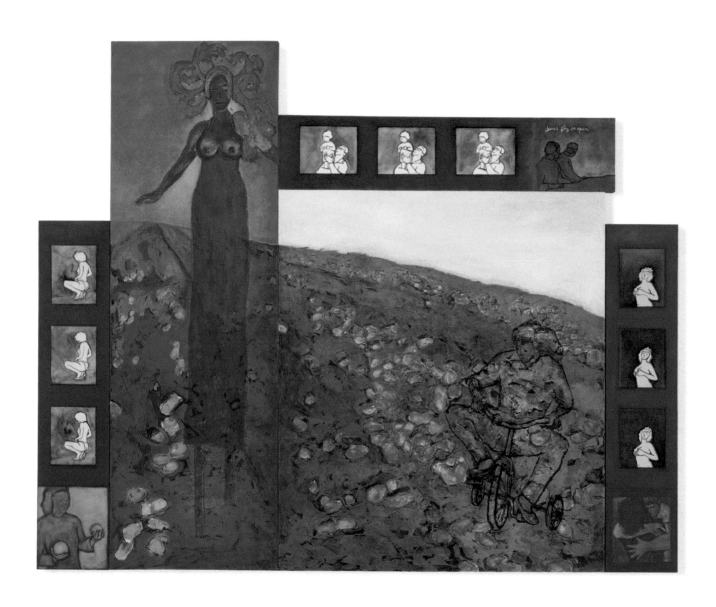

Velcro Village
1987 > oil on canvas,
four panels, 100" x 125 1/2"

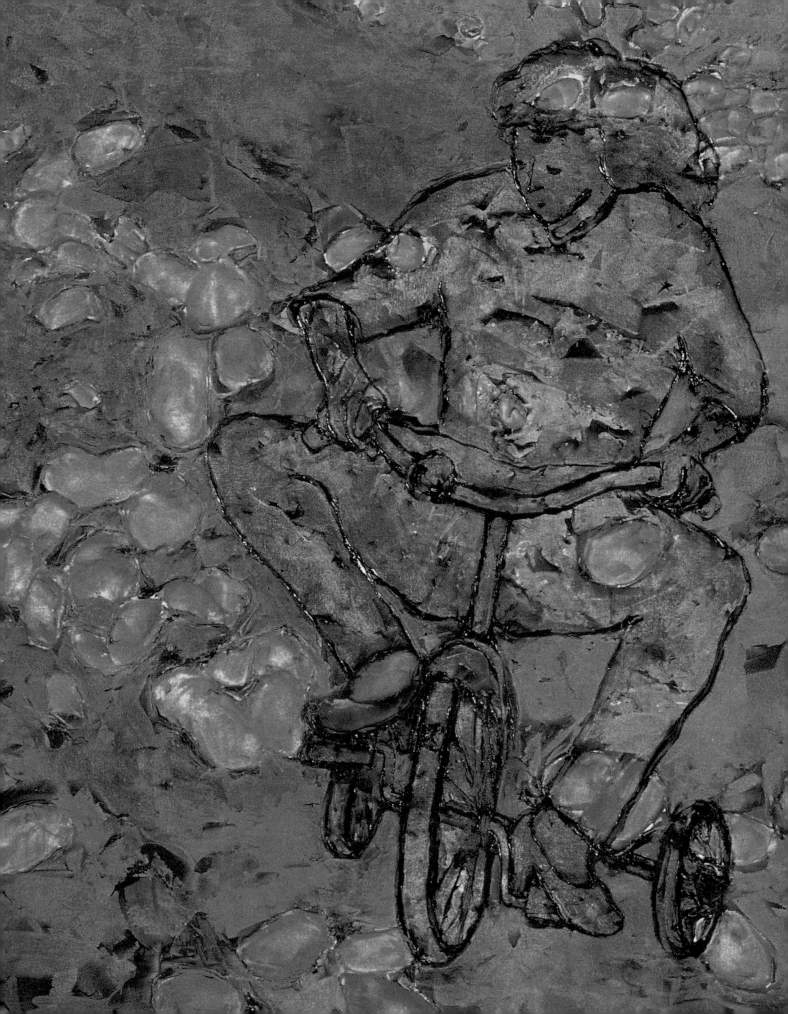

Untitled (man crawling)
1987 > oil on canvas, 16" x 16"

Applebroog seems more than ever devoted to chronicling the banality of evil, or at least of irreparable harm, documenting the ease with which it enters otherwise unremarkable lives and the scant distinction it bestows on those it touches.
N.P.

Untitled (person with two phones)
1987 > oil on canvas, 16" x 16"

What is the moral of Applebroog's stories. It's impossible to say. We don't know how they will come out. In part this results from a refusal on her part to provide happy endings as a inducement to endure the stress of paying attention. In part this results from the fact that these scenarios describe a society, and unlike stories centering on individual fates, societies do not offer dramatic closure but instead guarantee a constant change in the imbalance of forces that define their character. The flaws in the character of America are revealed by what Applebroog does in the context of its compensatory fantasies. The satisfactions to be derived from their unresolved antagonism are the awkward satisfactions of living without illusions in the midst of the illusions we cherish most.
R.S.

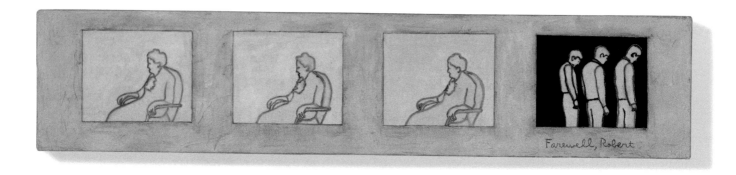

Untitled (Farewell, Robert)
1987 > oil on canvas, 14" x 66"

I'm back on the pill
1986 > oil on canvas, 14" x 66"

You're rat food
1986 > oil on canvas, 14" x 66"

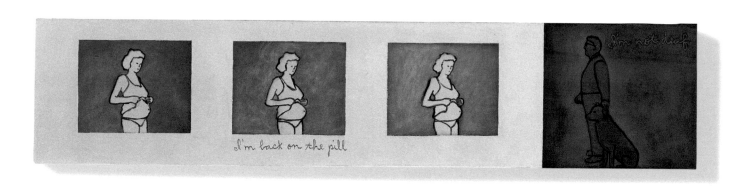

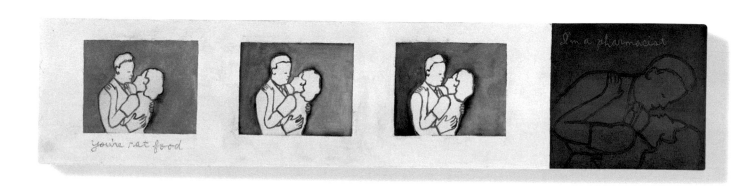

Her characters ... are the old, the destitute, the maimed or
the grotesquely mutilated, the cretinous, or, conversely, the
overly typical.... Applebroog's collages of images allow her to
suggest fragmentary narratives, implying violence that is
unexplained and inherently unmotivated or gratuitous. There
is no coherence to her world because the world itself is
incoherent, and because the codes that would give it solidity
are ruptured by the implosive turbulence of human cruelty.
K.L.

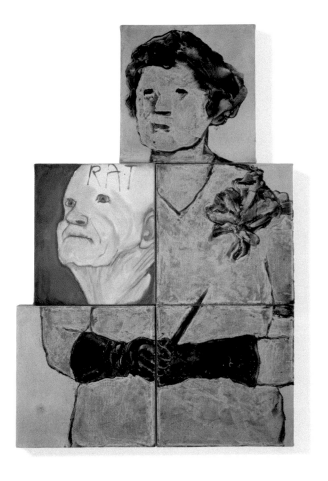

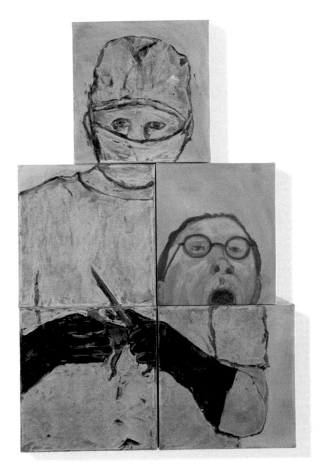

K-Mart Village II
1987 > oil on canvas,
5 panels, 48" x 32"

K-Mart Village I
1987 > oil on canvas,
5 panels, 48" x 32"

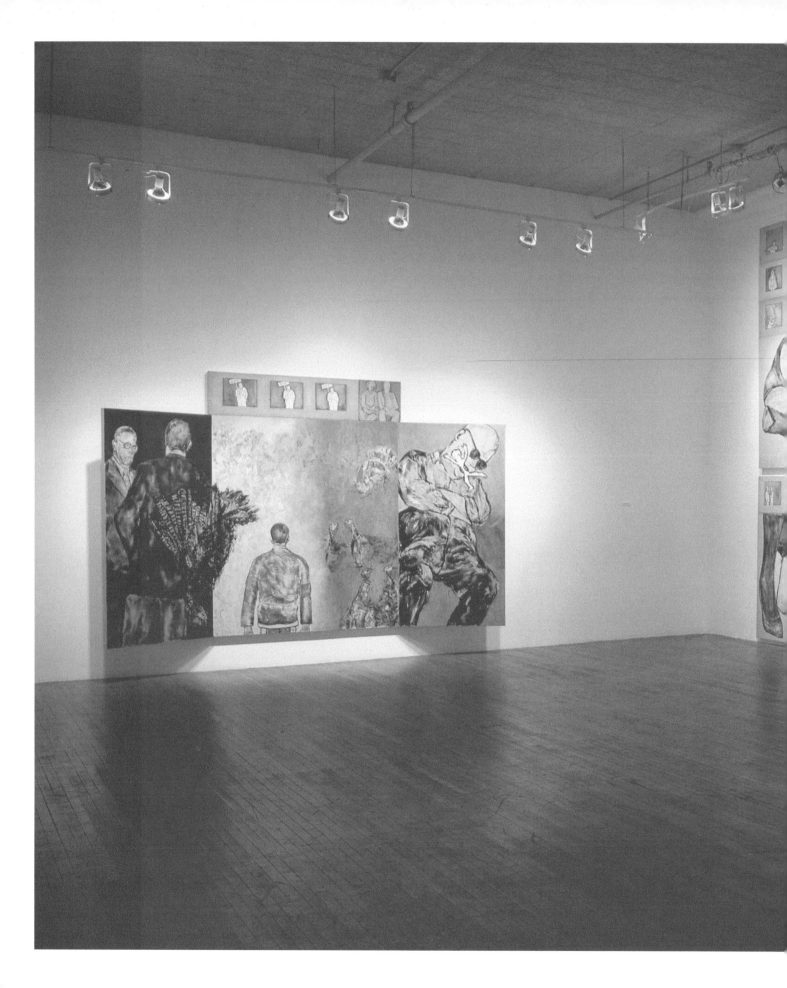

Nostrums:
a patent medicine, for which extroardinary claims are made; a pet scheme to remedy social or political problems, a panacea, a cure-all.

A Note of Fair Warning

Let the gallery-going public, or anyone else who may come into casual contact with the artwork of Ida Applebroog BEWARE: prolonged exposure to the paintings, performances, videos and books produced by a certain Ida Applebroog are believed to increase significantly the probability of some form of personal psychic crisis within individual audience members. Viewers are cautioned not to be easily deceived by the seemingly harmless, inoffensive, ordinary and mundane quality of Applebroog's subject matter and presentation. This simplicity and commonness of appearance are deliberate ploys to disguise the antagonistic intent and emotionally disruptive effects of her socially and politically critical message. Chances are that something odd about this art is what first attracted your attention; but then it slowly began to trouble you with a seductive sense of profound self-identification for reasons which you can't quite put your finger on, until it is too late to escape its contagious existential psycho-drama.

DO NOT STOP TO ASK YOURSELF "WHAT'S WRONG WITH THIS PICTURE?" Just tell yourself that, "Whatever it is, it has nothing to do with me: it must be someone else's problem."

This is the fine art of gaps; those wordless moments of truth and pregnant silences, those lulls before the storm and pauses before the kill; those nostalgic memories and longings for what is no longer there; those terrible flashes of utter emptiness and solitude, that we deposit as a trail of all that remains unspoken, ignored, overlooked and unattended to in its banal misery.
...
Certainly there is on Applebroog's part here some degree of mocking abhorrence for the trivialization of meaning and emotion in the arts. Quite knowingly, she mimics the dominant tongue of contemporary expression with graphics directly acquired from tabloids, comic strips, advertisements, and other unmistakable mass market low-art vernacularisms of the media age, and with preciously clever appropriations so voguishly "in" amidst the oversaturation of postmodernist hype, so that the predictable pop and post-pop expectations of her audience may be automatically detonated after they have been blindly embraced by all.
...
Applebroog's world is a space where calm, sanity, logic and security are precariously set on the near edge of collapse, and struggle to confine their mental infirmity, degeneration, or disassociation. Here even the slightly bizarre in attitude, behavior, or expression seems to carry some biological curse of deviance, aggression, melancholia, hysterical hallucination. Such a chaos is as deeply feared by the individual as it is dreaded within the collectively conceived social body, as both self and society try to maintain a jittery fragile picture of order.
C.McC.

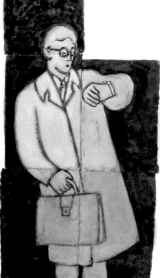

Anhedonia
1989 > oil on canvas,
11 panels, 102 1/2" x 142 1/2"

Untitled (toy airplanes)
1989 > oil on canvas, 14" x 66"

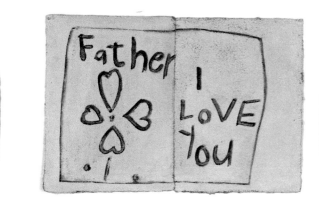

Father
I LOVE You

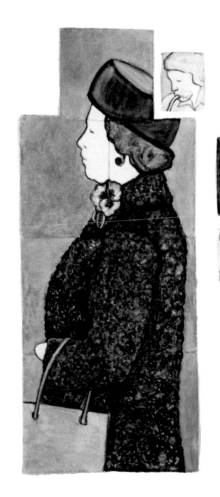

Variations on Emetic Fields
1990 > mixed media, dimensions variable

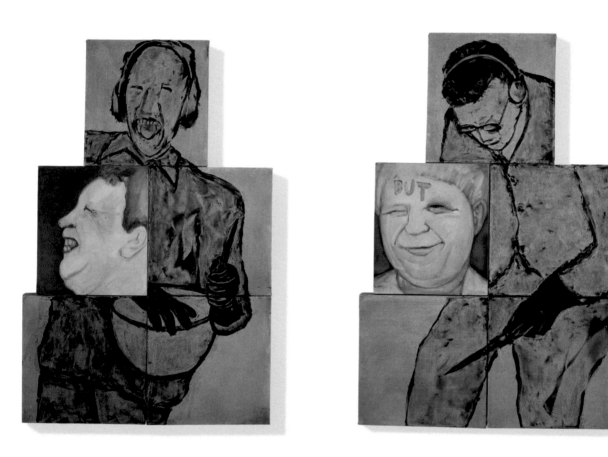

K-Mart Village III
1989 > oil on canvas, 5 panels, 48" x 32"

K-Mart Village IV
1989 > oil on canvas, 5 panels, 48" x 32"

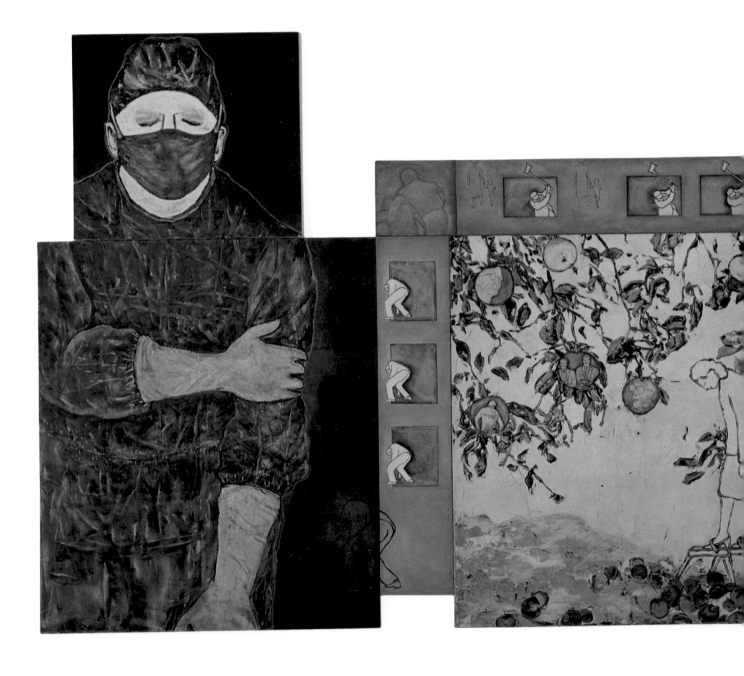

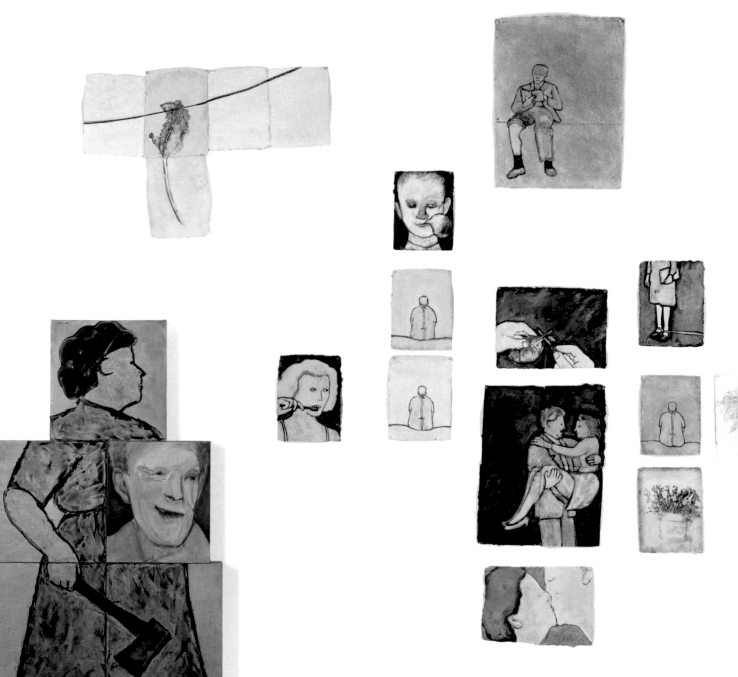

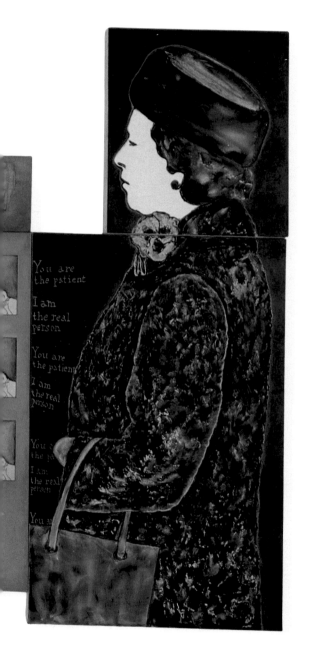

Emetic Fields
1989 > oil on canvas,
8 panels, 102" x 204 1/2"

Writers on her work have enjoyed it as a game of free association, or enthusiastically treated it as something to unriddle, often from a Freudian and/or feminist perspective. The first approach tries to get the sense of the art by ingenious guesswork; the other implies that this intuitive painter has strewn erudite clues for the benefit of critics learned in current theory.

…

For my part, I think her painting invokes a certain kind of chaotic world by means of an efficient poetics. It is a world in which people fail to perceive their emotional standing with others. There is a chronic deficiency in their social radar, and they unwittingly keep bad company. Many of Applebroog's tableaux hint of dire portents and misplaced trust. Devious in narrative, she keeps viewers from knowing who are the victims and who the perpetrators. A link nevertheless exists between the open-endedness of her "stories" and her mordant view of human exchange. And this link inveigles us into her "fields" - a word she often uses in the titles of her works - by a sustained metaphor of cognitive doubt.

…

There exists a visual parlor game called "What's wrong with this picture?" - usually a drawing of a scene replete with aberrations: for example, a clock with hands of equal length. Whoever detects the most details of this sort, many of them subtle, wins the game. Because its departures from our ideas of use, placement and order are proposed as anomalies, the game assumes our faith in a rational world. It's an effect opposite to that of Applebroog's art, where the pleasure might consist in finding something "right" with the picture. We hunt in vain for meaning that can be processed by reasonable conjecture. For her world is defined by its instabilities: mismatches between speaker and language, or gestures and thoughts. Motley non sequiturs are the norm.
M.K.

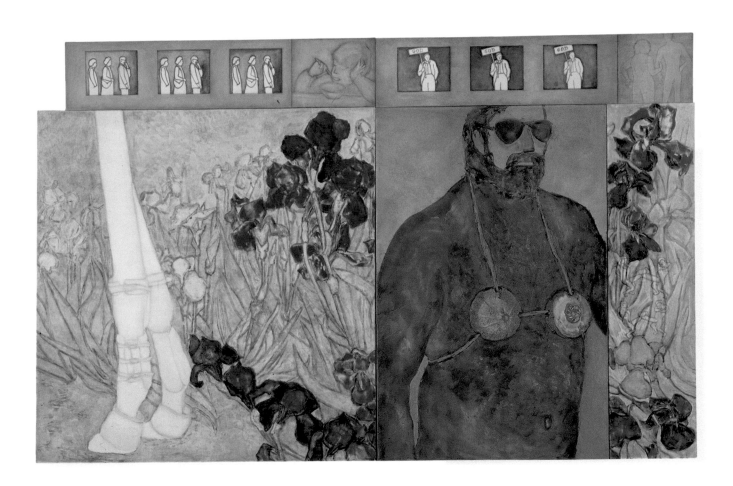

Peristaltic Garden
1988 > oil on canvas,
5 panels, 86" x 138"

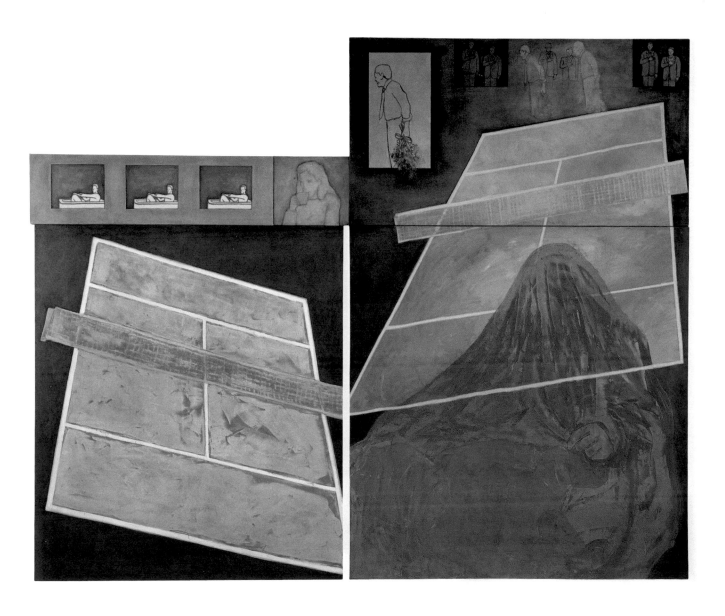

Lithium Square
1988 > oil on canvas,
4 panels, 110" x 137 1/4"

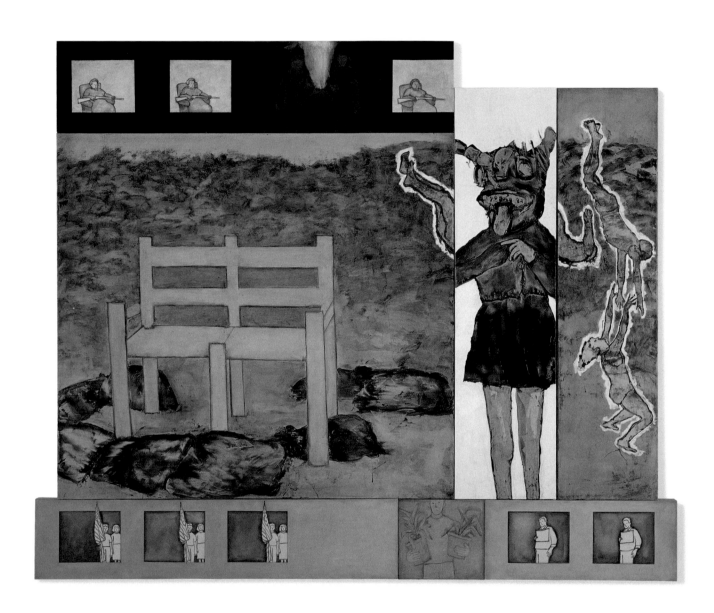

Chronic Hollow
1989 > oil on canvas,
6 panels, 94 1/2" x 116 1/4"

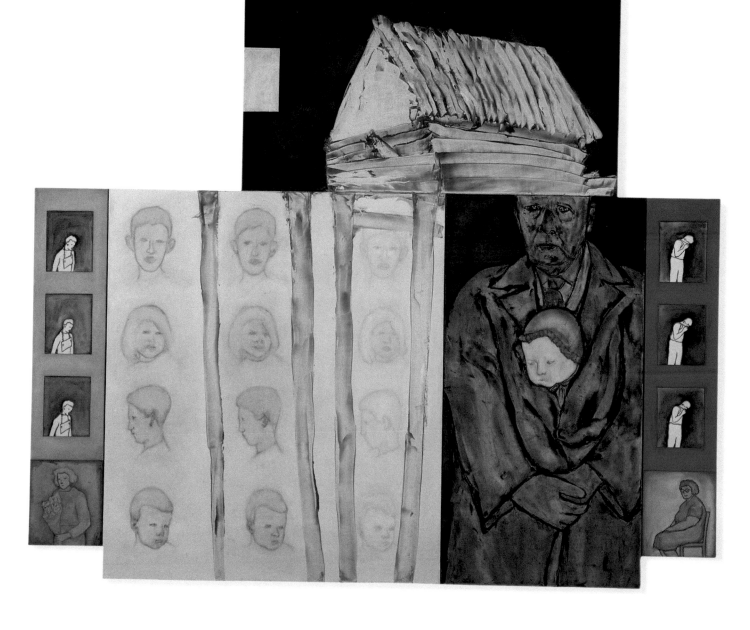

Idiopathic Center
1988 > oil on canvas,
5 panels, 110" x 130 1/2"

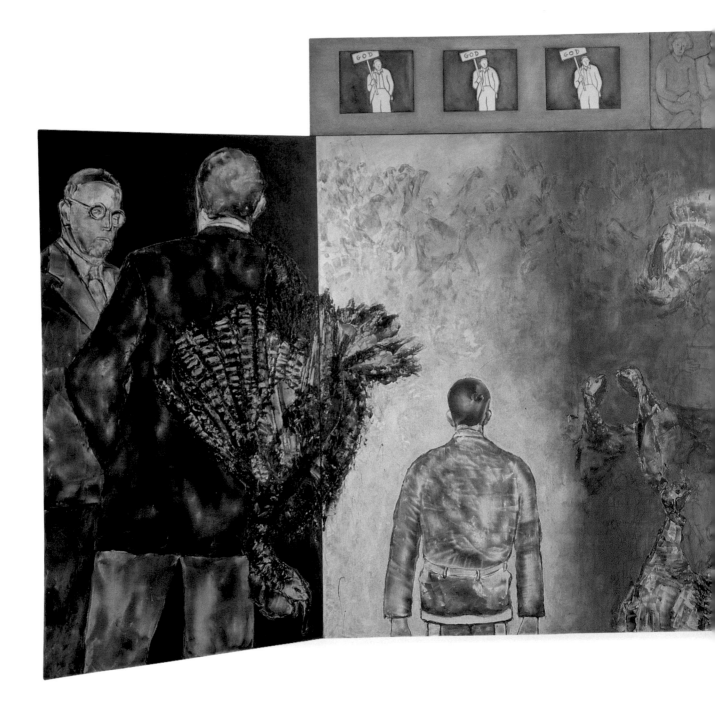

Camp Compazine
1988 > oil on canvas,
4 panels, 86" x 140" x 18"

In these dark days for the artistic object, it's a bit unusual to find that a room full of canvases from a 60-something figurative painter should feel like a bellwether for contemporary art. Balancing issues of appropriation, pictorial conventions, and disparate elements of contemporary social thought, Ida Applebroog's work is emblematic of numerous current intellectual and aesthetic concerns. What sets her apart from so many others addressing these issues is her ability to steer clear of the antisensual polemic often associated with such explorations. Not content to pull up at the foggy edge of the postmodern swamp that lies between the artist and the narrative space of the representational image, she strikes out to navigate it. Refusing simply to accede to the positioning of the passionately made object as a straw man for critical target practice, she instead reclaims it as territory for purposeful expression.

...

Subtexts of gender politics, communication breakdown and socio-sexual dysfunction of mythic proportions always colour the interraction. Combined with the redundant, lingering gaze of the stalled montage form she adopts, they create the disquieting sense that we're watching the same tragic scenes over and over again.

...

In works such as *Camp Compazine* (1988), she crosses postmodern and classical wires in her depiction of a dozing pensioner absentmindedly munching, Kronos-like, on a tiny person, as sombre suitjacketed men converse on the opposite panel of the perverse altarpiece. The 'altarpiece' reference is furthered by the inclusion of the strip painting along its top edge, the repetitive cells functioning like a Renaissance predella obliquely detailing the disenfranchisement of the anti-heroic characters memorialised below.

J.K.

227

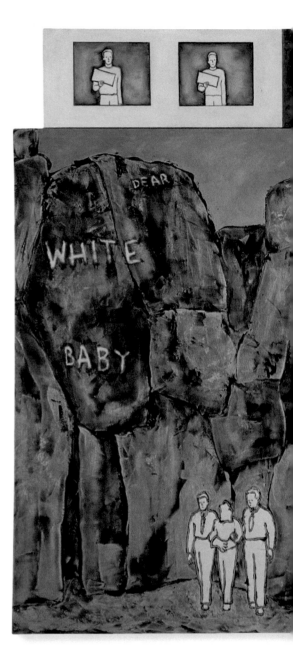

Guilt and penitence - it all comes down to a moral code, though not exactly a religious one. This is a moral code that has evolved through the telling of a long story, a social legend, not so much Homeric as quintessentially American, something close to the bone, a story the artist herself has heard over and over - the story of a daytime soap opera ... Like a good soap opera, Ida Applebroog's tales never begin and never end. Frequently, the most interesting elements are the small details of composition, marginalia providing crucial information. As in a good soap opera, we might only recognize the true perfidy of a protagonist's actions when, by means of a well-placed flashback, we recall the details of her birth some thirty years before.
T.W.S.

Vector Hills
1989 > oil on canvas,
5 panels, 86" x 150" x 18"

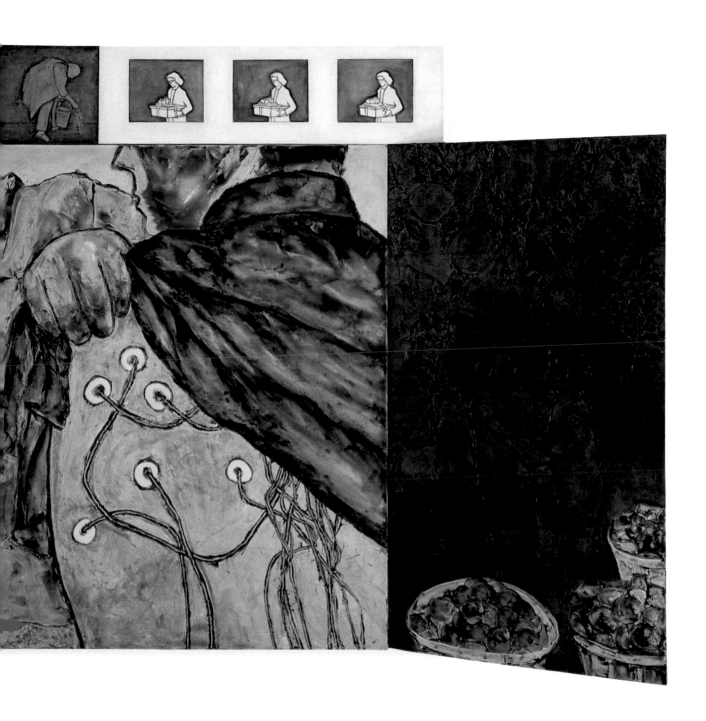

a person's skin
weighs about
six pounds

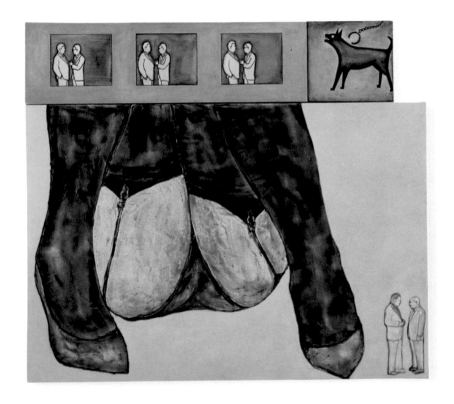

Elixir Tabernacle I
1989 > oil on canvas,
2 panels, 62" x 72"

Elixir Tabernacle II
1989 > oil on canvas,
4 panels, 92" x 72"

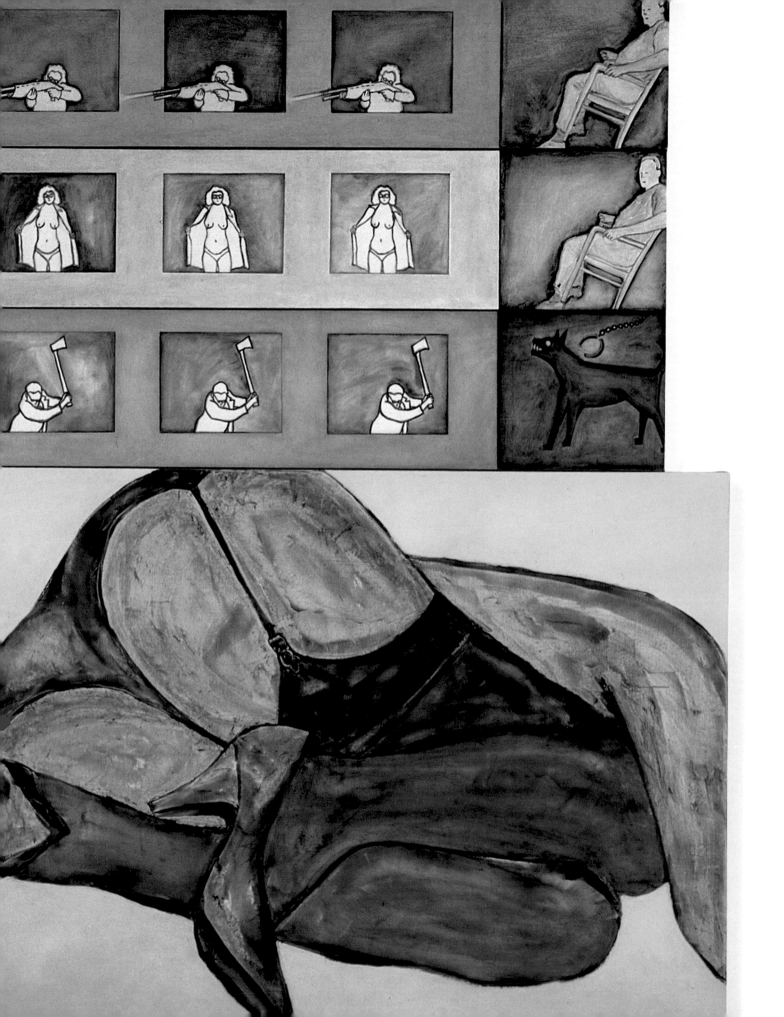

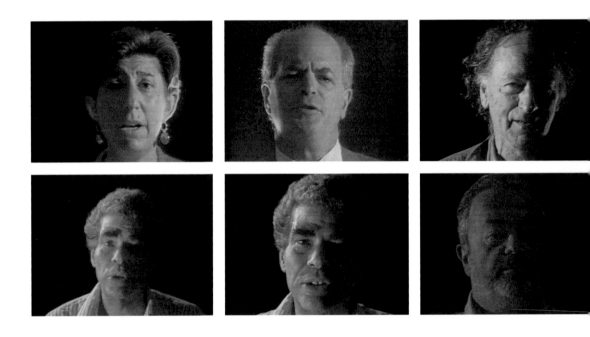

Belladonna is a mother/daughter collaboration between painter Ida Applebroog and filmmaker Beth B. Its premise is derived from Freud's classic text on sadomasochism, "A Child Is Being Beaten." However, it revises Freud's oedipal interpretation to focus on the child's rage at the power of the mother. Some 20 actors (most of them men) are filmed in dramatically lit close-up addressing the camera. Their lines are exerpted from the testimonies of Joel Steinberg and Josef Mengele. The text, randomly reordered and broken up among the performers, momentarily comes together - makes a kind of grotesque sense - then disintegrates into chaos by the end.
A.T.

In her video, *Belladonna*, the intercut talking heads of men, women and a small boy, disturbingly collages selected passages from the trial of Joel Steinberg, a childkiller, the testimonies of Joseph Mengele's victims, and Freud's essay "A Child is Being Beaten." Its spare, unflinching presentation emphasises the menace of the spoken words. Freud's analysis of phantasy is set against actual abuse; emotional identification with victim or perpetrator against possible motivation; guilt, both internalised and externalised, against the lost innocence of childhood.
K.D.

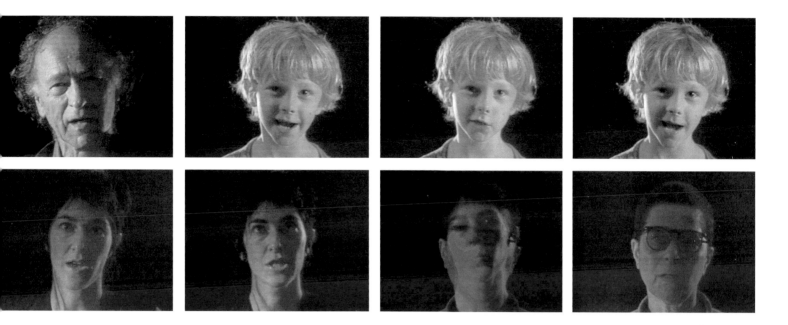

Belladonna (stills)

1989 > film/video, 12 min. 9 sec.

by Ida Applebroog and Beth B

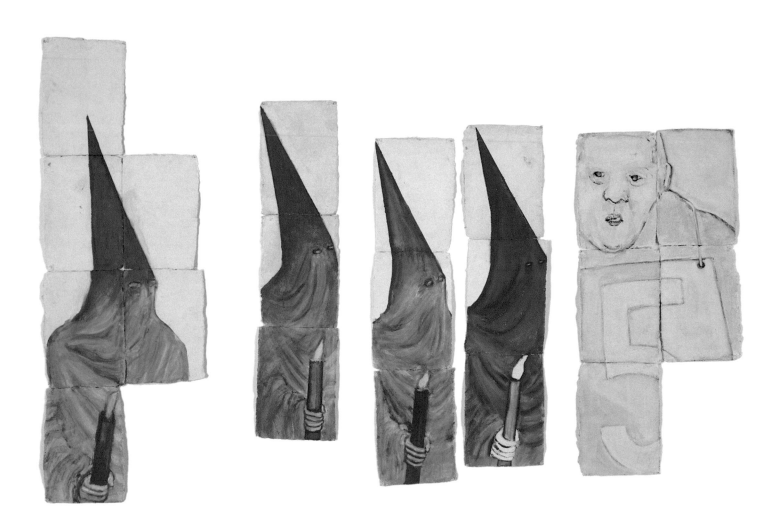

Study II for American Lesion
1989 > watercolor on paper,
23 panels, 71" x 154"

American Lesion II
1988 > oil on canvas,
2 panels, 72" x 32"

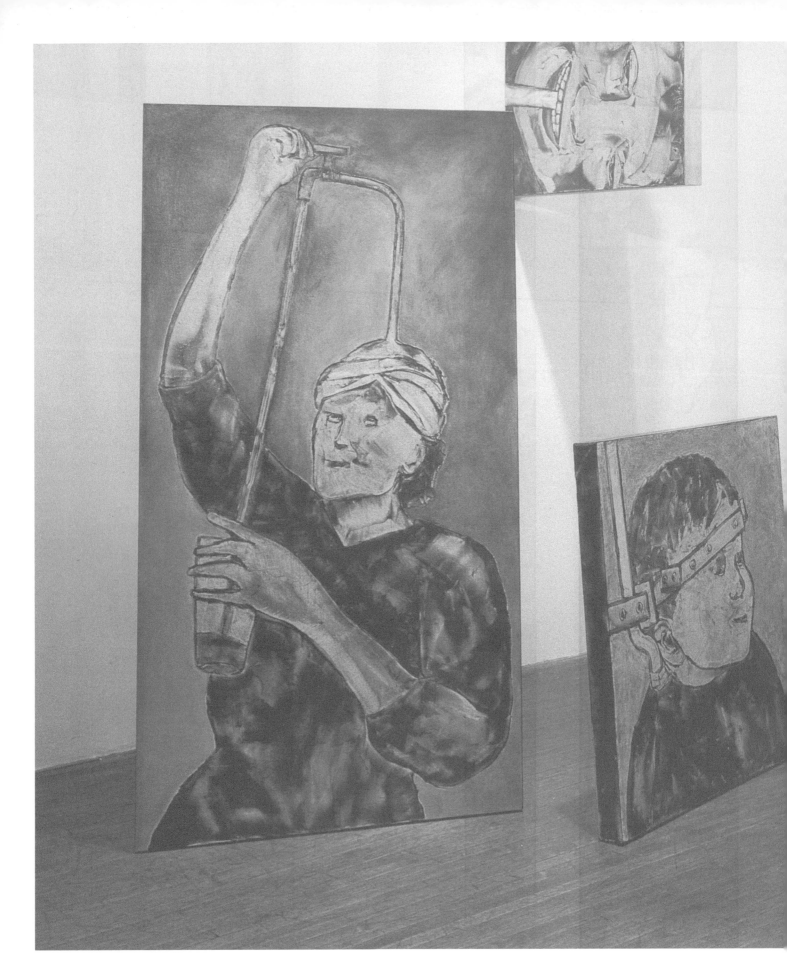

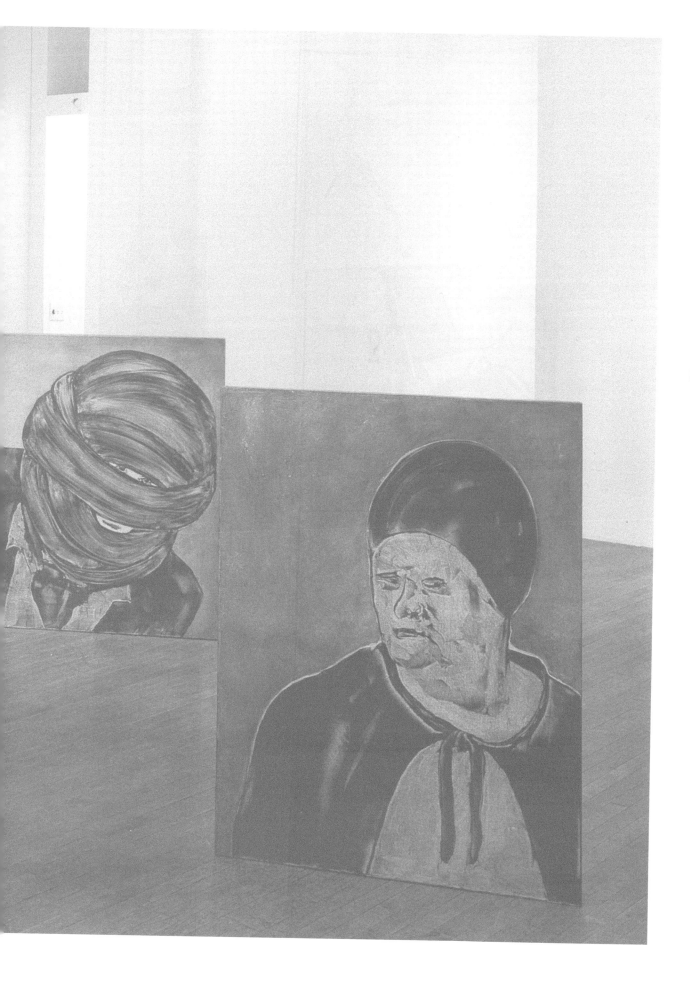

**Marginalia (woman with hat)
sides 1 and 2**

1991 > oil on canvas,

2 panels, 17" x 17 1/4" x 4 3/4" (F)

**Marginalia (Al Jolson)
sides 1 and 2**

1991 > oil on canvas,

2 panels, 17 1/4" x 15 1/4" x 4 3/4" (F)

**Marginalia (measure feet I)
sides 1 and 2**

1991 > oil on canvas,

4 panels, 33 1/2" x 17 1/4" x 4 3/4" (F)

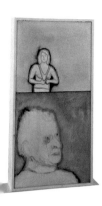

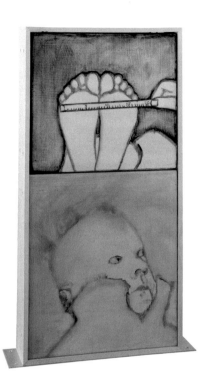

The main irony here is that since she has often been credited in private with providing an example to many younger artists who are exploring the issues of vulnerability and humanism in their work today, it is strange to note that Applebroog's sudden "arrival" as a painterly force at the age of sixty-two has taken place through a development that in a younger painter's hands might seem a tad gimmicky. The most important thing is that these paintings function superbly as both art and provocation, communicating their messages with a intensity and clarity that were only hinted at in the past.
D.C.

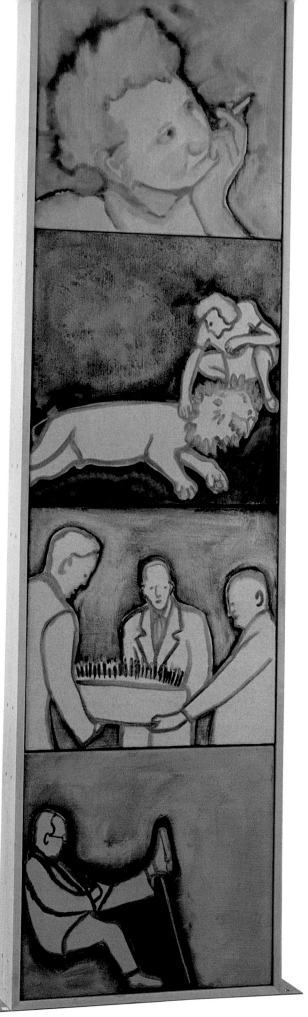

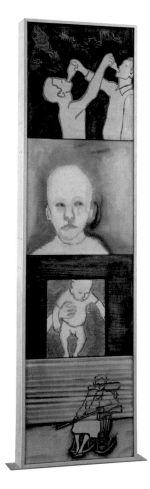

Marginalia (woman with lion)
sides 1 and 2

1991 > oil on canvas,

8 panels, 61 1/4" x 17 1/4" x 4 3/4" (F)

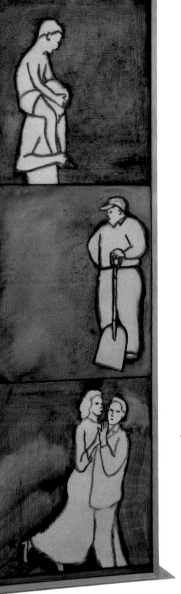
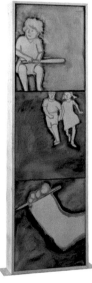
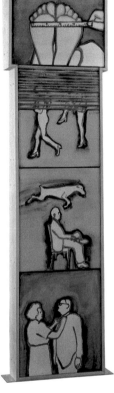
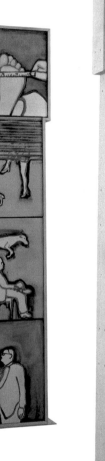

Marginalia (man with shovel)
sides 1 and 2

1991 > oil on canvas,

6 panels, 49 1/2" x 15 1/4" x 4 3/4" (F)

Marginalia (measure feet II)
sides 1 and 2

1991 > oil on canvas,

8 panels, 63 1/2" x 17 1/4" x 4 3/4" (F)

243

			Surname	First name	Date	Place
			Ticzeßka	Marton		
1902	Pole	J.L.	Jachowski	Nikla		
1911	Pole	J.L.	Lularczyk	Nathan		
69	Pole	J.L.	Tschechanov	Konrad	31.6.	
	Russe	J.L.	Baranowski	Alexander	24.1.	
	Pole	J.L.	Zadybovicz	Edward	12.10. 190	
	Franz	St.	Blachas	Karol	10.8. 1917.	
	Pole	St.	Stempien	Rene	12.8. 1896	
DR.	J.L.		Kleiner	Anton	29.10. 1893	
DR.	J.L.		Schneider	Helmut	16.12. 1909	
	J.L.		Langer	Alfred	25.5. 1890	Traun
	J.L.		Tschernysch	George	27.3. 1913	Antw
	J.L.		Wrotek	Gregory	24.10. 1924	Foroscha
	J.L.		Rybatschenko	Jan	19.3. 1907	Bialystok
	K.		Sajewski	Wasyly	22.3. 1912	Sparsloje
			Perrin	David	4.7. 1920	Warschau
			Eisenmesser	Rene	12.12. 1912	Lyon
			Maurer	Mosych	15.5. 1907	Tarnopol
			Chelstowski	Florian	23.4. 1900	Nagelsberg
raszab				Jean	15.4. 1909	Lyon
				Jakob	23. 1. 1909	Budapest

Marginalia (Mauthausen notebook)
1991 > oil on canvas, 43 1/4" x 48" x 3 1/8"

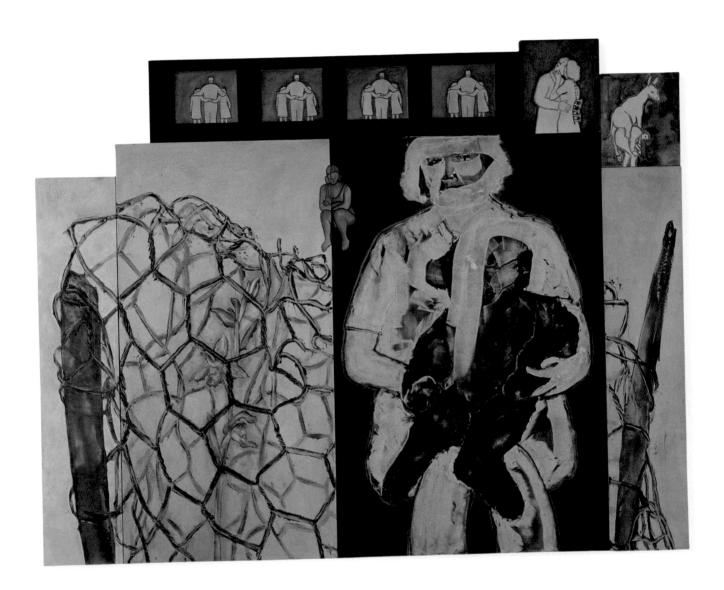

246

succulent/crapulent

1990 > oil on canvas,

7 panels, 88" x 115"

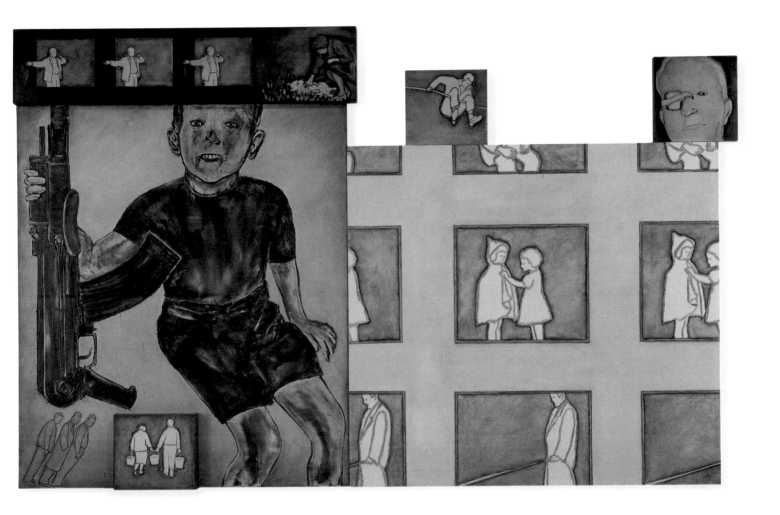

Her paintings repeatedly juxtapose the normal and abnormal, the benign and the sinister; her generic, illustration-based figurative style presents a disarmingly innocuous surface, but her images constantly remind us that even the most normal, happy people harbor painful memories, conflicted emotions and, on occasion, unthinkable thoughts.
R.S.

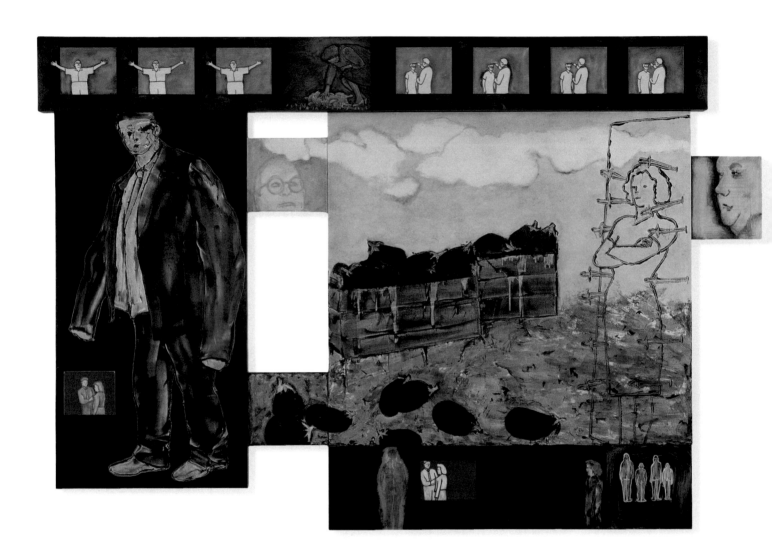

Lohengrin/bacitracin
1990 > oil on canvas.
8 panels, 94" x 141"

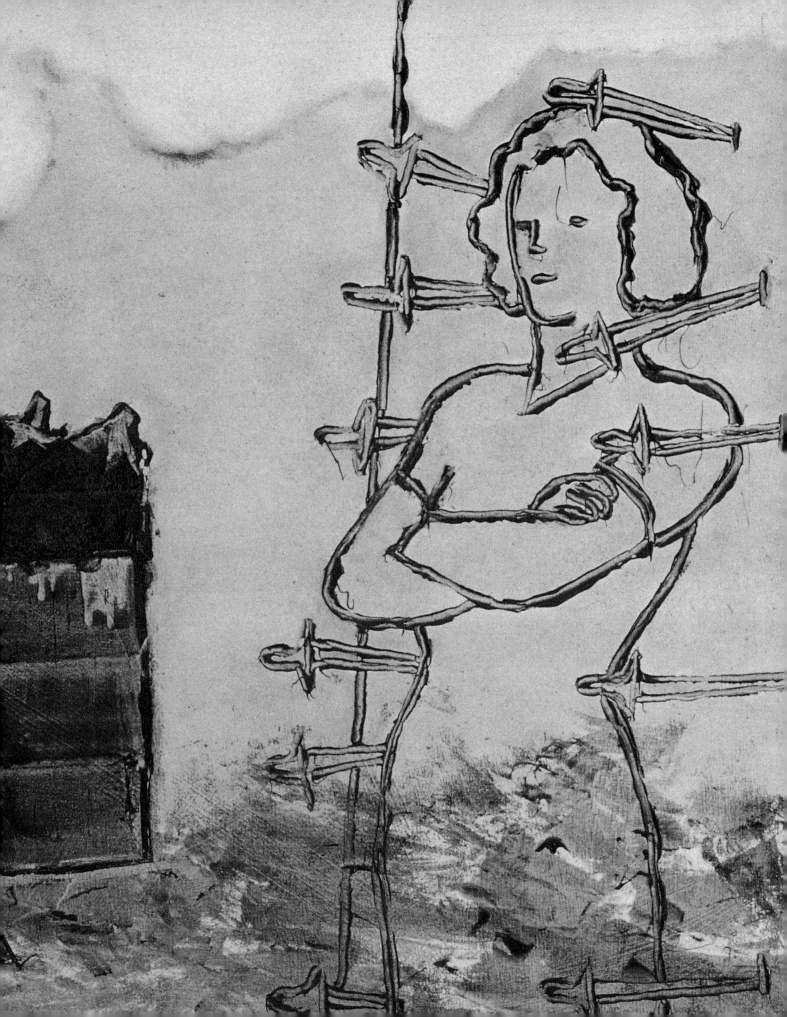

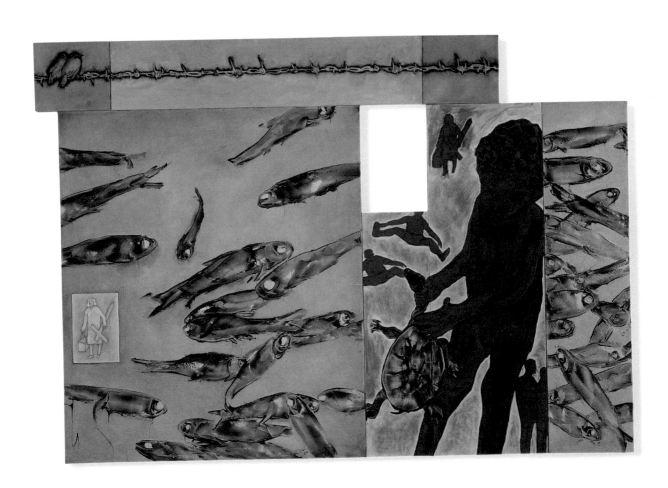

Elsewhere fish agitate while a child strangles a tortoise beneath robins perched on barbed wire. Seasons greetings, eh?
W.F.

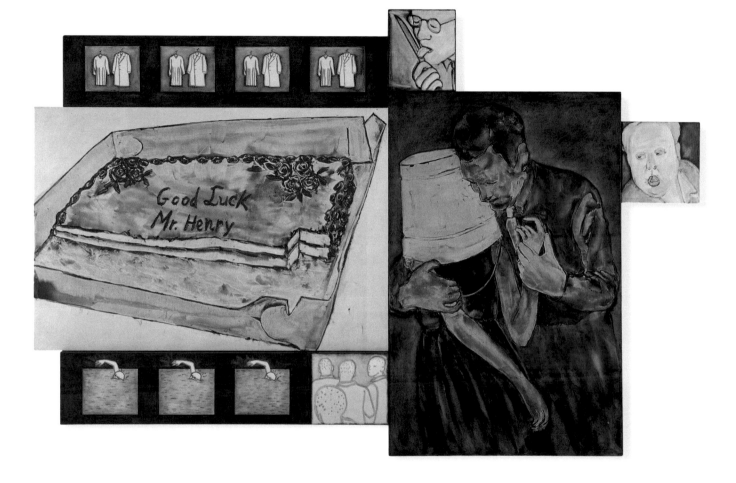

sacrament/flatulent
1991 > oil on canvas,
7 panels, 86" x 120"

circumsize/ostracize
1991 > oil on canvas,
6 panels, 88" x 136"

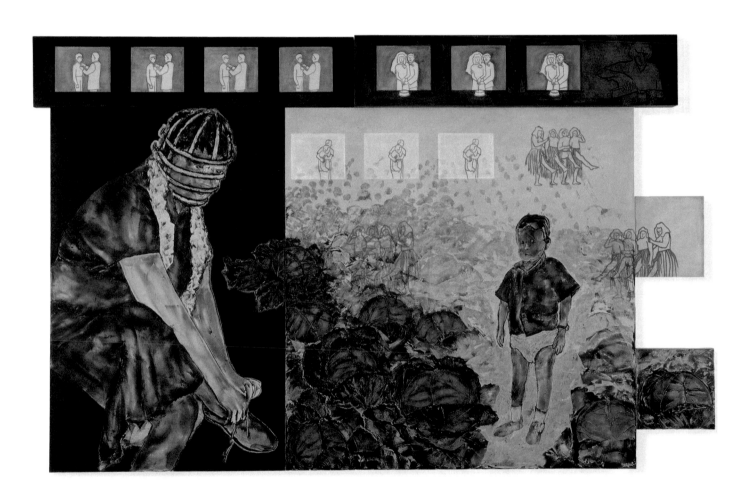

Applebroog fills her work with contradictory information, making sure that nothing is taken at face value. The most mundane event, say a woman rubbing a dog's belly, becomes charged with sexual anxiety. "Reality" is continually reinterpreted as a place where "normality" equals "madness."
E.H.

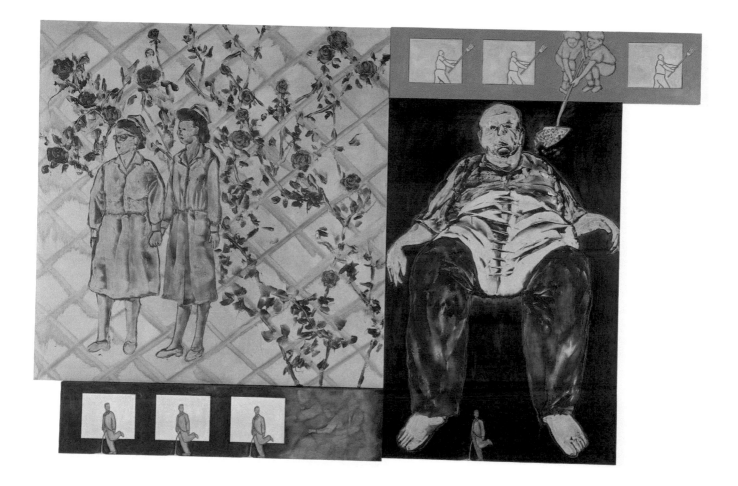

bridal, bridle/spermicidal

1990 > oil on canvas,
6 panels, 86" x 136"

ooze/whose

1991 > oil on canvas,
4 panels, 86" x 136"

Cinderella
is called Tuna
in Finland

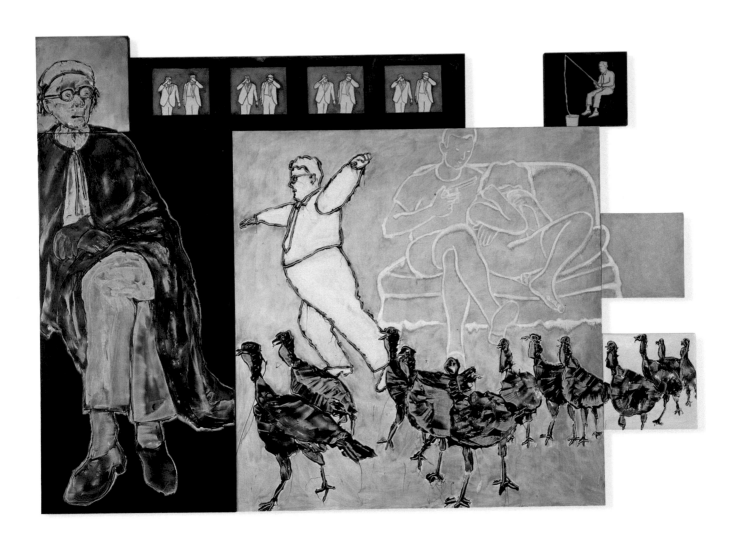

orgiastic/romantic plastic

1990 > oil on canvas,
7 panels, 90" x 128"

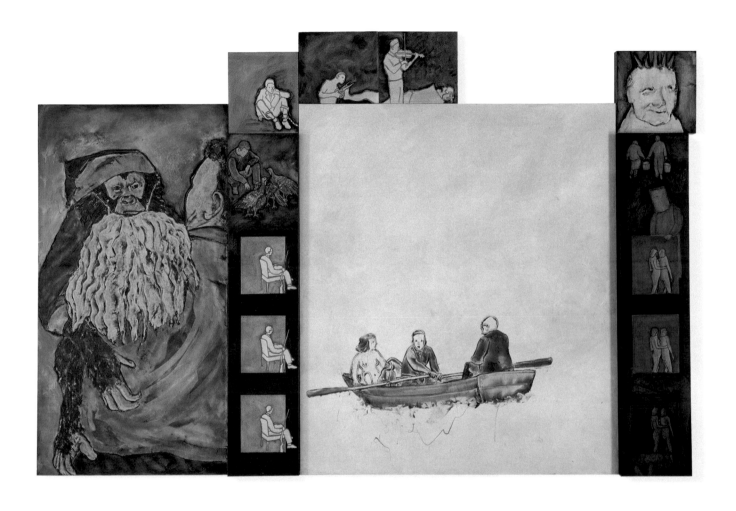

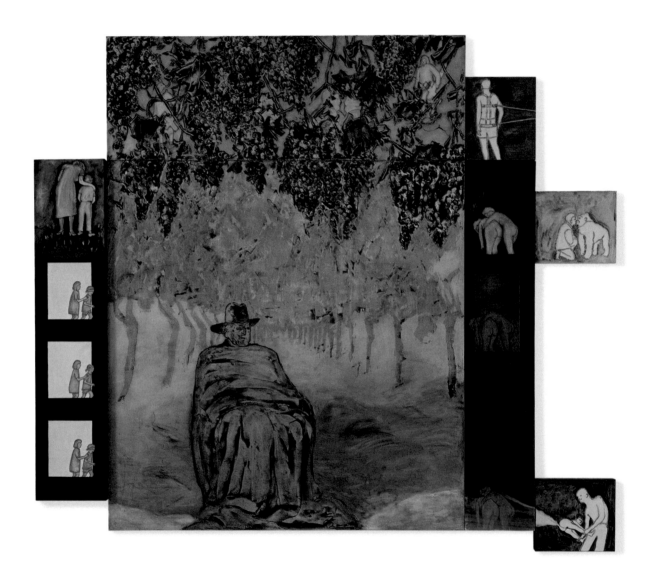

The psychological and physical "displacement" of these paintings, coupled with Applebroog's display of wit, provide a release from painterly tradition and a displacement of behavioral stereotypes through juxtaposition of surrealism and "realism." Applebroog is not erecting constructions of moralism or guilt around the viewer, but allowing a place for the margin to flow into the text and creating visual dialogues incorporating difference. K.F.

pandemic/endemic
1991 > oil on canvas,
7 panels, 96" x 116"

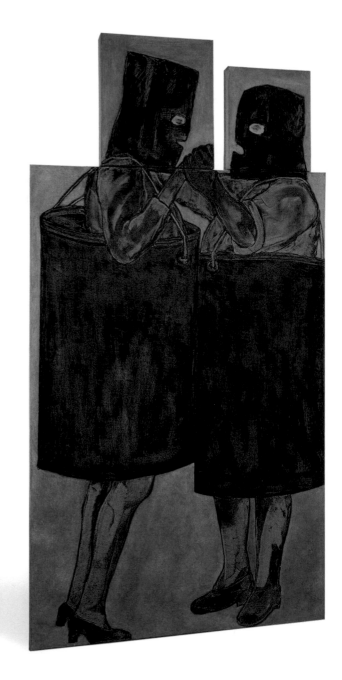

Marginalia (girl with curlers)
1991 > oil on canvas, 38 1/2" x 38" x 3"

Marginalia (dancing pails)
1991 > oil on canvas,
3 panels, 92 1/4" x 48" x 3 1/8"

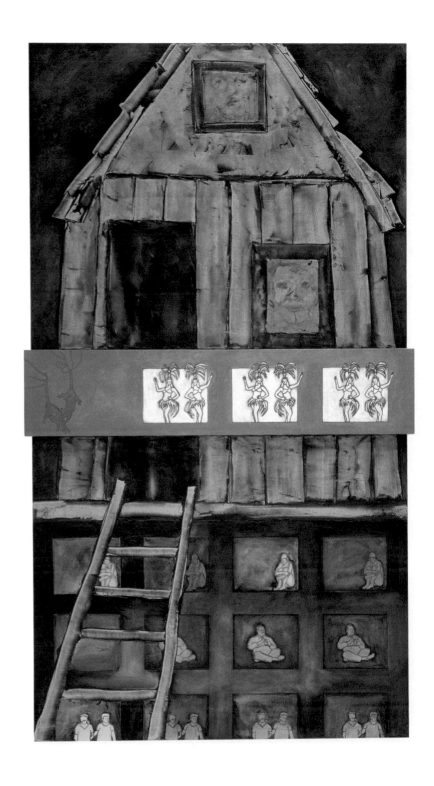

Rapunzel, Rapunzel

1990 > oil on canvas,

3 panels, 114" x 66"

262

Marginalia II (detail: baby)
1991 > oil on canvas

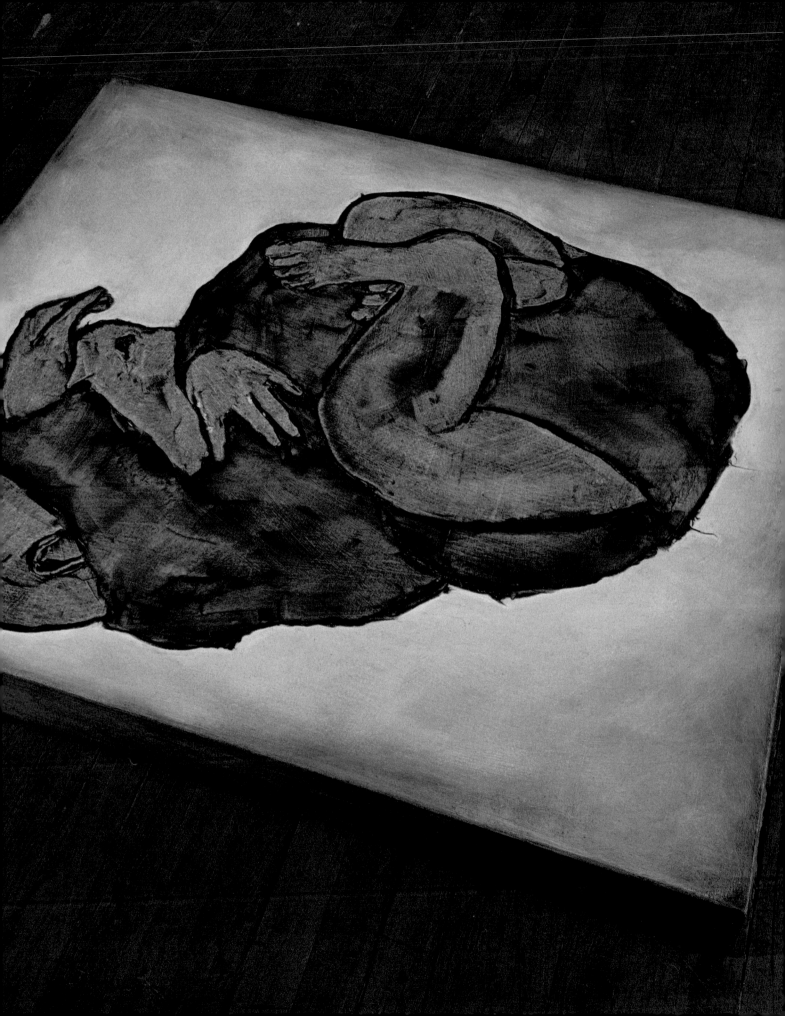

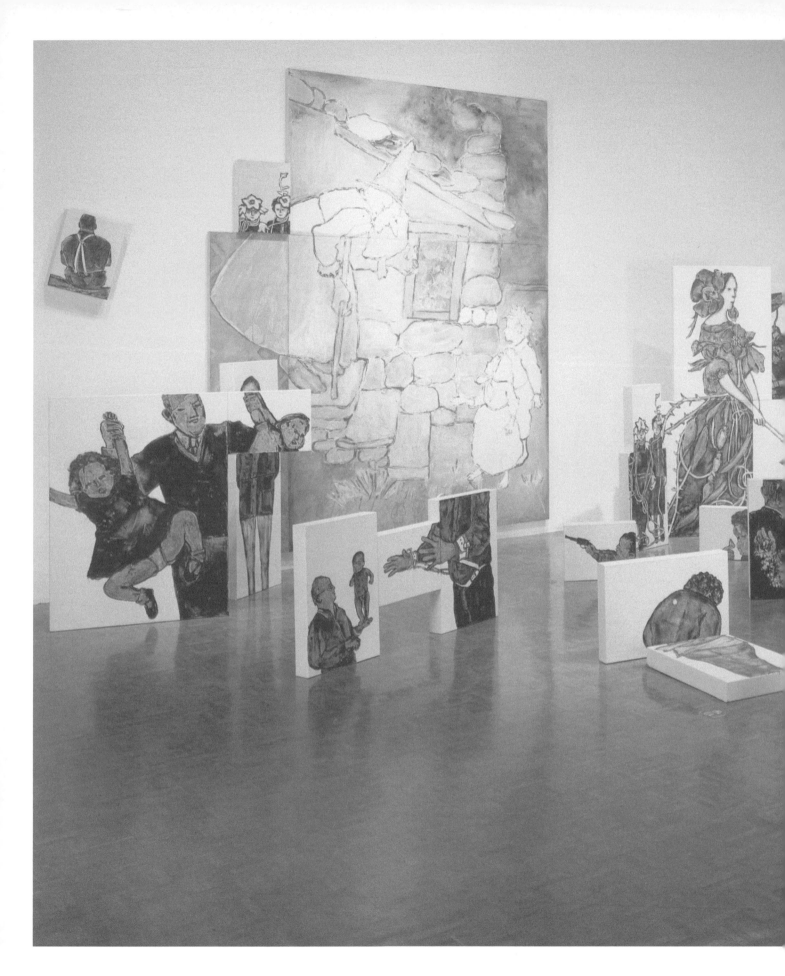

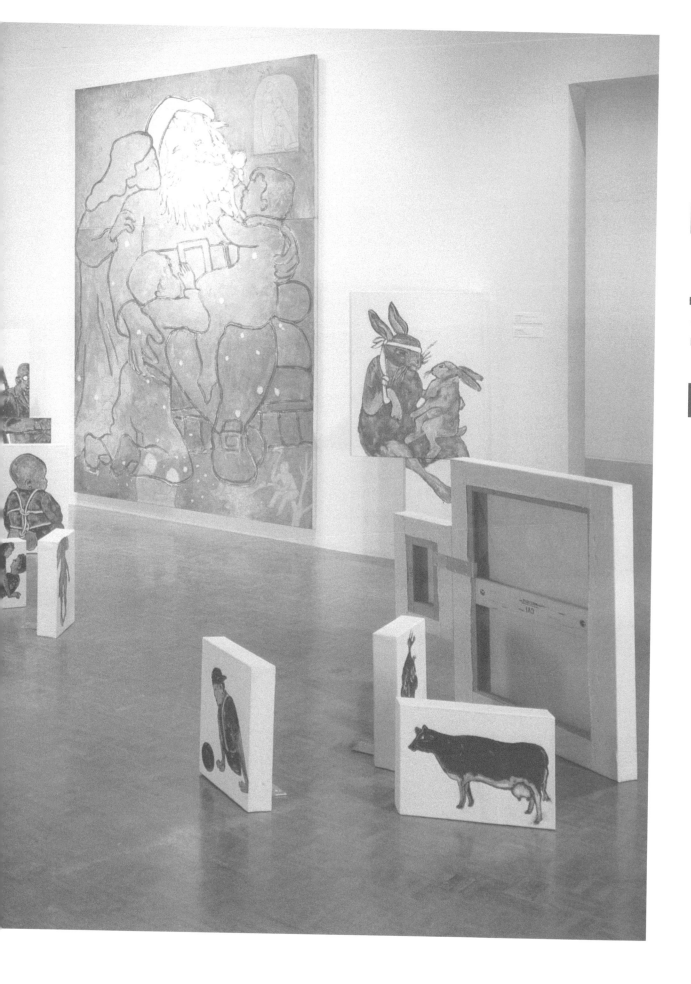

-pull them apart - then reconstruct them - reducing everything into a chaos of possibilities
I.A.

Marginalia (stairs)
1992 > oil on canvas,
3 panels, 96" x 32"

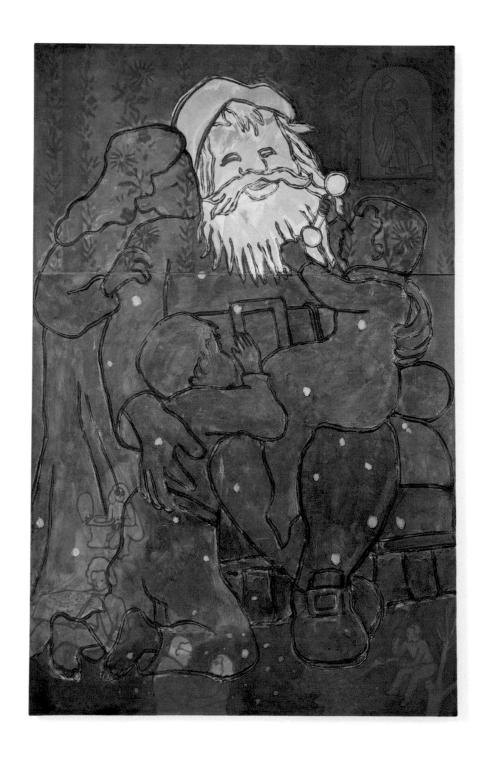

268

Kathy W
1992 > oil on canvas,
2 panels, 110" x 72"

Jack F
1992 > oil on canvas,
4 panels, 110" x 90"

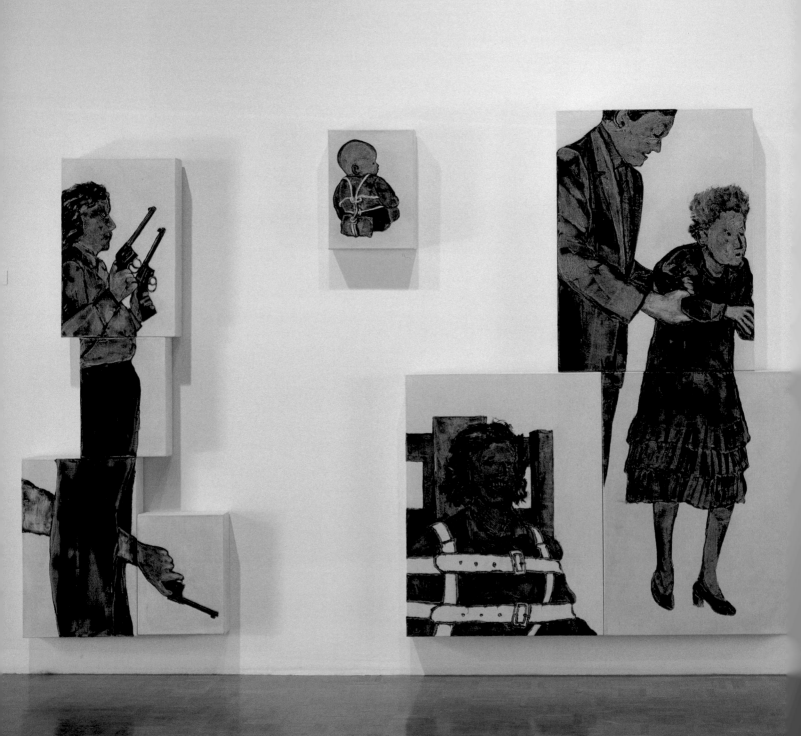

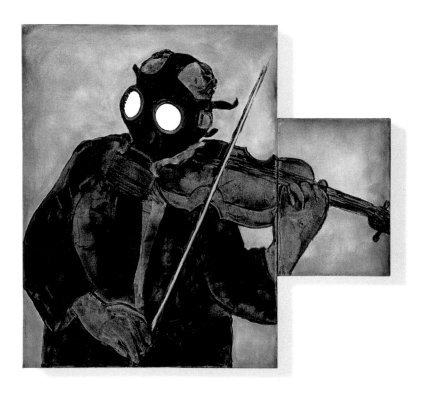

Marginalia (Isaac Stern)
1992 > oil on canvas,
2 panels, 35" x 39"

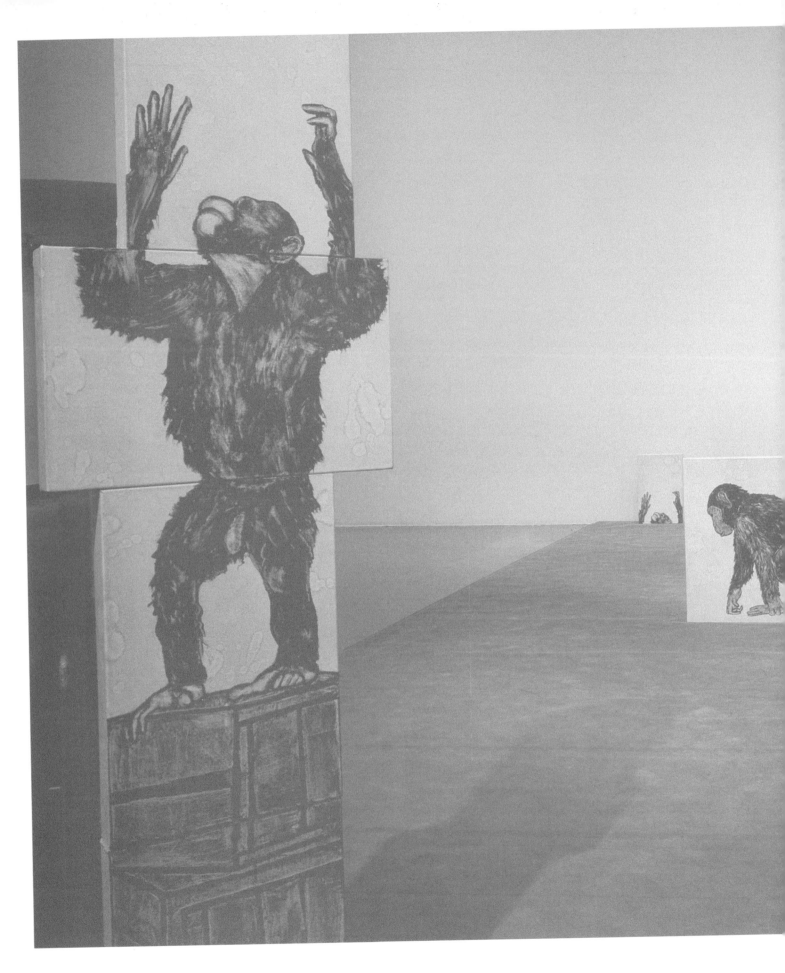

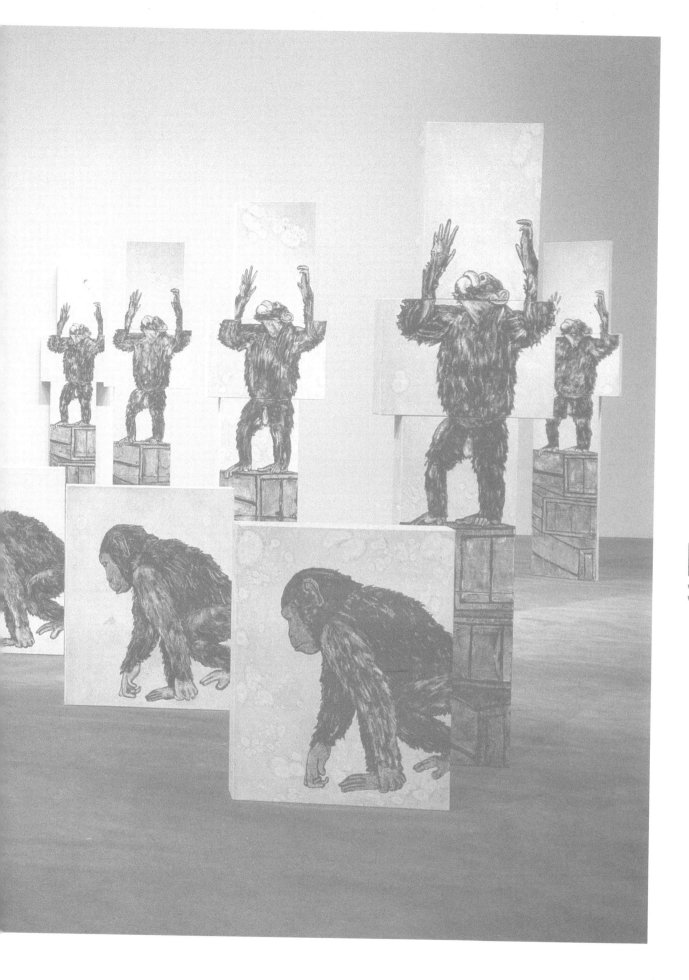

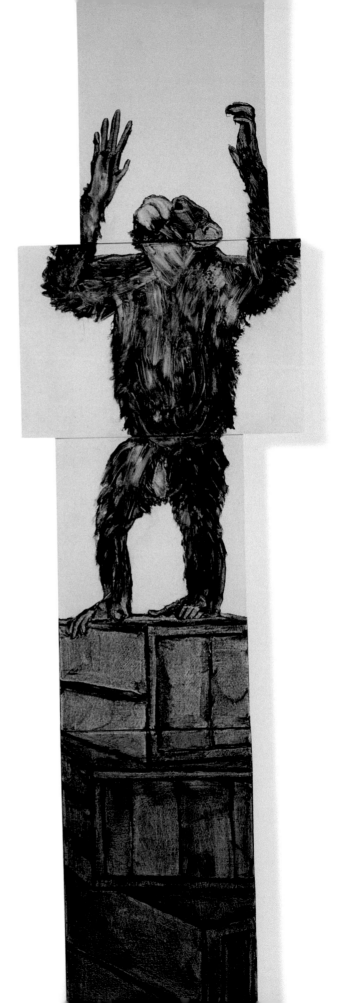

Unlike her earlier work - in which painted components offered a fragmented narrative of multiple scenarios, damaged personalities, incidents, threats, and fears - *Everything is Fine*, 1993, provided a deliberately focused but equally inconclusive narrative. Inspired by Richard Preston's account of a horribly aggressive virus carried by monkeys shipped to the United States for laboratory experiments, Applebroog's paintings depicted these silent, uncomprehending carriers of a menacing new virus.

...

Their abuse as laboratory animals can be read as a metaphor for the dangerous entitlements of power.

...

This work is not a reflexive response, nor is it a plaintive gesture; rather, it transcends obvious sloganeering. In fact, Applebroog makes no appeal at all. In her enigmatic but tenacious representations of violence she simply provides a practiced, skeptical view of the interdependence of contemporary environments.
P.C.P.

Everything is fine (detail)
1990-93 > oil on canvas

Yesterday
when I was crazy
I think I did
something
I didn't do

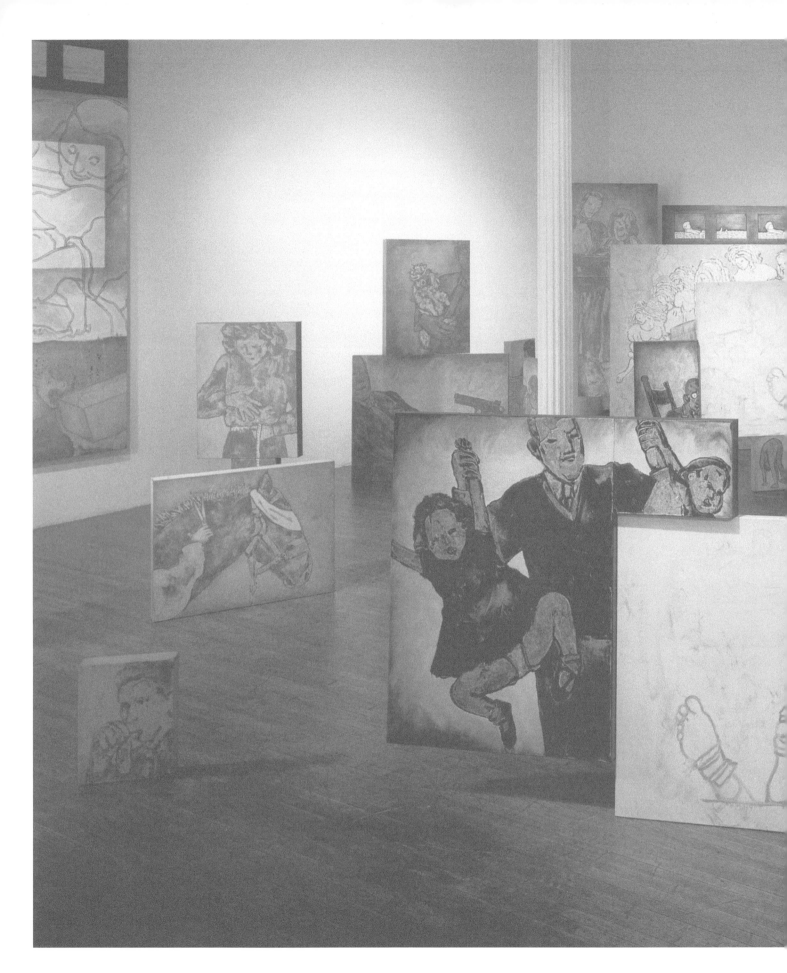

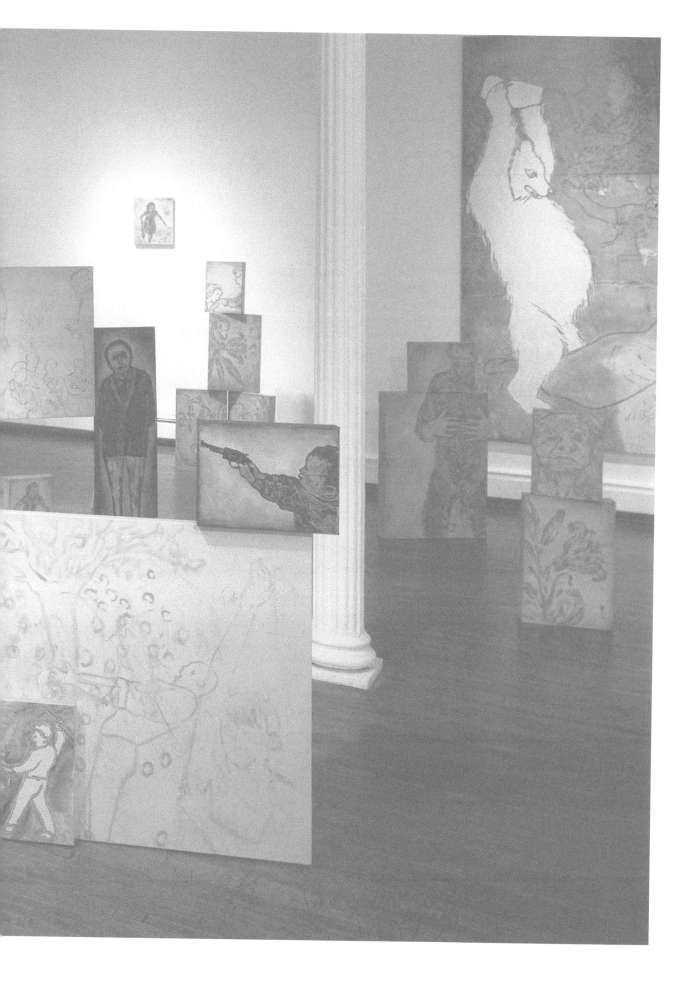

When you read a narrative, you usually read from left to right; there's a beginning, a middle, and an end. Mine only have middles: you walk into the middle of something. It has a montage effect. Think of it as filmic sequences, where they're behind one another, next to one another, hiding other things. You have to physically walk through the pieces to figure out what the story is or isn't. It's always your story: it's never my story, it's never someone else's story. You come with the content in your own head and do a Rorschach kind of association, so whatever it is that you're looking at is a do-it-yourself projective test. But it's also a chaos of nameless possibilities. You have to fill in the beginning, then you have to physically walk through and try to put together what those possibilities are. It's a lot of work that I'm asking of the viewer.

…

What I like about the work I'm doing now is that you get what you see. I don't try and hide the stretchers or the canvas, the writing in the back, or whatever. As you walk around, you see the guts of the piece. I'm not using the wall to hide the back structure. It's like living in the studio with a full body of work: some are down, some are up, and some are leaning against the others. It feels alive. From whatever position you enter into that space - you always have a sense of the front, the back or the side, and then each piece positions itself against something else. So, depending upon where the viewer is standing, the work can tell entirely different stories.

I.A.

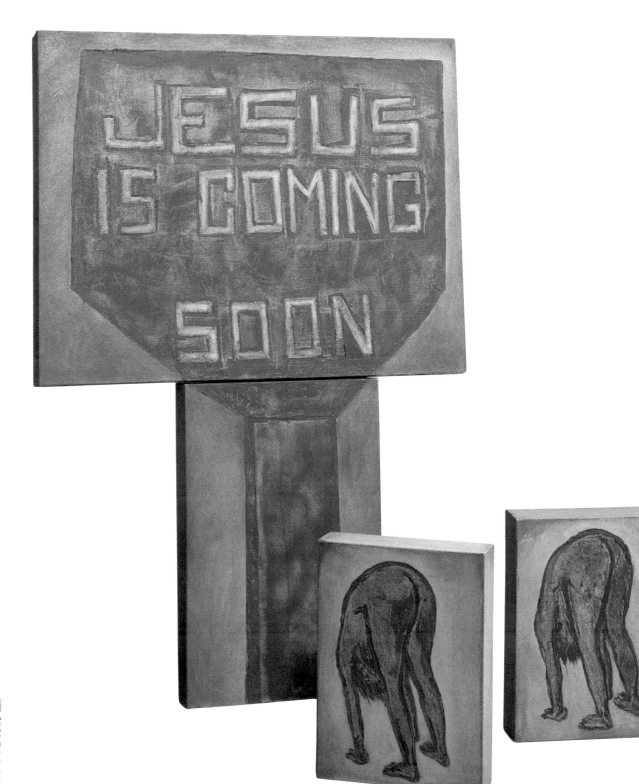

Marginalia (Jesus is coming)

1993 > oil on canvas, 4 panels,

Jesus is coming: 52" x 35" x 3 1/2"

Bend over 1 and 2: 16" x 12" x 3 1/2" each

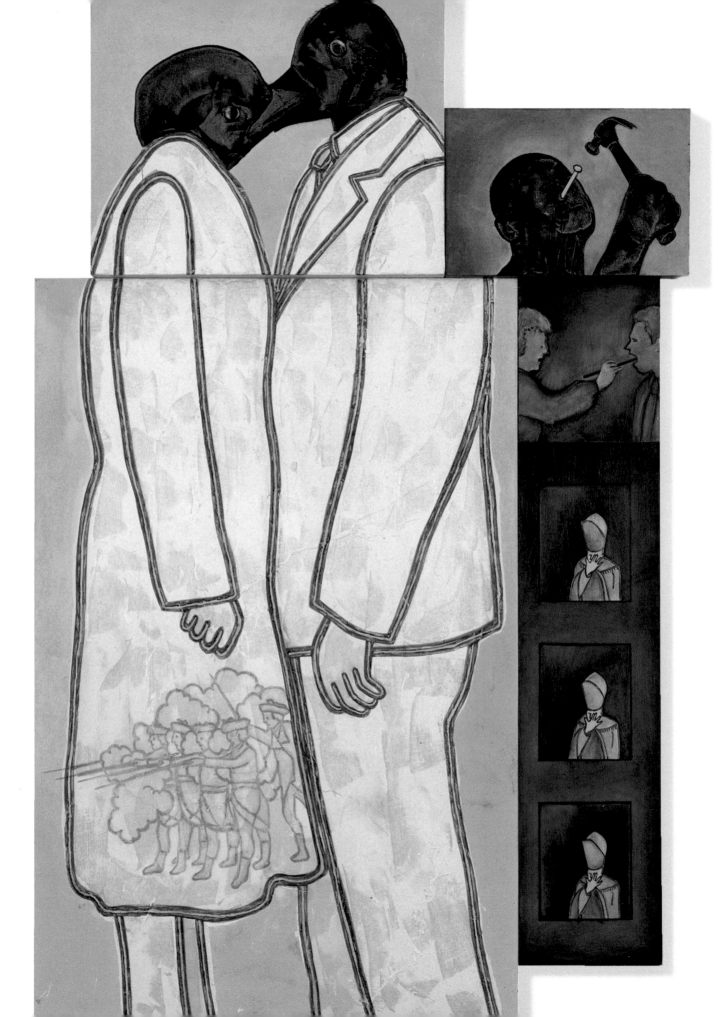

I'm rubber, you're glue
1993 > oil on canvas,
4 panels, 99" x 65"

Fatty fatty two by four I
1993 > oil on canvas,
2 panels, 72" x 34"

Baby baby suck your thumb
1994 > oil on canvas,
5 panels, 88" x 104"

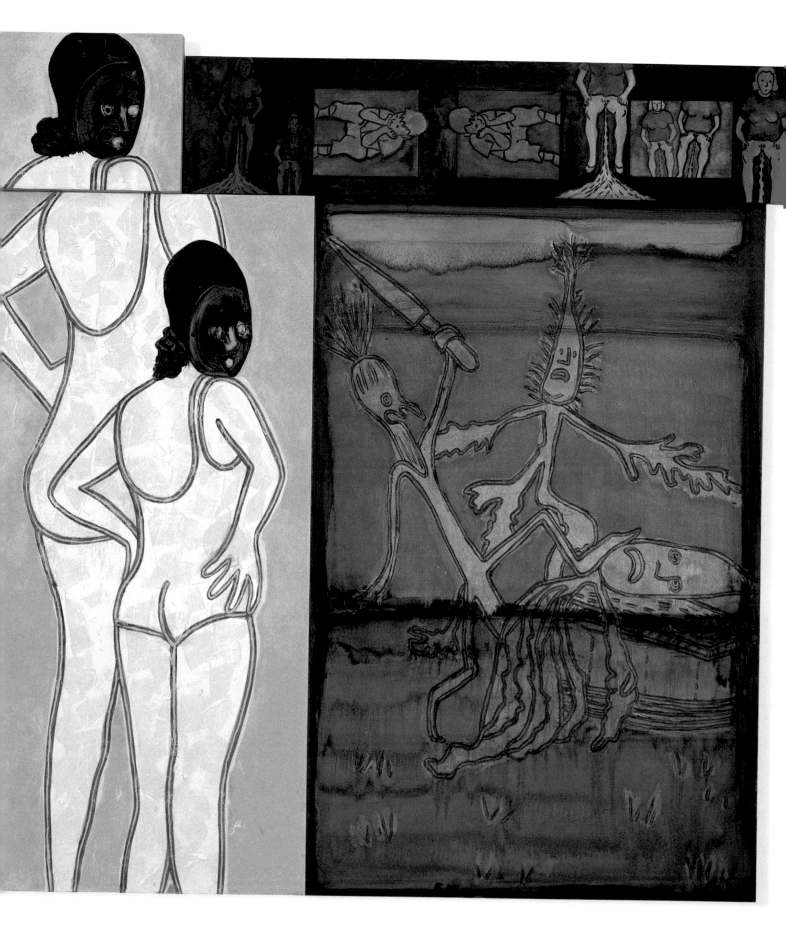

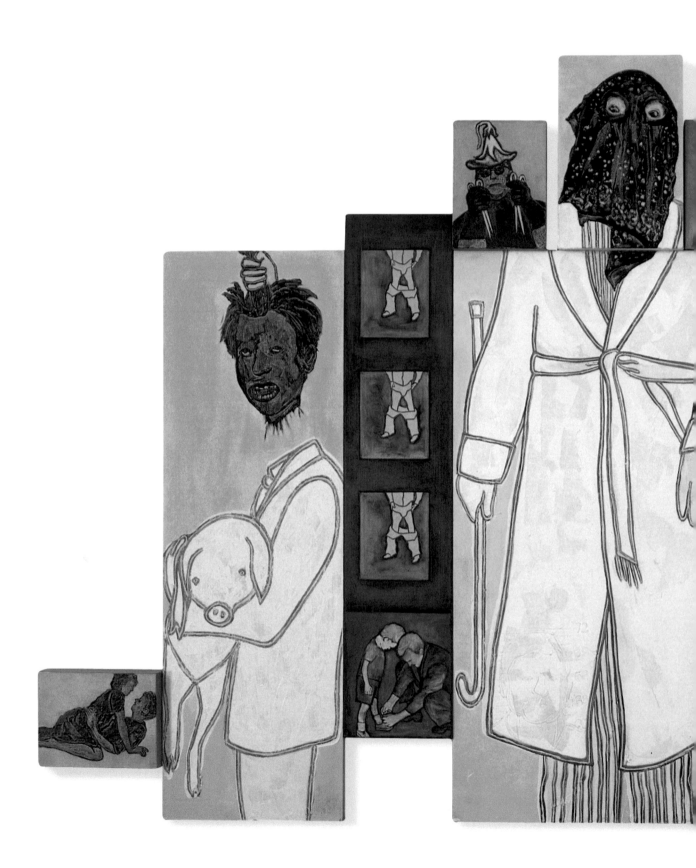

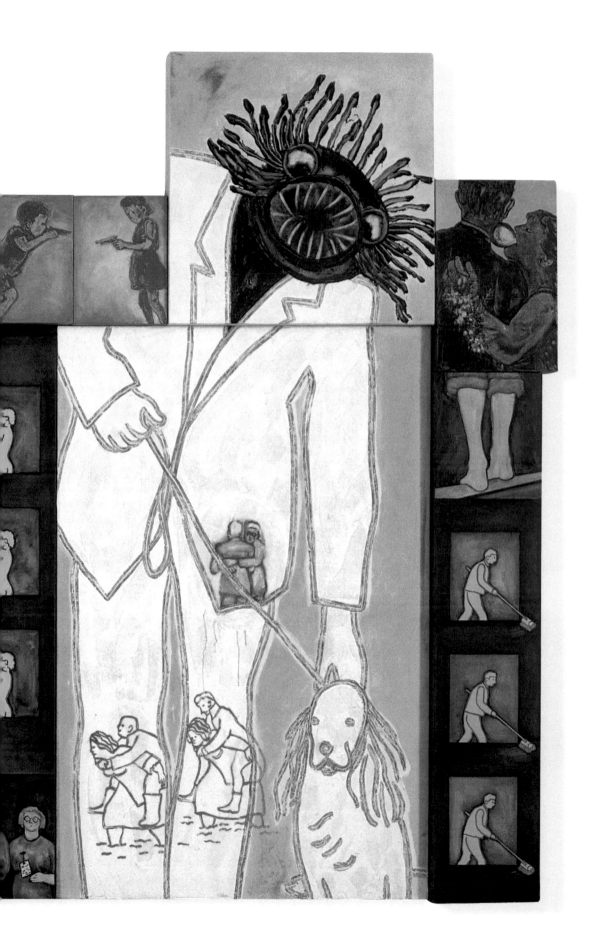

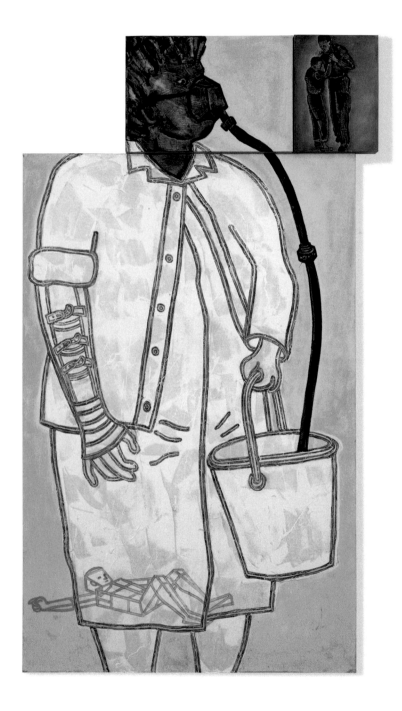

B, my name is Betty
1994 > oil on canvas,
3 panels, 88" x 51"

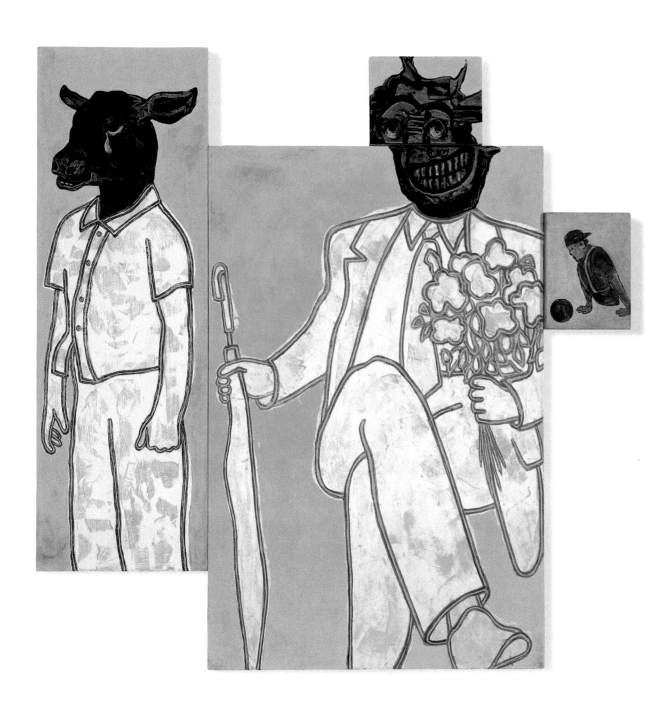

Winnie's Pooh
1994 > oil on canvas,
4 panels, 86" x 84"

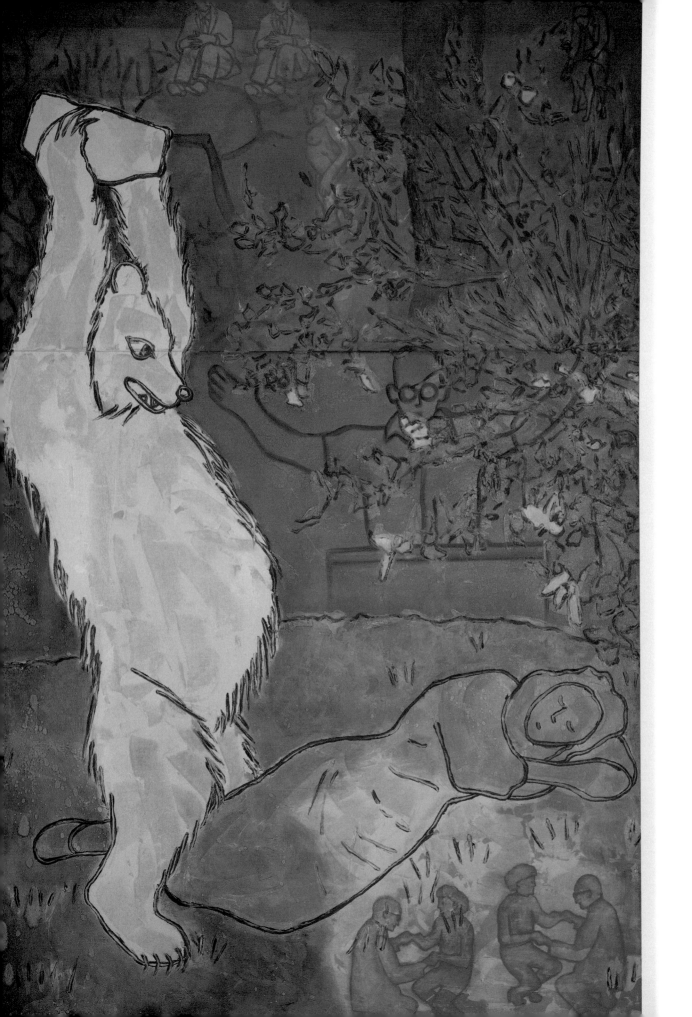

Mother mother I am ill

1993 > oil on canvas,

2 panels, 110" x 72"

Tra la la boom de-ay

1994 > oil on canvas

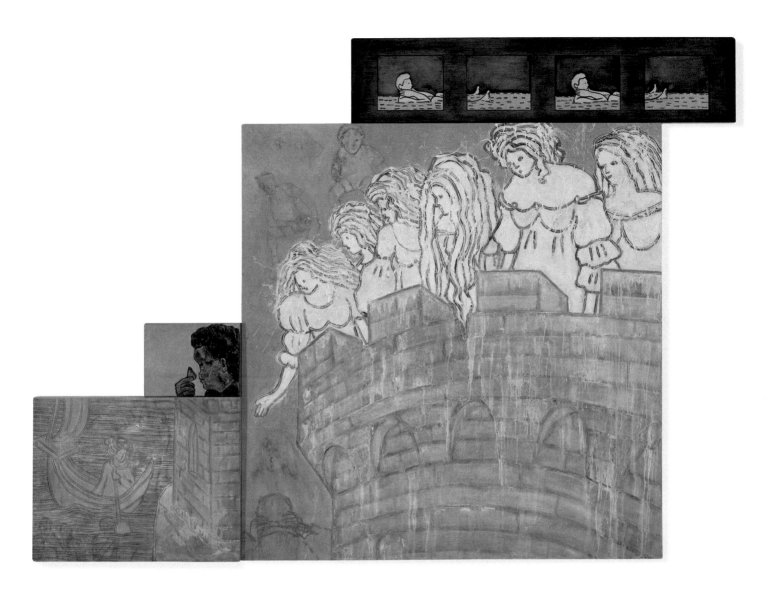

The solitary fairy tale figures conjured up in her later paintings - silhouettes outlined, isolated figures, generic baddies and your common bystanders - are borrowed from children's stories whose not-so-hidden agendas of violence have yet to be mapped out; for one wonders why so many of them develop strong and definitive scenarios of intentional cruelty.

This hard-core material is one of the implicit sources Applebroog uses to reveal certain mechanisms of human aberration. This kind of violence, often considered a "normal and harmless" facet of human relations, is restricted, in her work, to the naïve display of elementary creatures.

The furtive appearance of small shapes, familiar and animal, and that they continuously get caught in our field of vision, suggest a repetitive alphabet, a corporeal vocabulary seen and remembered, a simplified syntax of representative idiosyncrasies, some banal, others eloquently not so: small gestures (a stiff knee, a lax hand), plump curves, probable body hair, a bared belly's idiotic smile over black pants, snot drip and saliva drops climbing down the sleeper's breast.

Her protagonists' features are merely outlined, rarely detailed. She uses abstraction deliberately, to prevent the ready identification of a personality disorder. We see the monster, and we detect its soft side; we are made to attend its deliberate display (this is a show); and now we see its deformed way of being. The faces it is making encompass an event represented in a frozen state of latency: fat small limbs reach out to chop, blades meet throats, stones overhang; we look at it, those people hating and using one another.

This is violence in its infancy: we suspect, we guess, we project.

D.B.

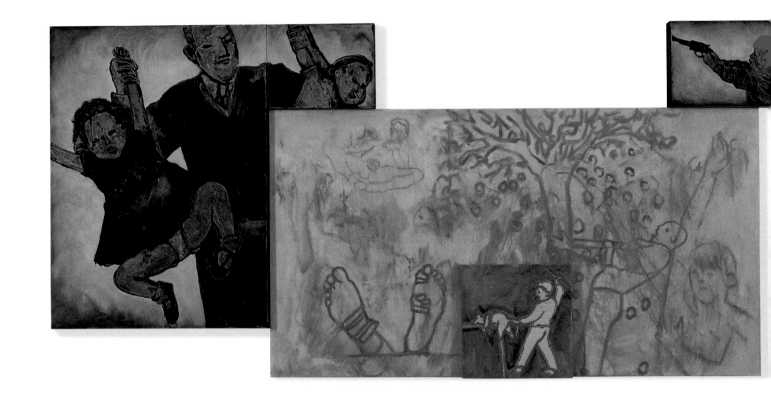

Three potato, four
1994 > oil on canvas,
5 panels, 50" x 107"

One potato, two potato
1994 > oil on canvas,
6 panels, 63 1/2" x 104"

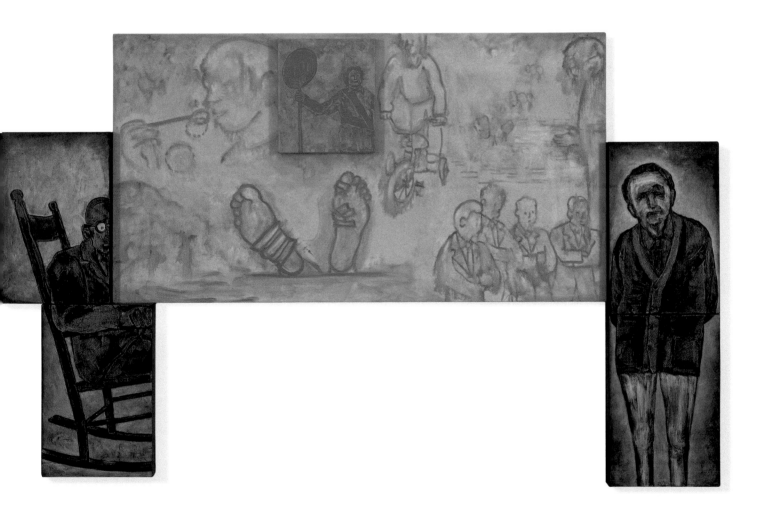

What are you up to, Uncle?

You silly girl
you don't know how nice it is

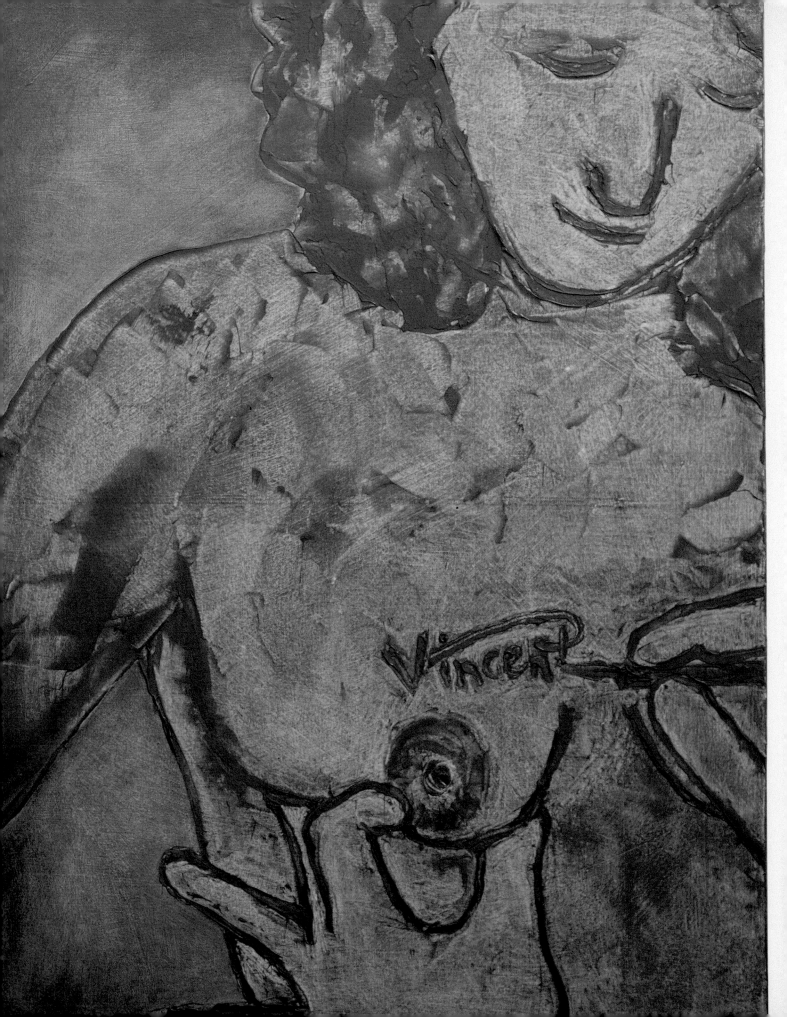

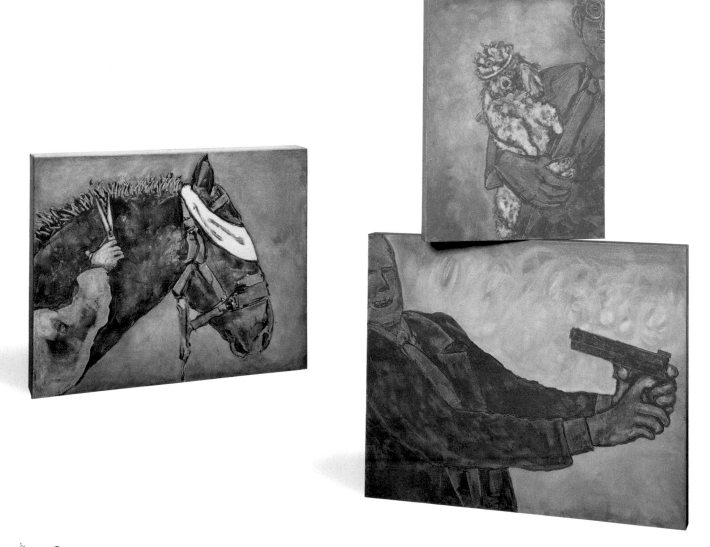

Marginalia (horse)
1993 > oil on canvas, 27" x 35" x 3 1/2"

Marginalia (dog with hat)
1994 > oil on canvas,
2 panels, 73" x 48" x 3 1/2"

1993 > oil on canvas, 35" x 27" x 3 1/2"

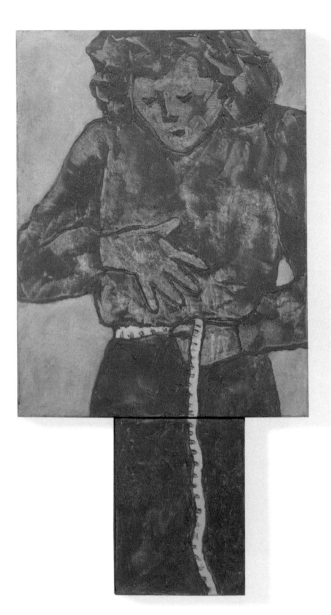

**Marginalia
(woman measuring waist)**
1994 > oil on canvas,
2 panels, 51" x 27" x 3 1/2"

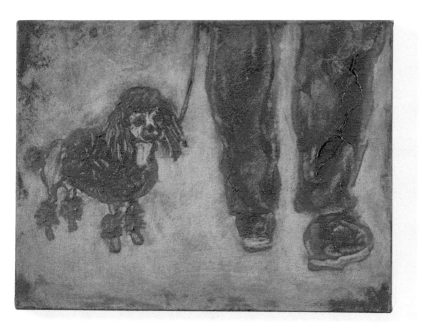

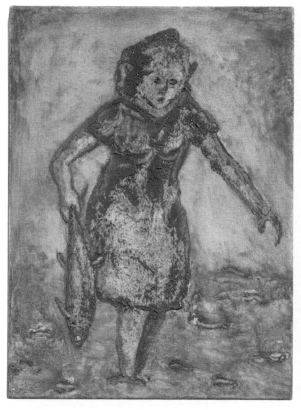

Marginalia (poodle)
1994 > oil on canvas, 12" x 16" x 3 1/2"

Marginalia (woman holding fish)
1994 > oil on canvas, 16" x 12" x 3 1/2"

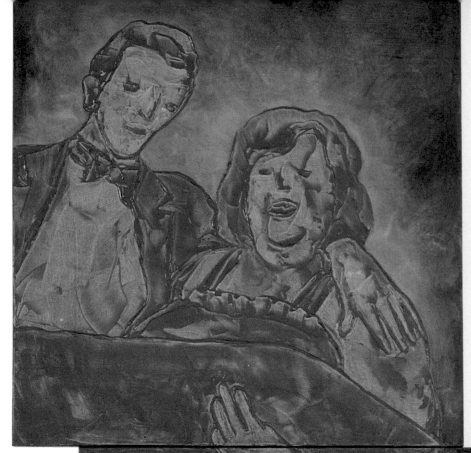

Marginalia (fat lady and living skeleton)

1994 > oil on canvas,
3 panels, 58" x 86" x 3 1/2"

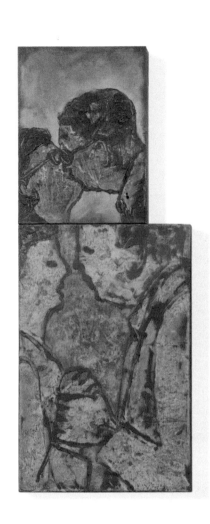

Marginalia (two couples)

1994 > oil on canvas,
2 panels, 40" x 16" x 3 1/2"

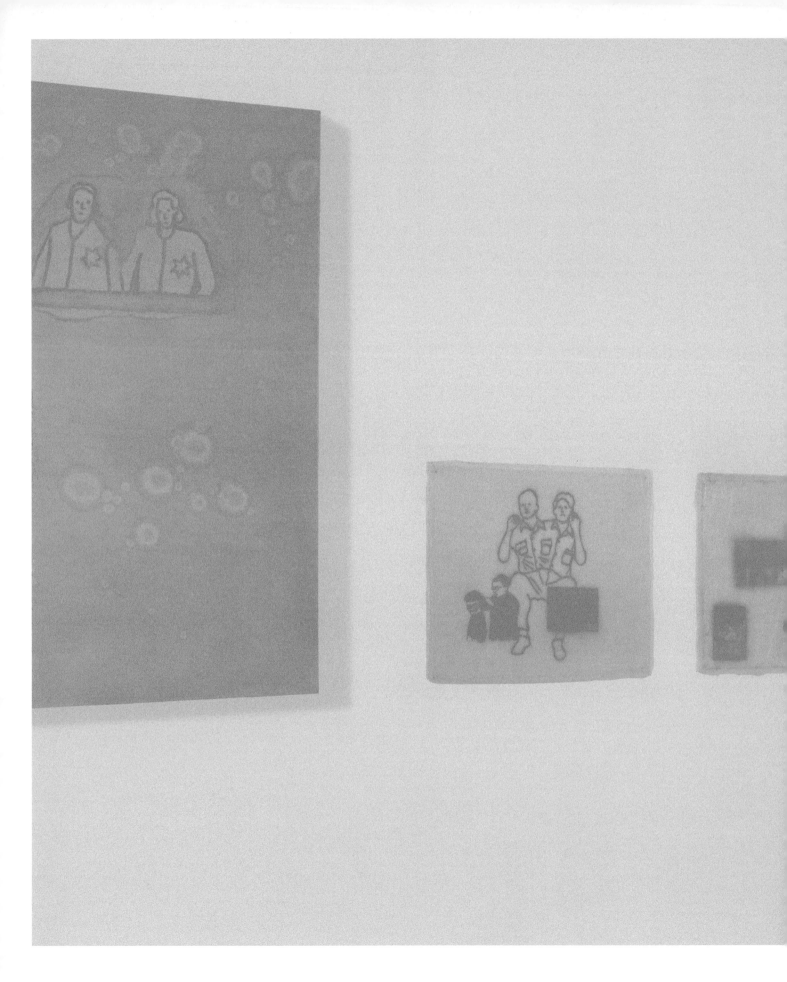

Prurient Interests

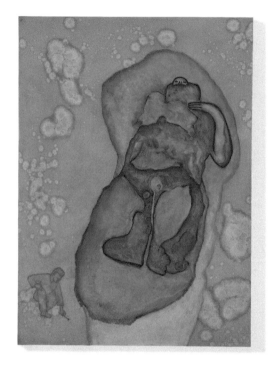

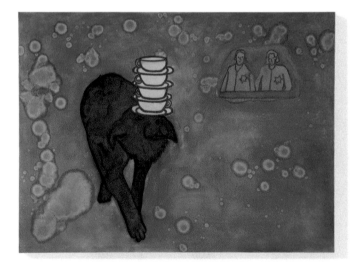

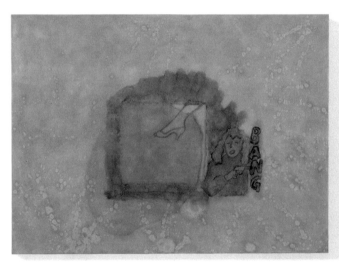

I'm a good-hearted racist (top)
1996 > oil on canvas, 35" x 48"

History marches on (bottom)
1996 > oil on canvas, 35" x 48"

Things change (top)
1996 > oil on canvas, 48" x 35"

I'm woman of the year (bottom)
1996 > oil on canvas, 35" x 48"

Still Nothing?
1996 > oil on canvas, 35" x 48"

I used to be bored
1996 > oil on canvas, 35" x 48"

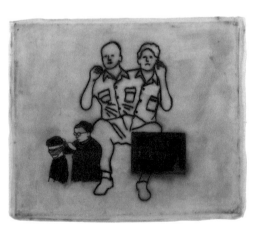

Untitled (Siamese twins)
1995 > ink on vellum, 14 3/4" x 17 1/2"

Untitled (woman stripping) top
1996 > ink on vellum, 14 3/4" x 18"

Untitled (nurse) bottom
1995 > ink on vellum, 14 3/4" x 22 3/4"

Untitled (stitched mouth)
1995 > ink on vellum, 22" x 17 1/2"

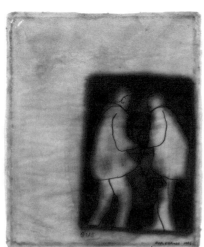
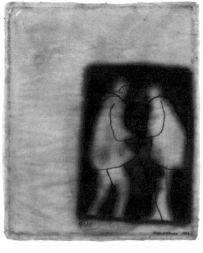

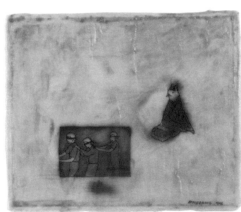

Untitled (bald man with glasses) top
1996 > ink on vellum, 17 3/4" x 14 3/4"

Yes, you can (bottom)
1996 > ink on vellum, 14" x 18"

Untitled (Gus) top
1996 > ink on vellum, 17 1/2" x 14 1/2"

Untitled (bird)
1996 > ink on vellum, 14 1/2" x 17 1/2"

Untitled (couple kissing) bottom
1996 > ink on vellum, 14 3/4" x 17 1/2"

Untitled (couple dancing) top
1996 > ink on vellum, 17 1/2" x 14 3/4"

Untitled (man squatting) bottom
1996 > ink on vellum, 14 1/2" x 17 1/2"

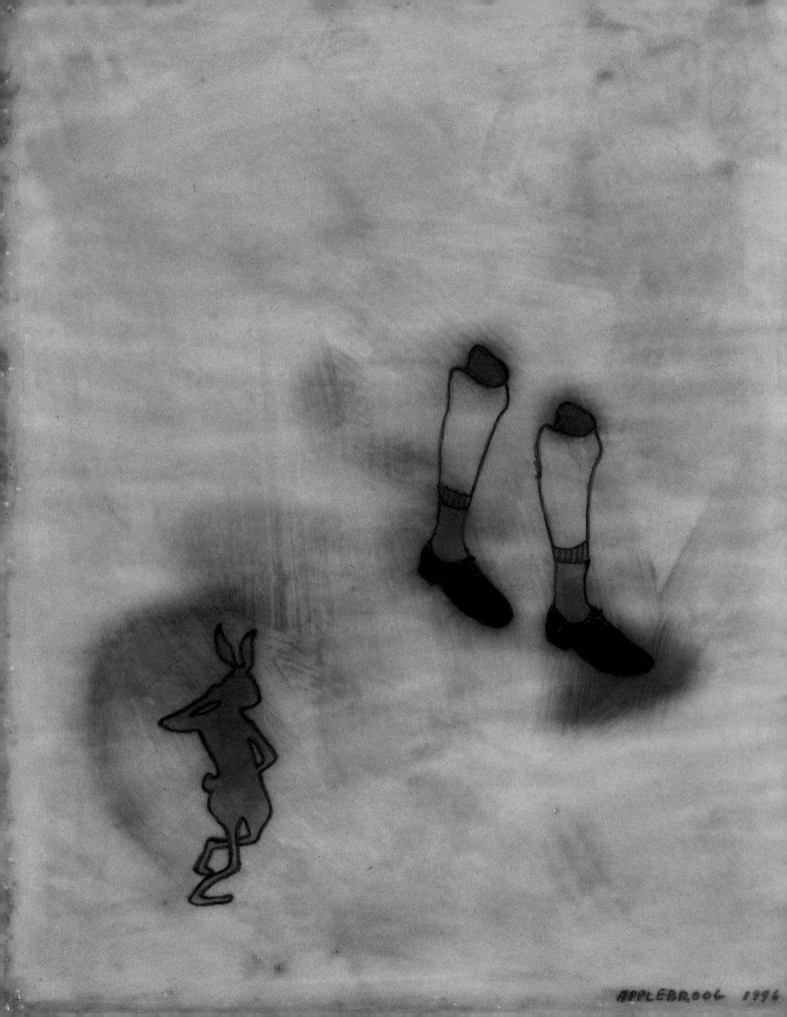

APPLEBROOG 1996

-don't always think in sentences
I.A.

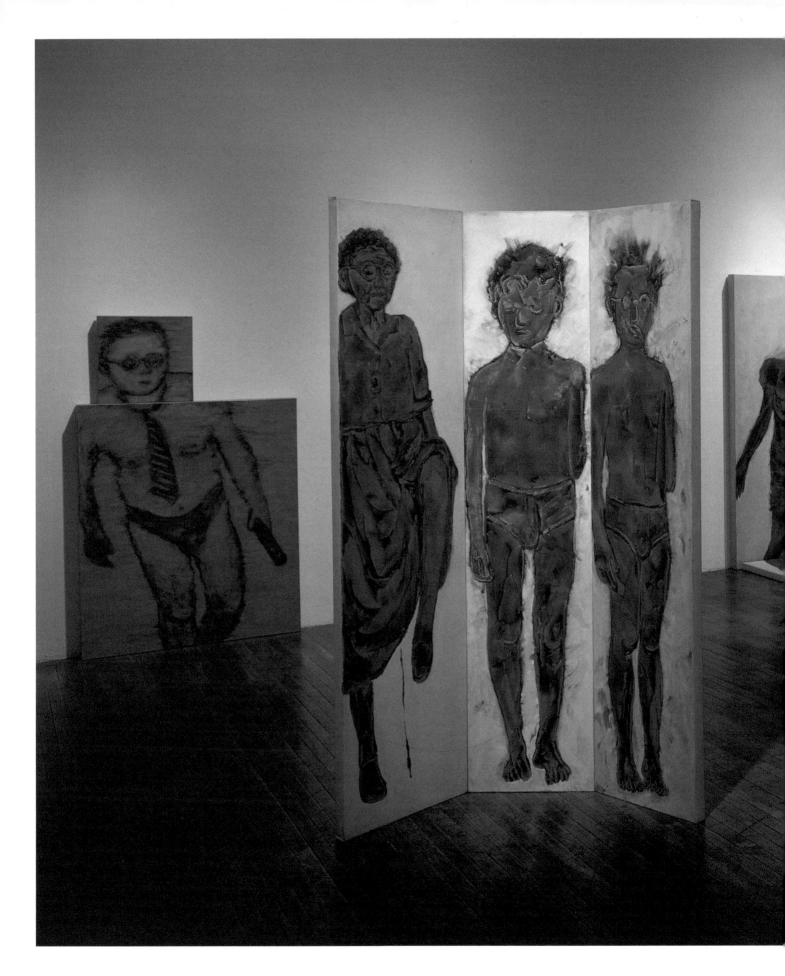

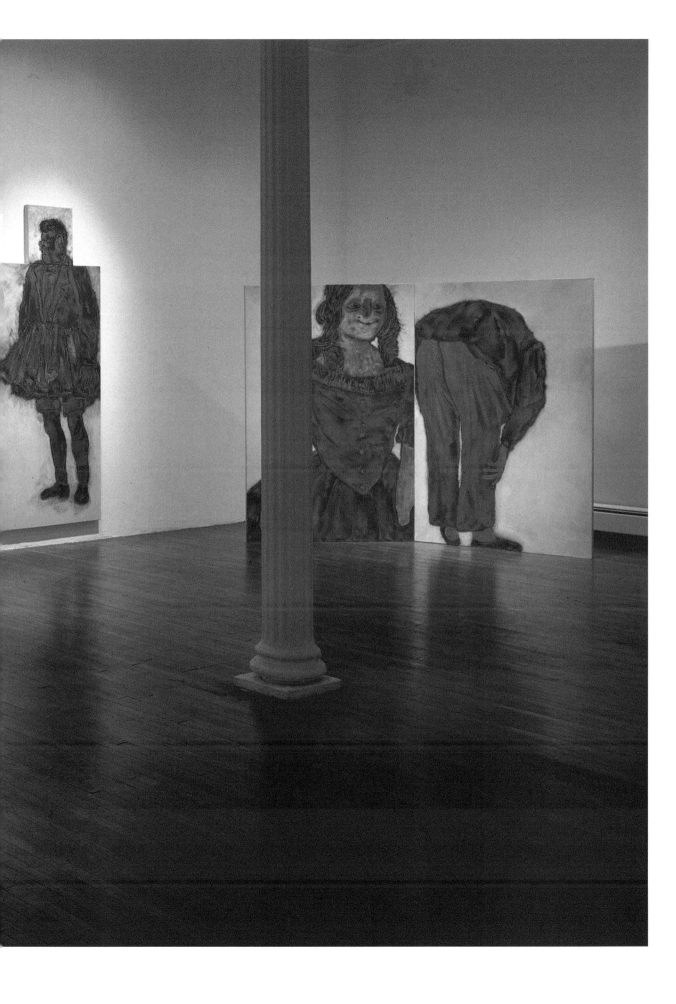

In television specials, newspaper articles, and most explicitly in her monthly magazine *Martha Stewart: Living*, the quintessential 1990's lifestyle maven Martha Stewart outlines the hyperbolic, retrograde domesticity of the have-it-all "perfectwoman" in excruciating detail. In her own *Living* series (1994-96), Applebroog replaces Stewart's calendar with what she dryly refers to as "schizoid notations", taking on this return to gentility with a lucid and sardonic humor as she asks, "How could we have gone through thirty years of progress and then totally succumb to this 1990's yearning nostalgia for the typical 1950's home style?"
T.S.

By confronting us with these characters who are simply *standing there*, Applebroog finds herself using a formal and conceptual repertoire usually associated with photography: the presentation of mute "social" situations suffused with latent ambiguity. And her work is all the more effective, as she avoids the ready clichés of violence-in-print; hers is an art of subtle abnormality.

It brings to memory a personal anecdote: When John Paul II went on his South American trip, when he was greeted as the santo padre, and cheered by thousands of fervent faithfuls, he accepted the prosternation of Argentina's military. And I remember seeing a black painting on a whitewashed wall, in an old street of Buenos Aires. It showed John Paul laying a forgiving hand on a soldier's cap, whose kneeling body, below, was merely suggested. Both figures were identifiable, the Holy Father especially. His features had been executed by the deft hand of an anonymous painter who had rendered perfectly, with the slight twist of a line, the left profile of his Pope, with an incomparably exact, buddha-like, miniature smile. A caption below, in thick lines made to mimic typed fonts, in small regular letters like a minute helvetica, read: "I came to bless the torturers, the rapists."

This depiction of banal and intrusive figures, on a stage where the only indication of action is the presence of pervasive bodies on a background without depth, tallies perfectly with an old painterly practice which shows, but not always defines, what proceeds from the abject. In some Italian city states, during the early renaissance,

it was customary to hang above the city gates, or at crossroads, the portrait of an infamous offender, after he had been judged or condemned *in absentia*. The culprit would be shown stealing, or lying, wearing recognizable garb, engaged in "telling" activities (he speaks to his clients, he steals with stealth, he feigns pious devotion to the Virgin or respect to civic institutions, he dresses well, he looks at us). If resemblance mattered, then one would request the services of a master-painter, whose fees were proportional to the number of revealing details, and to their degree of realism.

One assumes that the public appreciated these *pictura infamata* all the more, as they were executed by a celebrated artist whose repertoire they disparaged. We know Botticelli's Venuses, the angelotti, the virgins playing music and the allegories of Virtue; we don't know his criminals, his thieves, his whores, his heretics and double-dealing hypocrites, and yet, we are told he also painted them. It is understandable: the fate of these paintings often followed that of their "sitters": hung here and there, they would suffer public disgrace (here the flame, there the vengeful spit or the rotten egg).

In Applebroog's work, the effect seems reversed: the target is not clear, for her silent stages have many lodgers. Some are smiling sincerely, some are normal, many are not. Chances of escaping this breeding lot are small: they are too numerous, they pop-up everywhere, they vie for existence, and the infamy consists of the fact that we inhabit this space with them, this "normal" space.
D.B.

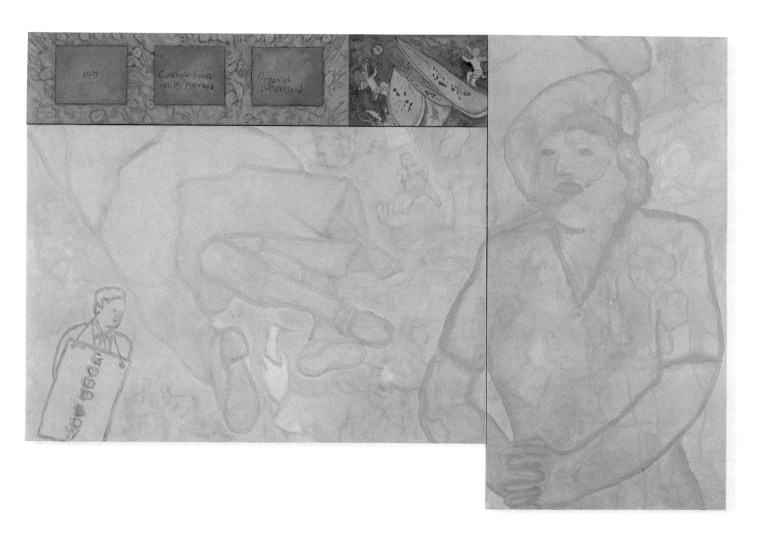

1944

1995-96 > oil on canvas,

3 panels, 72" x 110"

january

6

Plan cure
for ugliness

13

Restore
Mama's coffin

january

20

Design aprons
for nuthouse

27

Benefit dinner
for homeless
scrotum

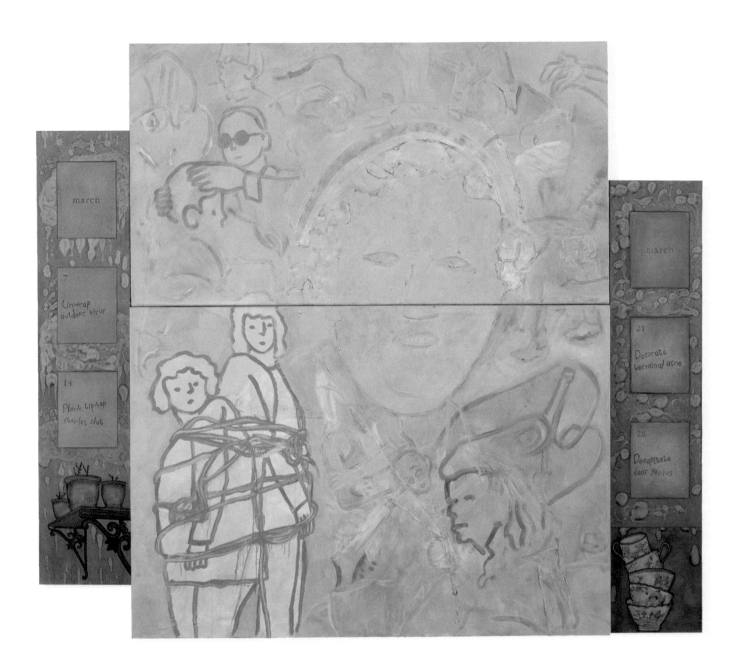

march

7

Unwrap
outdoor virus

14

Plant tip-top
scarlet slut

march

21

Decorate
terminal acne

28

Decapitate
dear genius

1948
1994-96 > oil on canvas,
4 panels, 86" x 100"

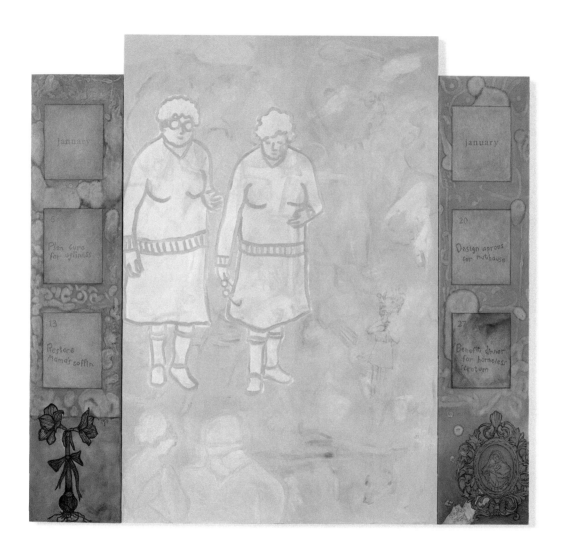

1956
1995-96 > oil on canvas,
3 panels, 72" x 76"

detail pp. 314-15

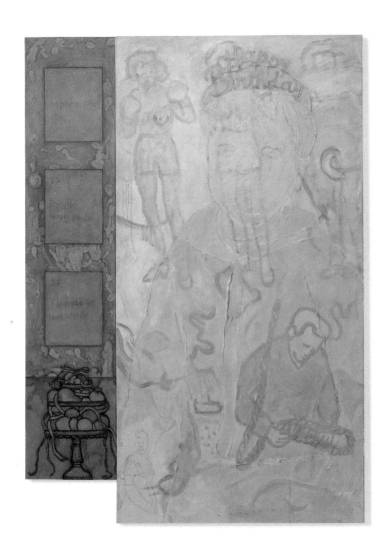

1969
1995-96 > oil on canvas,
2 panels, 72" x 52"

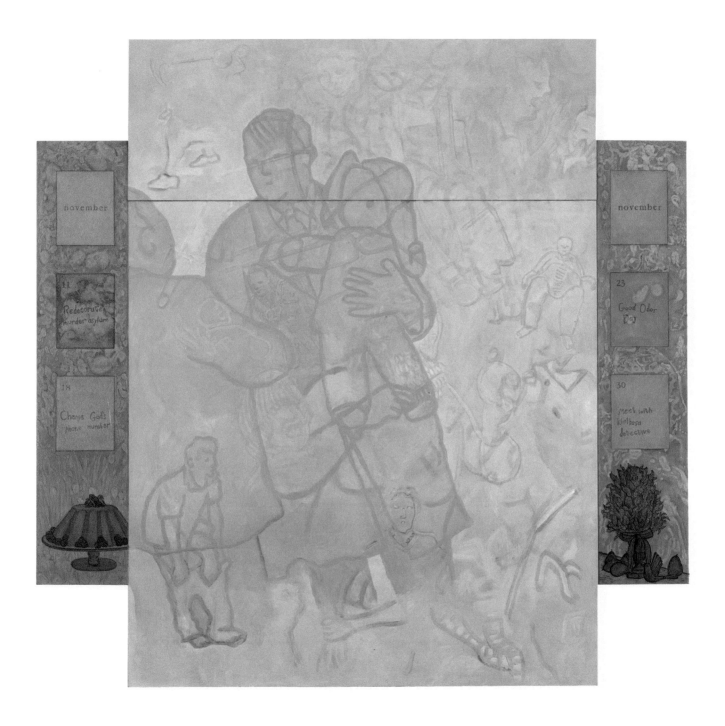

1974

1994-96 > oil on canvas,

4 panels, 96" x 100"

I will masturbate later darling

SO WHAT! I LIKE IDA APPLEBROOG. APPLEBROOG...CAN'T GET ANY PRETTIER THAN THAT.
THE STAGE IS SET. THE PLAYERS STRUCK DUMB BY CIRCUMSTANCE. THE HUMAN COMEDY
ADVANCES IN SILENCE. WHEN THE TITLES APPEAR, FEAR TAKES ALL THE CREDIT. I HAVE
A FEW OF HER EARLY ANNOUNCEMENTS. SCARY POSTCARDS.

Hey Julia, you really like her?

YEAH.

Better than who? Daumier? Munch?

MUNCH? Nah. I'M FAMILIAR WITH THE "SILENT SCREAM". DO IT MYSELF. BUT IN ART?
I PREFER DAUMIER. GOT HIS KICKS REVEALING THE CORRUPTION OF PETTY OFFICIALS,
LICENTIOUS CLERGY, ETC. STILL I PREFER APPLEBROOG. AS LONG AS INJUSTICE AND
CRUELTY EXIST IN THE HOME, OFFICE, AND SEEDY HOTEL ROOMS SHE WILL SEEK IT OUT
AND SHOW IT FOR WHAT IT IS.

What is it?

HOME MOVIES: FEAR, RAGE, REPRESSIONS, POWERLESSNESS, ISOLATION. NOT IN THAT ORDER.

Brava. Do you know her?

No.

R.D.

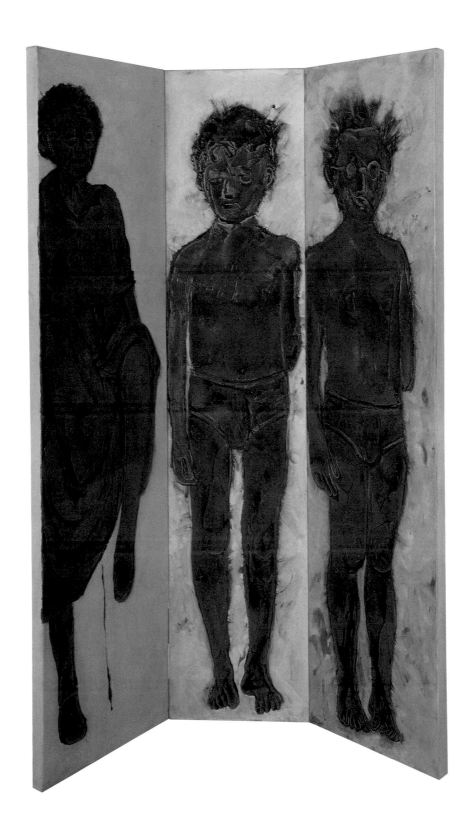

Marginalia (trio)
1996 > oil on canvas, triptych, 72" x 52" x 10"

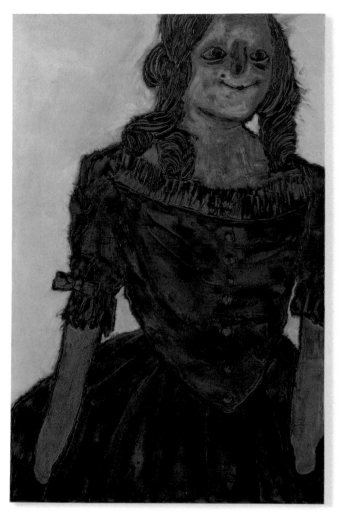

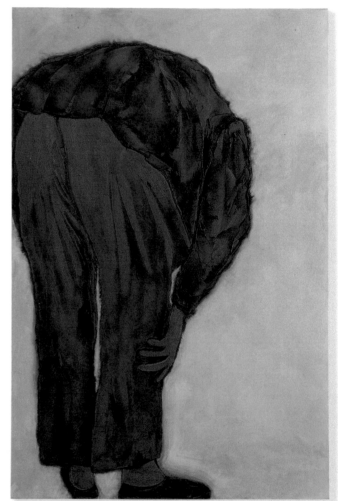

Marginalia (doll/bend over man)
1996 > oil on canvas, diptych, 72" x 48" each

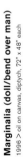

There is a difference between presenting scenes of violence in order to warn us to live righteously or to describe violence because it exists as a fact of life.
I.A.

Marginalia (chicken/tip toes)
1996 > oil on canvas, diptych, 16" x 14"; 20" x 14"

Marginalia (goggles/black face)
1996 > oil on canvas, diptych, 16" x 14"; 14" x 18"

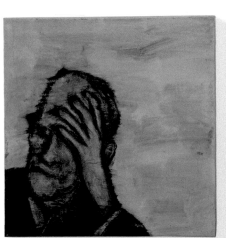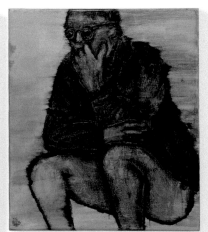

**Marginalia
(hand on forehead/squatting)**
1996 > oil on canvas, diptych, 16" x 16"; 16" x 14"

Marginalia (bottle/fish)
1996 > oil on canvas, diptych, 16" x 16"; 20" x 14"

Marginalia (tattoo/glove)
1996 > oil on canvas, diptych, 16" x 16" each

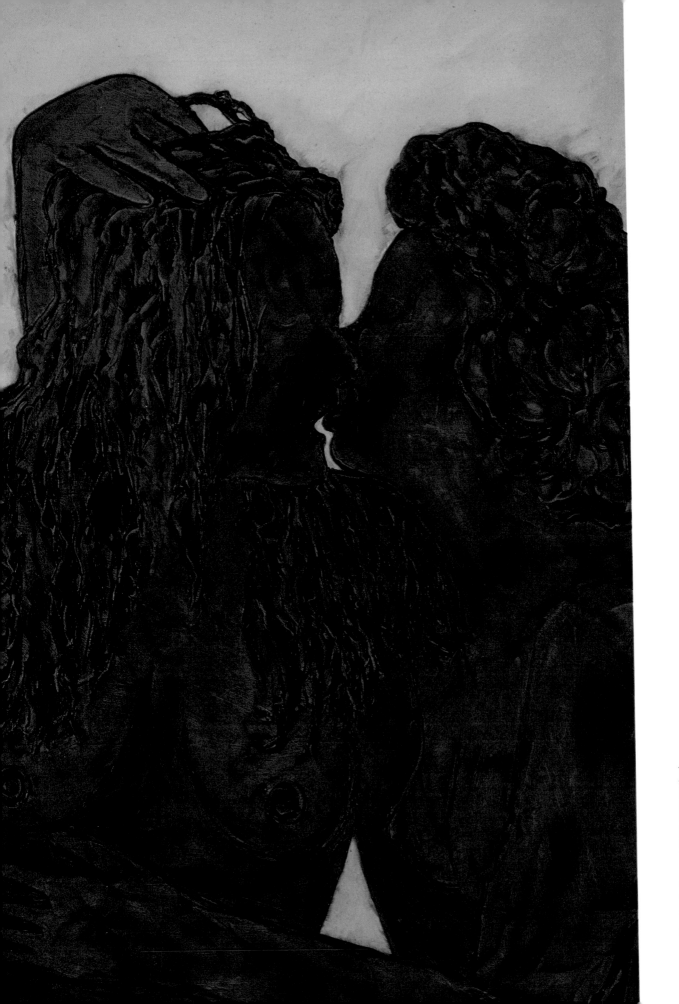

Marginalia (women kissing/squatting)
(detail)
1994-96 > oil on canvas

For the most part, it is just being an image gatherer. I'll never forget watching the Challenger takeoff. I thought, how could anyone in their right mind want to go on one of those things? And I'm sitting there and the rocket explodes, and what does the camera do? This was live – the camera zoomed in on that young teacher's mother, on the faces of all the relatives sitting in the stands and watching.
I.A.

Marginalia (32)
1996 > oil on canvas,
2 panels, 62" x 38" x 3"

Marginalia (crawling man)
1996 > oil on canvas,
2 panels, 32" x 72"

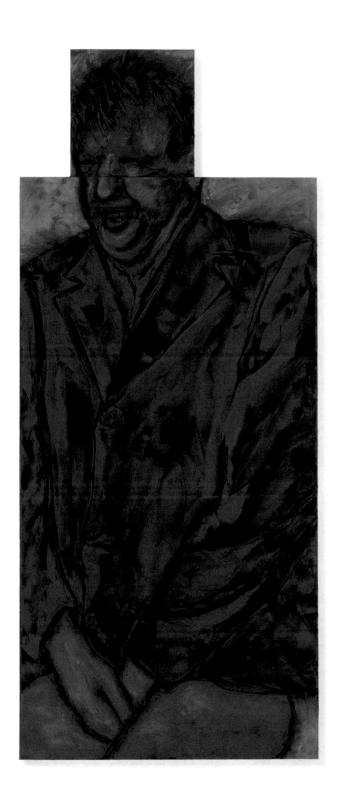

**Marginalia
(party hat/laughing)**
1994-95 > oil on canvas,
diptych, 50" x 72", 88" x 38"

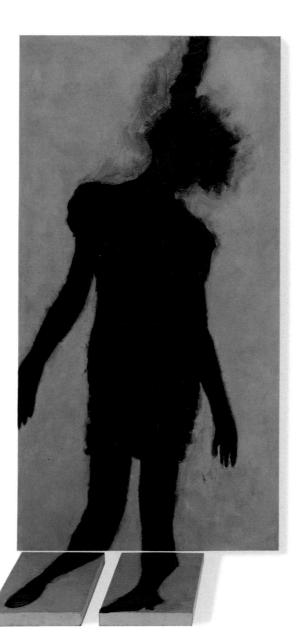
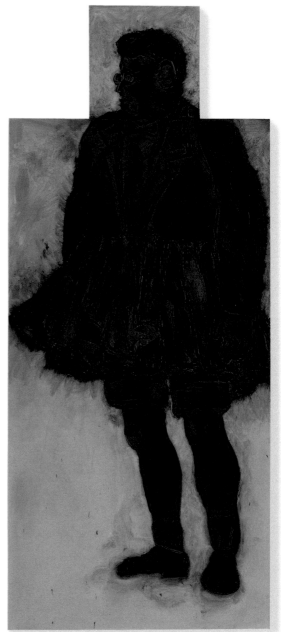

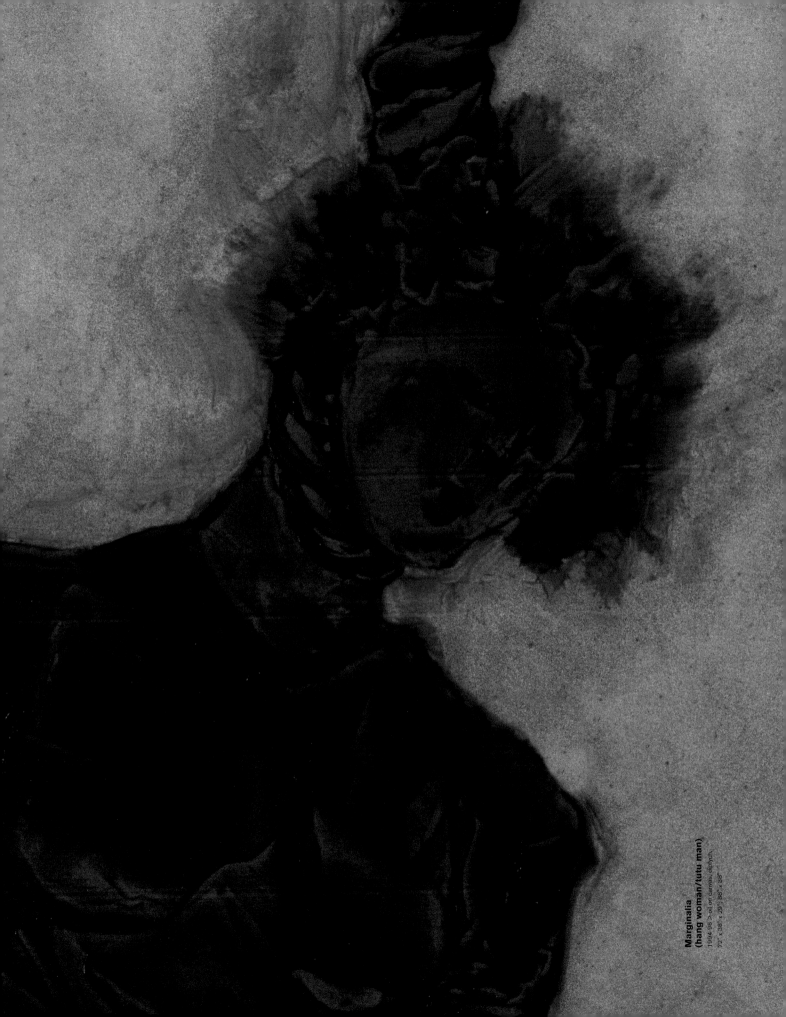

**Marginalia
(hang woman/tutu man)**
1994-96 > oil on canvas, diptych,
72" x 38" x 29" / 88" x 38"

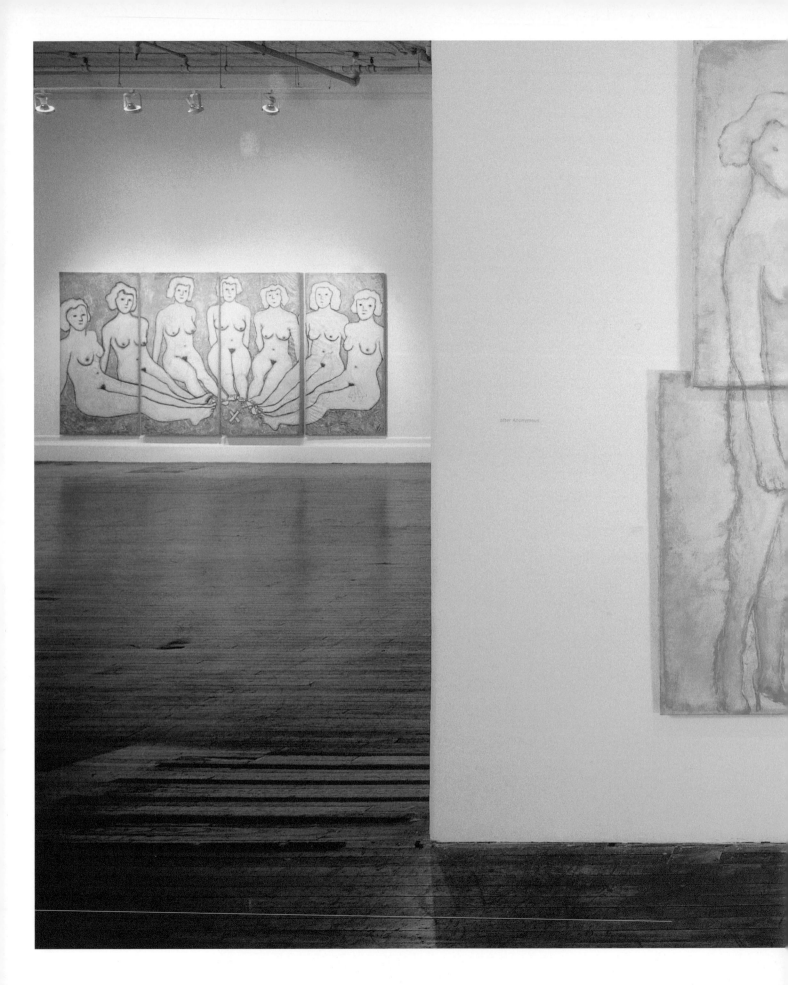

after Anonymous

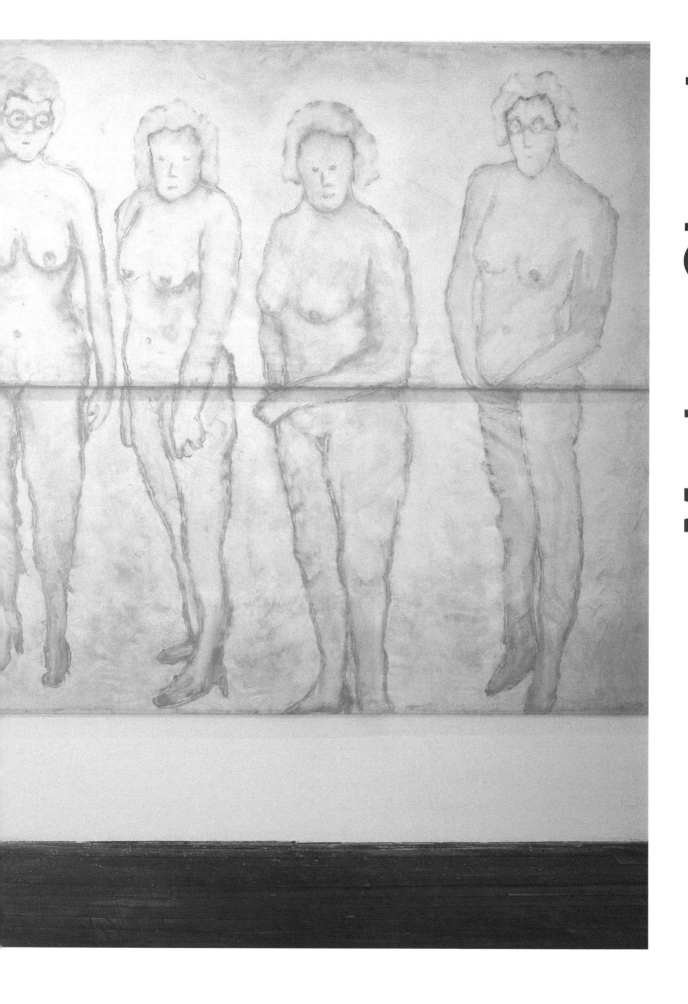

The most important things in an art work are often the things which get left out - a perception shared by trendy critical theorists and the not-so-trendy Sherlock Holmes, who first spotted the importance of the Dog that Didn't Bark. Look, for example, at the Pirelli calendar, and what do you see? No ugly women. Look around the National Gallery and what do we find? Not many ugly women there, either. What does this mean? A number of things, but the real moral is that if you happen to be a woman who wants to make a cultural mark, high or low, you'd be well advised to be (a) buxom and (b) as near as possible to naked.

This interest in what fails to show up in any given image is the staple fare of some of the more thoughtful art produced over the last ten years: it lends itself to art-for-art's sake theorising just as easily as it does to social comment. It's probably most interesting and productive when it combines the two.

C.H.

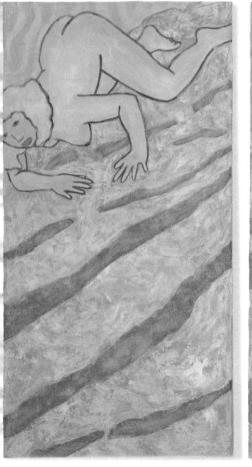 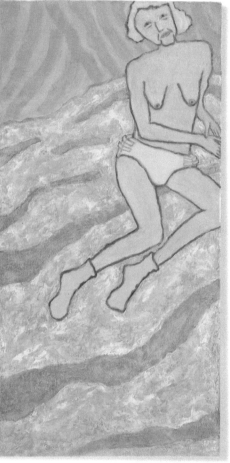 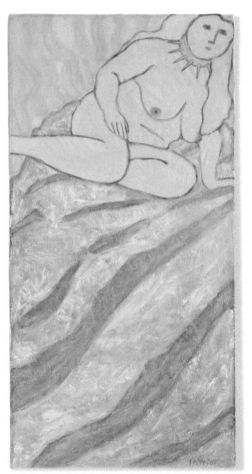

Modern Olympia (after Cézanne)
1997 - 2001 > oil and Gampi on canvas,
73 5/16" x 37 15/16"

Modern Olympia (after Cézanne)
1997 - 2001 > oil and Gampi on canvas,
73 5/16" x 37 1/8"

Modern Olympia (after Cézanne)
1997 - 2001 > oil and Gampi on canvas,
73 5/16" x 37 11/16"

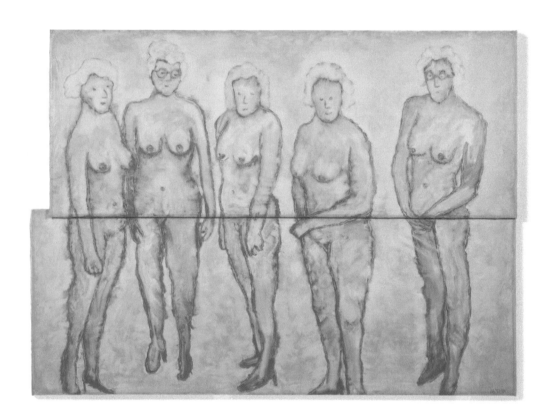

Modern Olympia (after Anonymous)
1997 - 2001 > oil and Gampi on canvas,
2 panels, 74 1/2" x 102 1/2"

Modern Olympia (detail)
1997 - 2001 > oil on canvas

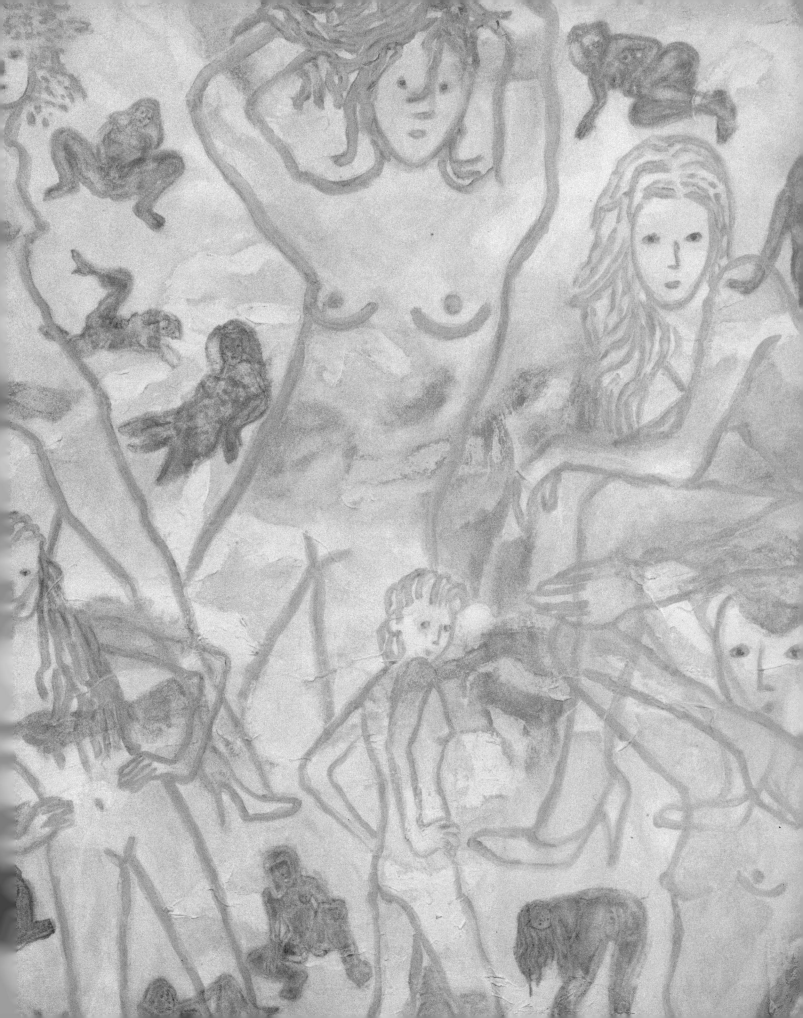

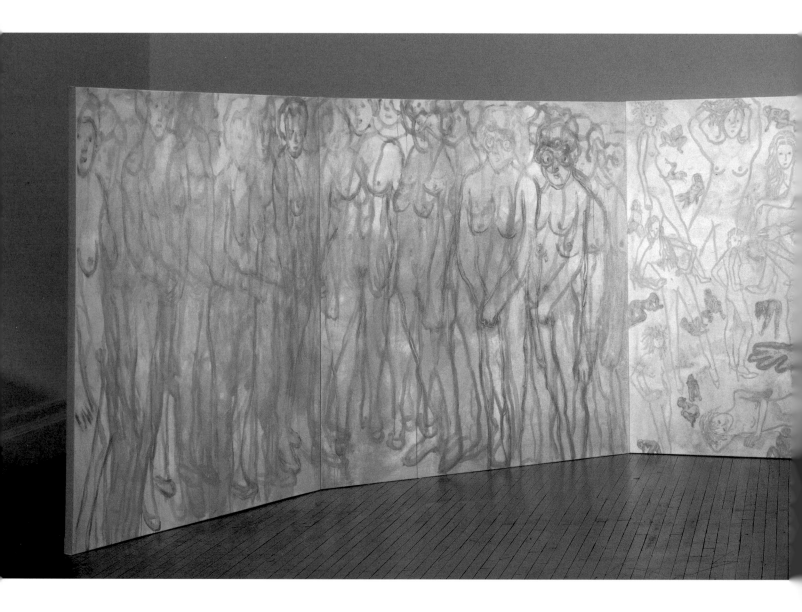

Modern Olympia
1997 - 2001 > oil on canvas,
5 panels, installation dimensions variable

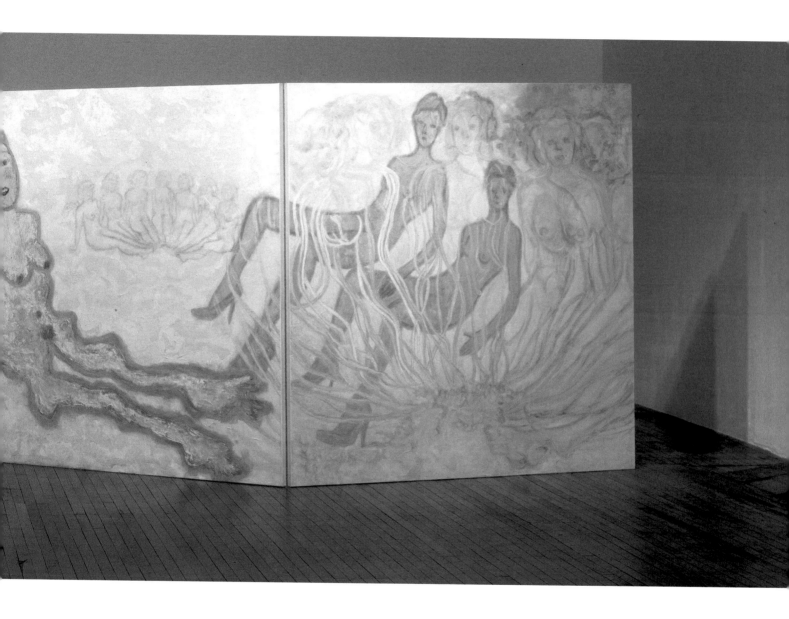

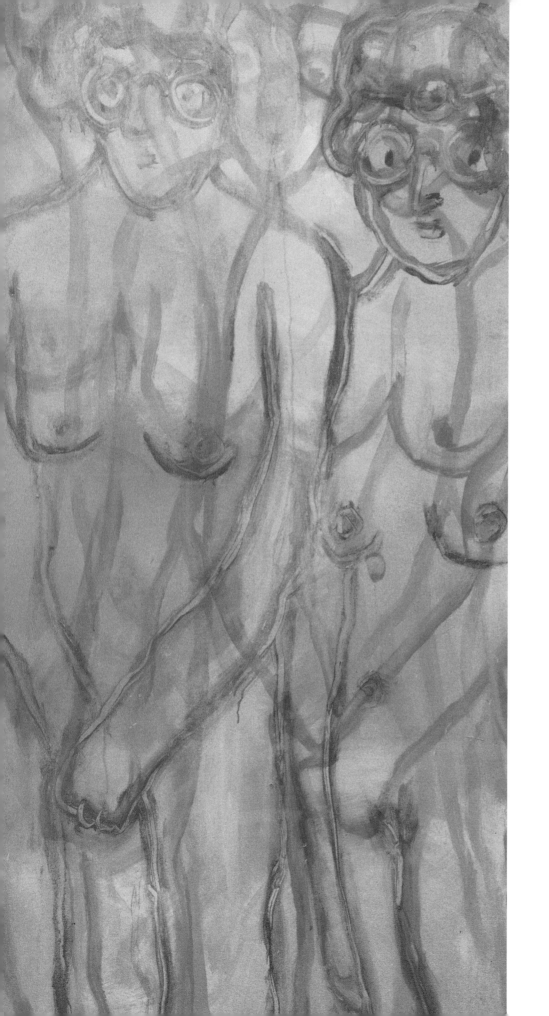

Modern Olympia (detail)
1997 - 2001 > oil on canvas

Modern Olympia (after Giotto)
1997 - 2001 > oil and Gampi on canvas,
7 panels, 113" x 89 1/2"

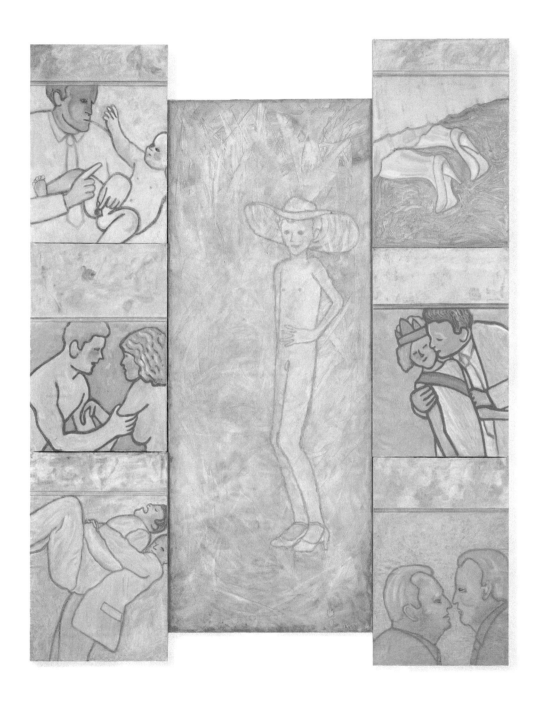

this is glorious

One might murder
one's father
for this

P.S.J. – Ida, what does feminism mean for you now, or does it mean anything at this point? I am curious.
I.A. – Me, too. (laughter) But seriously, feminism is still very meaningful for me. It is many things to different people. And there are lots of feminisms, a multiplicity of meanings, and yet, I'm having a very hard time with what it actually means today. Especially with the latest Clinton escapades. I'm not quite sure where young women stand today. I know we opened up many doors early on with the women's movement, and then by the 80s the movement was gone. Many younger women didn't realize there had ever been a problem, and then they were suddenly hit with the "glass ceiling." Then comes the 90s and I really don't know what feminism is at this point.

...

When I meet students or talk to younger artists, what I hear is, "What's your problem? There is no problem - I can go out and do anything I want." I have a really hard time with that.

Modern Olympia (after O'Keeffe) (detail)
1997 - 2001 > watercolor on Gampi

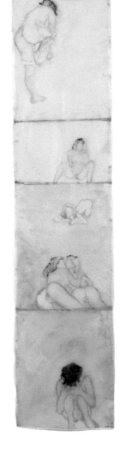
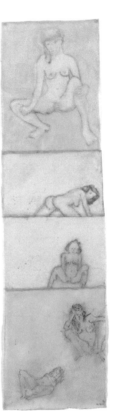
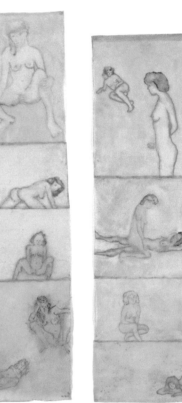

352

Modern Olympia (after O'Keeffe)
1997 - 2001 > watercolor on Gampi, 12 scrolls,
dimensions variable

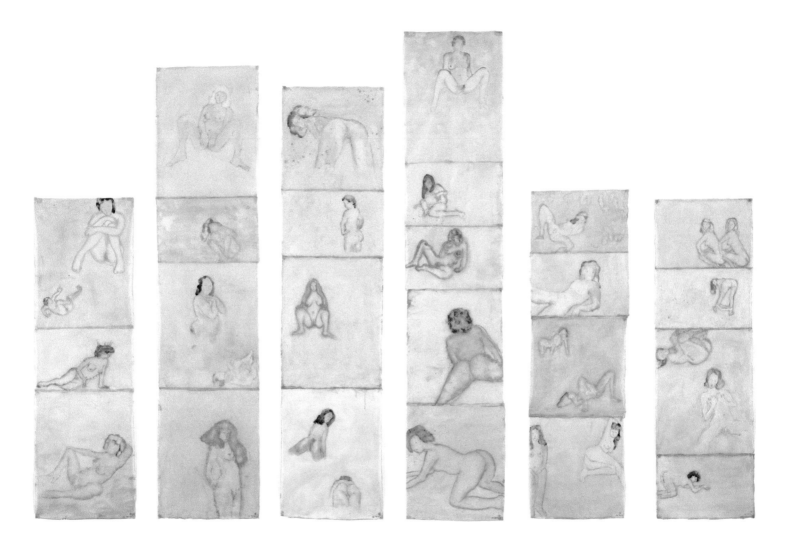

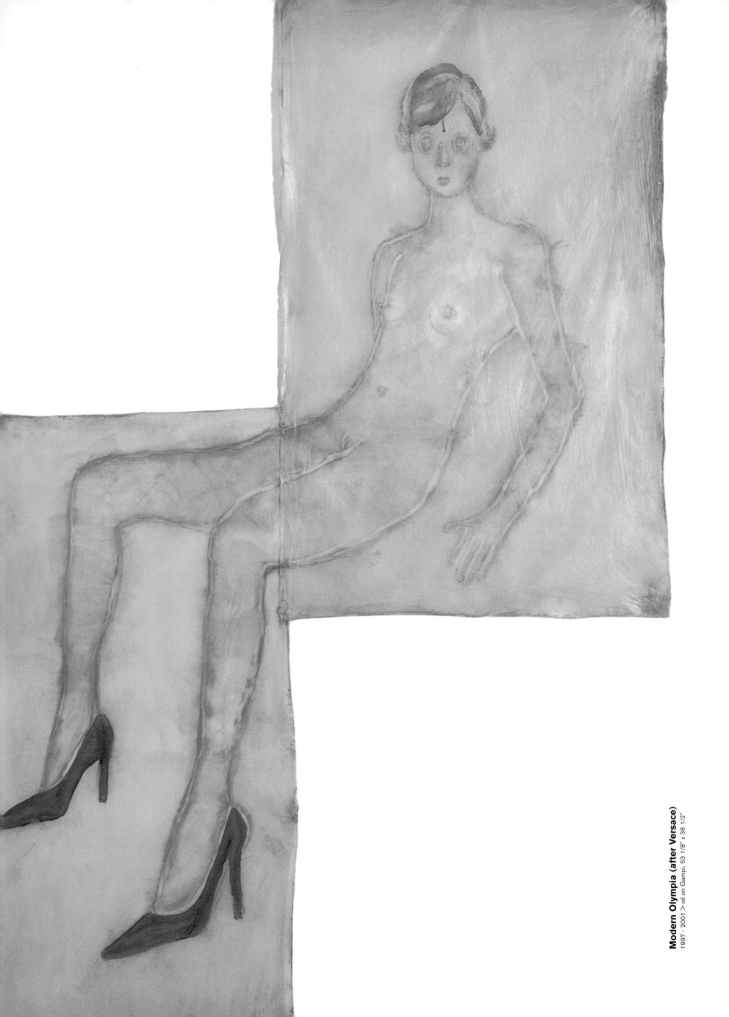

Modern Olympia (after Versace)
1997 - 2001 > oil on Gampi, 53 1/8" x 36 1/2"

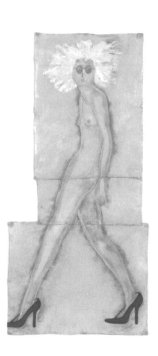

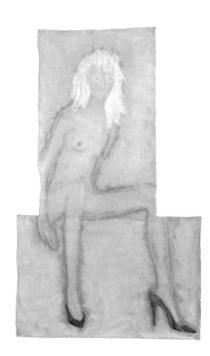

Modern Olympia (after Versace)
1997 - 2001 > oil on Gampi, 45 1/4" x 18 5/8"

Modern Olympia (after Versace)
1997 - 2001 > oil on Gampi, 47 7/8" x 23"

Modern Olympia (after Versace)
1997 - 2001 > oil on Gampi, 51 1/4" x 32 1/2"

Don't cry It's only a joke

Modern Olympia (after Versace)
1997 - 2001 > oil and Gampi on canvas,
100 3/16" x 38 1/8"

Modern Olympia (after Versace)
1997 - 2001 > oil and Gampi on canvas,
100 3/16" x 37 1/8"

Known for her cryptic, cartoon-like, comments on sexuality, power, mayhem, domestic violence, rage, guilt, emotional dysfunction and other charms of togetherness, the feminist artist Ida Applebroog here turns her attention to a provocative work of art: "Olympia," the sassy nude prostitute painted by Manet in 1863. With her boldly stated nakedness, ready-for-business demeanor and above all the brazen "sue me" gaze she presents to the viewer, "Olympia" caused a scandal at her Paris debut at the Salon of 1865. An ironic play on the idealized nudes of art history, she was nevertheless painted with such dazzling virtuosity that she could not be taken lightly. Viewing "Olympia" from her own perspective, Ms. Applebroog does some spirited riffs. A four-panel "Modern Olympia (After Manet)," shows a group of seven zaftig nudes in brown outline, seated in a semicircular lineup à la Busby Berkeley, their faces impassive, their toes pointed toward an X on the ground. Their expressions do not challenge; their pubic hair, unlike Olympia's, is unabashedly exposed. In this work the raw charge of "Olympia" has become a kitschy replay in which the body as commodity no longer shocks.

...

And there are six oils titled "Modern Olympia (after Versace)," in each of which a hooker clunks around in klutzy but fashionable high-heeled shoes that might be inspired by the sexy mules Manet's Olympia wears in bed. Ms. Applebroog also pays homage to Manet by the skill of her brushwork, laid down on a heavy Japanese rice paper called Gampi, with a wrinkled skinlike quality that takes happily to paint. It's nice to see that age doesn't count among her women, only talent.
G.G.

J.L. Let's speak about Ida's new work, *Modern Olympia*. I think she is going back to the beginning, to who she was before. Not as a way of creating an ending, but in order to make the circle whole.

R.F. Where do you see this circle?

J.L. The subjects are nude and sexy women. It took Ida six years to finish this group of work. It was a difficult period for her to get through, but now the paintings are completed and everything is okay again. She has placed herself amongst these women. What do you think of them?

R.F Many of us now take it for granted that women have, or should have, an equal voice, but for a great deal of Ida's life, this was not true at all. Until recently, women were prohibited or discouraged from becoming artists, and certainly women were not allowed historically to paint like this. And men for centuries have been voyeurs looking at sensual women painted by men. Art history is man's view of women. Ida is not afraid to comment on Manet's and Cézanne's female nudes. She admires and respects them. She has empathy for men; I think she enters men's psyches as well. At the same time, this is a dialogue by a woman about women. She joins Berthe Morisot and Mary Cassatt, but presents her subject matter even more directly. She suddenly places herself right in the middle of these issues.

J.L. With all these men.

R.F. Right in the center, in order to deal with the subject matter of art history and the many erotic images men have made of women.

The Impressionists did not go as far as Ida has. In an era of soft porn and nudity in movies and other media, she is out there making a critique of it all. And looking at this work, we are still a little shocked. We inquired of the post office whether the announcement could be mailed without an envelope. Their answer was quite revealing as to how far we've come. They said they only get involved if someone who receives mail makes a complaint.

M.B. But do you think maybe some of that, I wouldn't call it discomfort, but maybe a reaction, is just part of seeing Ida as sexual? I feel her presence in all of these women; the progression of her as a young woman to her present age.

J.L. I agree with that. It's a trace. That's why I was speaking of a cycle. It's her.

R.F. That's very important. The work is a reminiscence.
You may remember the aging Picasso's erotic work: the male painter seducing the young female model, or the voyeur looking from behind the curtain and watching a young couple having sex. This show also has a wonderful connection with Manet. In Ida's work, Manet's Olympia has left the couch and is now painting us. Ida connects her generation with women through the ages. In *Modern Olympia*, she tackles another taboo: aging women - naked, strong, vulnerable, and real.

Modern Olympia (after Manet)
1997 - 2001 > oil and Gampi on canvas,
4 panels, '73 3/8" x 148 1/16"

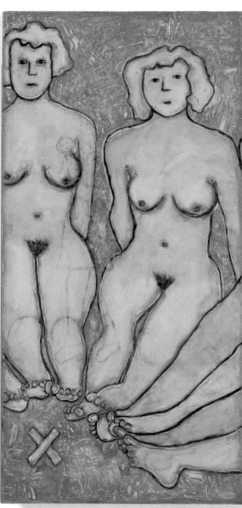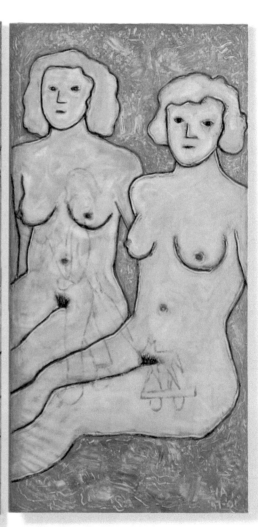

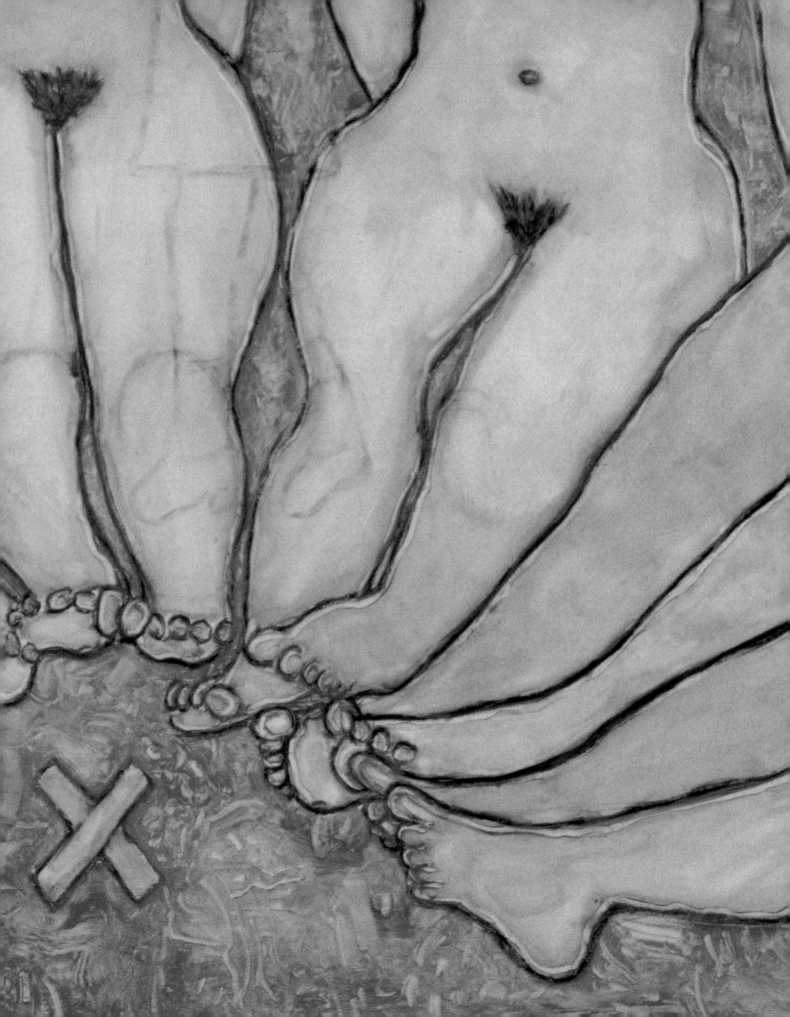

P.S.J. – What are your future plans as an artist?

I.A. – (laughter) As an artist? I'll work until I drop. That's the only plan I have. It's this weird idea,
you feel that you'll go on making art for the rest of your life, and then life comes in and interrupts.
No, I never talk about future plans, that's part of the

red notebooks

18-21
from the *red notebooks*, vol. I
1974-77 > Photos: Federico Farias
Collection of the artist

22-32
from the *red notebooks*, vol. II
1974-77 > Photos: Federico Farias
Collection of the artist

33-46
from the *red notebooks*, vol. III
1974-77 > Photos: Federico Farias
Collection of the artist

'76 Galileo works

50-51
Galileo works (installation view)
1976 > the artist's studio, Crosby Street, New York
Photo: Gideon Horowitz

52-53
Galileo Chronology:
I too am of the male race
1975 > ink and rhoplex on vellum & ink on mylar,
1 panel and 3 text panels, 21 3/4" x 57 1/4"
Photo: Federico Farias

54
Galileo Chronology:
At the age of 16
1975 > ink on mylar,
2 panels and 1 text panel, 28 3/4" x 37 3/4"
Photo: Federico Farias

55
Galileo Chronology:
At the age of 20
1975 > ink on mylar,
4 panels and 1 text panel, 60 3/4" x 34 1/4"
Photo: Federico Farias

55
Galileo Chronology:
I surprise everyone
1975 > ink on mylar,
2 panels and 6 text panels, 49 1/2" x 20 1/4"
Photo: Federico Farias

56-57
Galileo Chronology:
I'm hearing voices
1975 > ink and rhoplex on vellum & ink on mylar,
18 panels and 6 text panels, 82" x 148"
Photo: Federico Farias

58
Galileo Chronology:
I'm dying
1975 > ink and lacquer on mylar,
1 panel and 2 text panels, 69 1/2" x 79 1/2"
Photo: Federico Farias

59
Galileo Chronology:
I'm dying
1975 > ink and lacquer on mylar,
4 panels, 67 1/4" x 86 1/2"
Photo: Federico Farias

60-61
Galileo Chronology:
Virginia Galileo letters
1975 > ink on parchment,
3 panels, 28 3/4" x 37 3/4"
Photo: Federico Farias

62-63
Alberto
1975 > ink and rhoplex on vellum,
6 panels, 12" x 9 3/4" each, 16 1/2" x 72" (F)
Photo: Federico Farias
Collection of the Corcoran Museum of Art,
Washington, D.C.

64
Look between my legs
1975 > ink and rhoplex on vellum,
5 panels, 10 3/4" x 8 1/4" each,
15" x 52 1/4" (F)
Photo: Federico Farias

65
I am adrift in a medium deprived of significant boundaries
1975 > ink and rhoplex on vellum,
11 3/4" x 9 1/2", 15" x 13" (F)
Photo: Federico Farias

66-67
God never sends postcards (detail)
1975 > ink and rhoplex on vellum,
5 of 6 panels, 10" x 8" each, 14 1/2" x 61 1/4" (F)
Photo: Federico Farias

'77 Vellum stagings

70-71
Vellum stagings (installation view)
1977 > P. S. 1 Institute for Art and Urban Resources,
Long Island City, New York
Photo: Gideon Horowitz

72
The lifeguards are carrying a still body out of the water
1977 > ink and rhoplex on vellum,
5 panels, 12" x 9 1/2 each, 17" x 53" (F)
Photo: Jennifer Kotter
Collection of the artist

73
Sometimes a person never comes back
1977 > ink and rhoplex on vellum,
5 panels, 12" x 9 1/2 each, 17" x 53" (F)
Photo: Jennifer Kotter
Original installation included one extra panel
since removed by the artist.
Collection of Robert Ryman

74-75
I'm not your son, Act 2
1977 > ink and rhoplex on vellum,
3 panels, 12" x 10" each, 16 1/4" x 37 1/4" (F)
Photo: Federico Farias

76-77
Say something
1977 > ink and rhoplex on vellum,
7 panels, 10 1/2" x 9 3/4" each, 15 1/4" x 80 1/2" (F)
Photo: Federico Farias
Private Collection

78
Nobody ever dies of it (installation view)
1977 > P. S. 1 Institute for Art and Urban Resources,
Long Island City, New York
Photo: Gideon Horowitz

79
Nobody ever dies of it
1976 > ink and rhoplex on vellum,
14 panels, 10' x 6'
Photo: Gideon Horowitz

This work no longer exists.

'78
"It's no use Alberto"

82-83
It's no use Alberto (installation view)
1978 > Whitney Museum of American Art, New York
Photo: Gideon Horowitz

84
It's no use Alberto (installation detail)
1978 > Whitney Museum of American Art, New York
Photo: Gideon Horowitz

86
It's no use Alberto (stills)
1975 > black and white video, 21 minutes

87
Lunch Hour Tapes (stills)
1977 > black and white video, 25 minutes

88-89
Lunch Hour Tapes (stills)
1977 > black and white video, 25 minutes

'79
Illuminated
Manuscripts

90-91
Illuminated Manuscripts (installation view)
2001 > reconstruction of original '79 installation
at Franklin Furnace, New York
Photo: Federico Farias

92
Codex n°2
1976 > ink and rhoplex on vellum, 18" x 14"
Photo: Jennifer Kotter
Collection of the artist

93
Codex n°9
1976 > ink and rhoplex on vellum, 18" x 14"
Photo: Jennifer Kotter
Collection of the artist

93
Codex n°10
1976 > ink and rhoplex on vellum, 18" x 14"
Photo: Jennifer Kotter
Collection of the artist

94
Codex n°3
1976 > ink and rhoplex on vellum, 18" x 14"
Photo: Jennifer Kotter
Collection of the artist

94
Codex n°8
1976 > ink and rhoplex on vellum, 18" x 14"
Photo: Jennifer Kotter
Collection of the artist

95
Codex n°7
1976 > ink and rhoplex on vellum, 18" x 14"
Photo: Jennifer Kotter
Collection of the artist

97
Codex n°1
1976 > ink and rhoplex on vellum, 18" x 14"
Photo: Jennifer Kotter
Collection of the artist

98-99
Untitled (birth)
1979 > lacquer, ink and rhoplex on vellum,
6 panels, 9 1/2" x 5" each, 13 1/4" x 41 3/4" (F)
Photo: Federico Farias

'81
Dyspepsia

104-105
Dyspepsia (installation view)
1981 > Ronald Feldman Fine Arts, New York
Photo: Eeva-Inkeri

106
Now then
1978-79 > ink and rhoplex on vellum,
5 panels, 11 1/2" x 9 3/8" each, 17 1/4" x 56" (F)
Photo: Federico Farias
*Original installation included two extra panels
since removed by the artist.*
Collection of the artist

107
Shake
1980 > ink and rhoplex on vellum, 48" x 48"
Photo: Jennifer Kotter
Collection of Robert Yung

108-109
Sure I'm sure
1979-80 > ink and rhoplex on vellum,
6 panels, 12" x 9 1/2" each, 17" x 68 1/2" (F)
Photo: Jennifer Kotter
*Original installation included one extra panel
since removed by the artist.*
Collection of the artist

110-111
Look at me (installation view)
1981 > Ronald Feldman Fine Arts, New York
Photo: Eeva-Inkeri

112
Look at me
1980 > ink and rhoplex on vellum, 48" x 48"
Photo: D. James Dee
Collection of the artist

113
But I wasn't there
1980 > ink and rhoplex on vellum, 48" x 48"
Photo: D. James Dee
Collection of Jenette Kahn

113
Sweet smell of sage
1980 > ink and rhoplex on vellum, 48" x 48"
Photo: D. James Dee
Collection of Beth B

'81
Blue Books

118-119
I mean it
1981 > ink and rhoplex on vellum,
6 panels, 10 1/2" x 9 1/2" and 9 1/4" x 9 1/4",
14 1/4" x 67 3/4" (F)
Photo: Jennifer Kotter
Collection of Naomie and Charles Kremer

'82
Past Events

120-121
Gentlemen, America is in trouble
(installation view)
1982 > detail from the site specific installation,
the Great Hall, New York Chamber of Commerce,
sponsored by Creative Time.
Photo: Robin Holland

123
Gentlemen, America is in trouble
1982 > site specific installation, the Great Hall,
New York Chamber of Commerce.
Photomontage: Ida Applebroog

'82
Current Events

124-125
Current Events (installation view)
1982 > Ronald Feldman Fine Arts, New York
Photo: D. James Dee

126
I can't
1982 > acrylic and rhoplex on canvas, 83" x 66"
Photo: Jennifer Kotter
Private Collection

127
Untitled (time)
1982 > acrylic and rhoplex on canvas, 83" x 66 1/4"
Photo: Jennifer Kotter
Collection of the artist

128
Yes, twice
1982 > acrylic and rhoplex on canvas, 83" x 65 1/2"
Photo: Jennifer Kotter

129
Happy Birthday to me
1982 > acrylic and rhoplex on canvas, 83" x 66 1/2"
Photo: D. James Dee
Private Collection

129
Thank you very much
1982 > acrylic and rhoplex on canvas, 83" x 89"
Photo: D. James Dee
Collection of the Addison Gallery of American Art,
Phillips Academy, Andover, Massachussetts

130
Trinity Towers
1982 > acrylic and rhoplex on vellum,
diptych, 85" x 55" each
Photo: Jennifer Kotter

131
Mercy Hospital
1982 > acrylic and rhoplex on vellum,
diptych, 85" x 55" each
Photo: Federico Farias

132-133
It's very simple
1981 > ink and rhoplex on vellum,
6 panels, 10 1/2" x 9 1/2" and 9" x 9 1/2",
14 1/4" x 67 3/4" (F)
Photo: Jennifer Kotter

134
Ocean Parkway:
Five more minutes
1982 > painted lead, 2" high
Photo: Jennifer Kotter

134
Ocean Parkway:
101, 102, 103, 104, 105, 106, 107
1982 > painted lead, 2" high
Photo: Jennifer Kotter

135
Ocean Parkway:
Priapism? What's priapism?
1982 > painted lead, 2" high
Photo: Jennifer Kotter

135
Ocean Parkway:
I was beautiful once
like a movie star
1982 > painted lead, 2" high
Photo: Jennifer Kotter

'83
"Life is good"

136-137
Life is good, isn't it Mama?
1983 > animated display,
Spectacolor billboard, Times Square, New York
Photomontage: Ida Applebroog

138
Life is good, isn't it Mama?
1983 > animated display,
Spectacolor billboard, Times Square, New York
Photomontage: Ida Applebroog

'84
Inmates & Others

140-141
Inmates & Others
1984 > Ronald Feldman Fine Arts, New York
Photomontage: Lionel Avignon

142
Riverdale Home for the Aged
1984 > oil on canvas, 2 panels, 100" x 100"
Photo: Erik Landsberg

142-143
Wentworth Gardens
1984 > oil on canvas, 2 panels, 100" x 100"
Photo: D. James Dee
Collection of the artist

145
Thank you, Mr. President
1983 > rhoplex and enamel on canvas, 12" x 60"
Photo: D. James Dee
Collection of the artist

145
**Tell me. Does your condition
have a name?**
1983 > rhoplex and enamel on canvas, 12" x 60"
Photo: D. James Dee
Collection of Lars Josephson

145
Your eggs are getting cold
1983 > rhoplex and enamel on canvas, 12" x 60"
Photo: D. James Dee
Collection of Marvin Gerstin

146
Tweedle Animal Hospital
1983-84 > oil on canvas,
2 panels, 86" x 60"
Photo: Jennifer Kotter
Collection of the artist

147
Hillcrest State
1983-84 > oil on canvas,
2 panels, 86" x 60"
Photo: Jennifer Kotter
Collection of Idelle Weber

147
**Missionary Sisters of the
Immaculate Heart of Mary**
1983-84 > oil on canvas,
2 panels, 86" x 60"
Photo: Jennifer Kotter
Collection of the Ulmer Museum, Ulm, Germany

147
Lovelace Clinic
1983-84 > oil on canvas,
2 panels, 86" x 60"
Photo: Jennifer Kotter
Collection of Martin Sklar

150
Come on, look happy
1983 > oil on paper, 30" x 22"
Photo: D. James Dee
Whereabouts unknown

151
You're leaving? For good?
1983 > oil on paper, 4 panels, 98" x 30"
Photo: D. James Dee

152-153
Triple triptych
1984 > oil on paper,
9 panels, 56 1/2" x 57"
Photo: D. James Dee
Collection of the artist

154
Bite
1983 > charcoal on paper, 2 panels, 47" x 30"
Photo: D. James Dee
Courtesy Galerie Nathalie Pariente, Paris, France

155
Thank you for the two rose bushes
1983 > charcoal on paper, 2 panels, 47" x 30"
Photo: D. James Dee
Courtesy Galerie Nathalie Pariente, Paris, France

155
Dancers
1983 > charcoal on paper, 2 panels, 30" x 47"
Photo: D. James Dee
Courtesy Barbara Gross Galerie, Munich, Germany

157
Couple I
1983 > charcoal on paper,
12 panels, 91" x 92"
Photo: D. James Dee
Collection of the Museum of Modern Art, New York

'84
Sign on a Truck

158-159
Sign on a Truck
1984 > animated display,
Grand Army Plaza, Brooklyn, New York
Photo: Unknown

'86
Cul-de-sacs

166-167
Cul-de-sacs (installation view)
1986 > Institute of Contemporary Art, University of
Pennsylvania, Philadelphia
Photo: Eugene Mopsik

168
Don't be stupid
1985 > oil on canvas, 14" x 66"
Photo: D. James Dee
Private Collection

169
Yes, that is art
1985 > oil on canvas, 14" x 66"
Photo: D. James Dee
Collection of Frayda and Ronald Feldman

170
Two Women II (after de Kooning)
1985 > oil on linen,
2 panels, 72" x 74"
Photo: D. James Dee
Collection of the artist

170
Two Women I (after de Kooning)
1985 > oil on linen,
2 panels, 72" x 74"
Photo: D. James Dee
Collection of the artist

171
Two Women III (after de Kooning)
1985 > oil on linen,
2 panels, 72" x 74"
Photo: Jennifer Kotter
Collection of the artist

171
**Two Women III
(after de Kooning) (study)**
1985 > charcoal on paper,
4 panels, 60" x 44"
Photo: John Lamka

172
**Two Women II
(after de Kooning) (study)**
1985 > charcoal on paper,
4 panels, 60" x 66"
Photo: John Lamka

172
**Two Women I
(after de Kooning) (study)**
1985 > charcoal on paper,
5 panels, 60" x 88"
Photo: John Lamka

'87
Magic Kingdom

173
Two Women IV
(after de Kooning) (study)
1985 > charcoal on paper,
4 panels, 60" x 66"
Photo: John Lamka

173
Two Women IV (after de Kooning)
1985 > oil on linen, 72" x 74"
Photo: D. James Dee
Collection of the artist

174
Hurry up and die
1985 > oil on canvas, 3 panels, 42" x 66"
Photo: Jennifer Kotter
Collection of Arthur Berliner

175
You still here?
1985 > oil on canvas, 3 panels, 42" x 66"
Photo: Jennifer Kotter
Private Collection

176
Is everything ready?
1986 > watercolor, gouache on treated paper
17 panels, 112" x 81"
Photo: Jennifer Kotter
*Collection of the Weatherspoon Art Gallery,
Greensboro, North Carolina*

176-177
Promise I won't die?
1985 > watercolor, gouache on treated paper
14 panels, 97" x 95"
Photo: D. James Dee
Collection of the Metropolitan Museum of Art, New York

178
I've chosen cyanide (detail)
1985 > oil on canvas
Photo: Jennifer Kotter

179
Life is a Jacuzzi
1985 > oil on canvas, 4 panels, 62" x 120"
Photo: Jennifer Kotter
Collection of Arthur Berliner

179
I've chosen cyanide
1985 > oil on canvas, 5 panels, 62" x 132"
Photo: Jennifer Kotter
*LeWitt Collection at the Wadsworth Atheneum,
Hartford, Connecticut*

182
Sunflower Drive
1985 > oil on canvas, 84" x 54"
Photo: D. James Dee
Private Collection

183
God's white too
1985 > oil on canvas,
2 panels, 86" x 60"
Photo: Jennifer Kotter
Collection of the artist

183
Peel me like a grape
1985 > oil on canvas,
2 panels, 86" x 60"
Photo: Jennifer Kotter

184-185
Magic Kingdom (installation view)
1987 > Ronald Feldman Fine Arts, New York
Photo: Jennifer Kotter

186
Jesus loves U
1987 > oil on canvas,
8 panels, 32" x 78"
Photo: Jennifer Kotter
Collection of Mr. and Mrs. Howard Ganek

188
Church of St. Francis Xavier
1987 > oil on canvas,
5 panels, 86" x 136"
Photo: Jennifer Kotter
*Collection of Vicki and Kent Logan;
Fractional and promised gift to the San Francisco
Museum of Modern Art, San Francisco, California*

189
Boboli Gardens
1987 > oil on canvas,
5 panels, 86" x 132"
Photo: Jennifer Kotter
*Collection of the Williams Museum of Art,
Williamstown, Massachussetts*

190-191
Tomorrowland
1986 > oil on canvas,
5 panels, 86" x 132"
Photo: Jennifer Kotter
Collection of the Denver Art Museum, Denver, Colorado

192
Insight bores me
1987 > oil on canvas, 66" x 14"
Photo: Jennifer Kotter
Collection of Bernice Steinbaum

193
Don't call me mama
1987 > oil on canvas, 66" x 14"
Photo: Jennifer Kotter
Private Collection

193
You got balls, Steven
1987 > oil on canvas, 66" x 14"
Photo: Jennifer Kotter

*This panel is now part of the painting Sphincter Pond, 1987
Private Collection*

194
Beulahland (for Marilyn Monroe)
1987 > oil on canvas, 2 panels, 96" x 72"
Photo: Jennifer Kotter
Collection of the Metropolitan Museum of Art, New York

198
Goya Road I
1987 > oil on canvas,
4 panels, 72" x 94 1/2"
Photo: Jennifer Kotter
Collection of the artist

199
Goya Road II
1987 > oil on canvas,
5 panels, 82" x 62 1/2"
Photo: Jennifer Kotter
Collection of the Denver Art Museum, Denver, Colorado

199
Goya Road III
1987 > oil on canvas,
7 panels, 88 1/4" x 75"
Photo: Jennifer Kotter
Courtesy Barbara Gross Galerie, Munich, Germany

200-201
Noble Fields
1987 > oil on canvas, 5 panels, 86" x 132"
Photo: Jennifer Kotter
*Collection of the Solomon R. Guggenheim Museum,
New York*

202
Crimson Gardens
1986 > oil on canvas,
4 panels, 86" x 136"
Photo: Jennifer Kotter
Collection of Gideon Horowitz

205
Delmore Arms
1987 > oil on canvas,
4 panels, 58" x 44"
Photo: Jennifer Kotter
Collection of Elizabeth Hess and Peter Biskind

206-207
Velcro Village
1987 > oil on canvas,
4 panels, 100" x 125 1/2"
Photo: Jennifer Kotter
Collection of Carol and Eric Schwartz

208
Untitled (man crawling)
1987 > oil on canvas, 16" x 16"
Photo: Jennifer Kotter
Collection of Halfdan Mustad

209
Untitled (person with two phones)
1987 > oil on canvas, 16" x 16"
Photo: Jennifer Kotter
Collection of Halfdan Mustad

210
Untitled (Farewell, Robert)
1987 > oil on canvas, 14" x 66"
Photo: Jennifer Kotter

The artist has removed the text from this painting.

211
I'm back on the pill
1986 > oil on canvas, 14" x 66"
Photo: Jennifer Kotter

211
You're rat food
1986 > oil on canvas, 14" x 66"
Photo: Jennifer Kotter

213
K-Mart Village II
1987 > oil on canvas,
5 panels, 48" x 32"
Photo: Jennifer Kotter
Collection of the artist

213
K-Mart Village I
1987 > oil on canvas,
5 panels, 48" x 32"
Photo: Jennifer Kotter
Collection of the artist

214-215
Nostrums (installation view)
1989 > Ronald Feldman Fine Arts, New York
Photo: Jennifer Kotter

217
Anhedonia
1989 > oil on canvas,
11 panels, 102 1/2" x 142 1/2"
Photo: Jennifer Kotter

218
Untitled (toy airplanes)
1989 > oil on canvas, 14" x 64"
Photo: Federico Farias
Private Collection

219
K-Mart Village III
1989 > oil on canvas, 5 panels, 48" x 32"
Photo: Jennifer Kotter
Collection of the artist

219
K-Mart Village IV
1989 > oil on canvas, 5 panels, 48" x 32"
Photo: Jennifer Kotter
Collection of the artist

Gatefold
Variations on Emetic Fields
1990 > mixed media, dimensions variable
Photo: Jennifer Kotter

220-221
Emetic Fields
1989 > oil on canvas,
8 panels, 102" x 204 1/2"
Photo: Jennifer Kotter
*Collection of the Whitney Museum of American Art,
New York*

222
Peristaltic Gardens
1988 > oil on canvas,
5 panels, 86" x 138"
Photo: Jennifer Kotter
Private Collection

223
Lithium Square
1988 > oil on canvas,
4 panels, 110" x 137 1/4"
Photo: Jennifer Kotter
*Collection of the Bayerische Staatsgemäldesammlungen,
Munich*

224
Chronic Hollow
1989 > oil on canvas,
6 panels, 94 1/2" x 116 1/4"
Photo: Jennifer Kotter
*Collection of the Museum of Modern Art,
New York*

225
Idiopathic Center
1988 > oil on canvas,
5 panels, 110" x 130 1/2"
Photo: Jennifer Kotter
Private Collection

226-227
Camp Compazine
1988 > oil on canvas,
4 panels, 86" x 140" x 18"
Photo: Jennifer Kotter
Collection of Frayda and Ronald Feldman

228-229
Vector Hills
1989 > oil on canvas,
5 panels, 86" x 150" x 18"
Photo: Jennifer Kotter
Private Collection

232
Elixir Tabernacle I
1989 > oil on canvas,
2 panels, 62" x 72"
Photo: Jennifer Kotter
Private Collection

233
Elixir Tabernacle II
1989 > oil on canvas,
4 panels, 92" x 72"
Photo: Jennifer Kotter
Private Collection

234-235
Belladonna (stills)
1989 > film/video, 12 min. 9 sec.

by Ida Applebroog and Beth B

236-237
Study II for American Lesion
1989 > watercolor on paper,
23 panels, 71" x 154"
Photo: Jennifer Kotter

237
American Lesion II
1988 > oil on canvas,
2 panels, 72" x 32"
Photo: Jennifer Kotter

238-239
Safety Zone
(installation view: Marginalia II, detail)
1991 > Ronald Feldman Fine Arts, New York
5 of 6 panels
Photo: Jennifer Kotter
Collection of the artist

240
Marginalia (woman with hat)
1991 > oil on canvas, double sided,
2 panels, 17" x 17 1/4" x 4 3/4" (F)
Photo: Jennifer Kotter

240
Marginalia (Al Jolson)
1991 > oil on canvas, double sided,
2 panels, 17 1/4" x 15 1/4" x 4 3/4" (F)
Photo: Jennifer Kotter
Private Collection

241
Marginalia (measure feet I)
1991 > oil on canvas, double sided,
4 panels, 33 1/2" x 17 1/4" x 4 3/4" (F)
Photo: Jennifer Kotter
Collection of the artist

242
Marginalia (woman with lion)
1991 > oil on canvas, double sided,
8 panels, 61 1/4" x 17 1/4" x 4 3/4" (F)
Photo: Jennifer Kotter

243
Marginalia (man with shovel)
1991 > oil on canvas, double sided,
6 panels, 49 1/2" x 15 1/4" x 4 3/4" (F)
Photo: Jennifer Kotter
Collection of Charlotte and Paul Cordry

243
Marginalia (measure feet II)
1991 > oil on canvas, double sided,
8 panels, 63 1/2" x 17 1/4" x 4 3/4" (F)
Photo: Jennifer Kotter
Collection of the Honolulu Academy of Art, Honolulu, Hawaii

244-245
Marginalia (Mauthausen notebook)
1991 > oil on canvas, 43 1/4" x 48" x 3 1/8"
Photo: Jennifer Kotter

278-279
Tattle Tales 2 (installation view)
1994 > Ronald Feldman Fine Arts, New York
Photo: Zindman/Fremont

281
Marginalia (Jesus is coming)
1993 > oil on canvas, 4 panels,
Jesus is coming: 52" x 35" x 3 1/2"
Bend over 1 and 2: 16" x 12" x 3 1/2" each
Photo: Dennis Cowley

282
I'm rubber, you're glue
1993 > oil on canvas,
4 panels, 99" x 65"
Photo: Dennis Cowley

283
Fatty fatty two by four I
1993 > oil on canvas,
2 panels, 72" x 34"
Photo: Dennis Cowley
Private Collection

284-285
Baby baby suck your thumb
1994 > oil on canvas,
5 panels, 88" x 104"
Photo: Dennis Cowley

286-287
Shirley Temple went to France
1993 > oil on canvas,
14 panels, 106" x 170"
Photo: Dennis Cowley
Collection of the artist

288
B, my name is Betty
1994 > oil on canvas,
3 panels, 88" x 51"
Photo: Dennis Cowley

289
Winnie's Pooh
1994 > oil on canvas,
4 panels, 86" x 84"
Photo: Dennis Cowley

290
Mother mother I am ill
1993 > oil on canvas,
2 panels, 110" x 72"
Photo: Dennis Cowley
*Collection of the Corcoran Museum of Art,
Washington, D.C.*

291
Tra la la boom de-ay
1994 > oil on canvas,
4 panels, 96" x 126"
Photo: Dennis Cowley

292
Three potato, four
1994 > oil on canvas,
5 panels, 50" x 107"
Photo: Dennis Cowley

293
One potato, two potato
1994 > oil on canvas,
6 panels, 63 1/2" x 104"
Photo: Dennis Cowley

296
Marginalia (Vincent)
1993 > oil on canvas, 35" x 27" x 3 1/2"
Photo: Dennis Cowley

297
Marginalia (horse)
1993 > oil on canvas, 27" x 35" x 3 1/2"
Photo: Dennis Cowley
Collection of the artist

297
Marginalia (dog with hat)
1994 > oil on canvas,
2 panels, 73" x 48" x 3 1/2"
Photo: Dennis Cowley

298
**Marginalia
(woman measuring waist)**
1994 > oil on canvas,
2 panels, 51" x 27" x 3 1/2"
Photo: Dennis Cowley

299
Marginalia (poodle)
1994 > oil on canvas, 12" x 16" x 3 1/2"
Photo: Dennis Cowley

299
Marginalia (woman holding fish)
1994 > oil on canvas, 16" x 12" x 3 1/2"
Photo: Dennis Cowley

300-301
Marginalia (fat lady and living skeleton)
1994 > oil on canvas,
3 panels, 58" x 86" x 3 1/2"
Photo: Dennis Cowley
Private Collection

301
Marginalia (two couples)
1994 > oil on canvas,
2 panels, 40" x 16" x 3 1/2"
Photo: Dennis Cowley
Collection of Steven and Deborah Bernstein

302-303
Prurient Interests
1995-96 >
Photomontage: Lionel Avignon

304
I'm a good-hearted racist
1996 > oil on canvas, 35" x 48"
Photo: Dennis Cowley

304
History marches on
1996 > oil on canvas, 35" x 48"
Photo: Dennis Cowley
*Collection of Vicki and Kent Logan;
Fractional and promised gift to the San Francisco
Museum of Modern Art, San Francisco, California*

304
Things change
1996 > oil on canvas, 48" x 35"
Photo: Dennis Cowley

304
I'm woman of the year
1996 > oil on canvas, 35" x 48"
Photo: Dennis Cowley

305
Still nothing?
1996 > oil on canvas, 35" x 48"
Photo: Dennis Cowley

305
I used to be bored
1996 > oil on canvas, 35" x 48"
Photo: Dennis Cowley

306
Untitled (Siamese twins)
1995 > ink on vellum, 14 3/4" x 17 1/2"
Photo: Dennis Cowley
Private Collection

306
Untitled (woman stripping)
1996 > ink on vellum, 14 3/4" x 18"
Photo: Dennis Cowley

306
Untitled (nurse)
1995 > ink on vellum, 14 3/4" x 22 3/4"
Photo: Dennis Cowley

'96
Living

'02
Modern Olympia

306
Untitled (stitched mouth)
1995 > ink on vellum, 22" x 17 1/2"
Photo: Dennis Cowley

307
Untitled (bald man with glasses)
1996 > ink on vellum, 17 3/4" x 14 3/4"
Photo: Dennis Cowley
Collection of Jeanette Ingberman and Papo Colo

307
Yes, you can
1996 > ink on vellum, 14" x 18"
Photo: Dennis Cowley
Collection of the artist

307
Untitled (Gus)
1996 > ink on vellum, 17 1/2" x 14 1/2"
Photo: Dennis Cowley
Collection of Martina Batan

307
Untitled (bird)
1996 > ink on vellum, 14 1/2" x 17 1/2"
Photo: Dennis Cowley
Private Collection

307
Untitled (couple kissing)
1996 > ink on vellum, 14 3/4" x 17 1/2"
Photo: Dennis Cowley
Private Collection

307
Untitled (couple dancing)
1996 > ink on vellum, 17 1/2" x 14 3/4"
Photo: Dennis Cowley
Collection of Terrie Sultan

307
Untitled (man squatting)
1996 > ink on vellum, 14 1/2" x 17 1/2"
Photo: Dennis Cowley

308
Untitled (two legs)
1996 > ink on vellum, 17 1/2" x 14 1/2"
Photo: Dennis Cowley

310-311
Living (installation view)
1996 > Ronald Feldman Fine Arts, New York
Photo: Zindman/Fremont

313
1944
1995-96 > oil on canvas,
3 panels, 72" x 110"
Photo: Dennis Cowley
Collection of the artist

314-315
1956 (detail)
1995-96 > oil on canvas
Photo: Dennis Cowley

316
1948
1994-96 > oil on canvas,
4 panels, 86" x 100"
Photo: Dennis Cowley
Private Collection

317
1956
1995-96 > oil on canvas,
3 panels, 72" x 76"
Photo: Dennis Cowley
Private Collection

318
1969
1995-96 > oil on canvas,
2 panels, 72" x 52"
Photo: Dennis Cowley
Private Collection

319
1974
1994-96 > oil on canvas,
4 panels, 96" x 100"
Photo: Dennis Cowley
Private Collection

323
Marginalia (trio)
1996 > oil on canvas, triptych, 72" x 52" x 10"
Photo: Zindman/Fremont

324
Marginalia (doll/bend over man)
1996 > oil on canvas, diptych, 72" x 48" each
Photo: Dennis Cowley
Collection of the artist

325
Marginalia (chicken/tip toes)
1996 > oil on canvas, diptych, 16" x 14"; 20" x 14"
Photo: Dennis Cowley

326-327
Marginalia (goggles/black face)
1996 > oil on canvas, diptych, 16" x 14"; 14" x 18"
Photo: Dennis Cowley

328
Marginalia
(hand on forehead/squatting)
1996 > oil on canvas, diptych, 16" x 16"; 16" x 14"
Photo: Dennis Cowley
Progressive Art Collection, Cleveland, Ohio

329
Marginalia (bottle/fish)
1996 > oil on canvas, diptych, 16" x 16"; 20" x 14"
Photo: Dennis Cowley

329
Marginalia (tattoo/glove)
1996 > oil on canvas, diptych, 16" x 16" each
Photo: Dennis Cowley

330
Marginalia (women kissing/squatting)
(detail)
1994-96 > oil on canvas, 1 of 2 panels
Photo: Dennis Cowley

331
Marginalia (32)
1996 > oil on canvas,
2 panels, 62" x 38" x 3"
Photo: Dennis Cowley

This work no longer exists.

333
Marginalia (crawling man)
1996 > oil on canvas,
2 panels, 32" x 72"
Photo: Dennis Cowley
Private Collection

334-335
Marginalia
(party hat/laughing)
1994-95 > oil on canvas, diptych,
50" x 72"; 88" x 38"
Photo: Dennis Cowley
Private Collection

336-337
Marginalia
(hang woman/tutu man)
1994-96 > oil on canvas, diptych,
72" x 38" x 29"; 88" x 38"
Photo: Dennis Cowley
Private Collection

338-339
Modern Olympia (installation view)
2002 > Ronald Feldman Fine Arts, New York
photo: Dennis Cowley

341
Modern Olympia (after Cézanne)
1997 - 2001 > oil and Gampi on canvas,
73 5/16" x 37 15/16"
Photo: Dennis Cowley

341
Modern Olympia (after Cézanne)
1997 - 2001 > oil and Gampi on canvas,
73 5/16" x 37 1/8"
Photo: Dennis Cowley

341
Modern Olympia (after Cézanne)
1997 - 2001 > oil and Gampi on canvas,
73 5/16" x 37 11/16"
Photo: Dennis Cowley

342
Modern Olympia (after Anonymous)
1997 - 2001 > oil and Gampi on canvas,
2 panels, 74 1/2" x 102 1/2"
Photo: Dennis Cowley
Private Collection

342-343
Modern Olympia (detail)
1997 - 2001 > oil on canvas
Photo: Dennis Cowley

344-345
Modern Olympia
1997 - 2001 > oil on canvas,
5 panels, installation dimensions variable,
Panels 1-2 and 4-5: 72" x 72"
Panel 3: 72" x 42"
Photo: Dennis Cowley

346
Modern Olympia (detail)
1997 - 2001 > oil on canvas
Photo: Dennis Cowley

347
Modern Olympia (after Giotto)
1997 - 2001 > oil and Gampi on canvas,
7 panels, 113" x 89 1/2"
Photo: Dennis Cowley
Collection of the artist

351
Modern Olympia (after O'Keeffe)
(detail)
1997 - 2001 > watercolor on Gampi
Photo: Dennis Cowley

Miscellaneous

352-353
Modern Olympia (after O'Keeffe)
1997 - 2001 > watercolor on Gampi, 12 scrolls,
Scroll n°12: 58 1/4" x 18 3/4"
Scroll n°3: 81 1/2" x 18 3/8"
Scroll n°6: 51" x 18 3/8"
Scroll n°7: 77" x 18 1/2"
Scroll n°11: 66 3/4" x 18 3/8"
Scroll n°4: 64" x 18 1/2"
Scroll n°1: 55 7/8" x 18 3/8"
Scroll n°9: 78 1/2" x 18 3/4"
Scroll n°8: 74 1/4" x 18 1/2"
Scroll n°5: 85" x 18 1/4"
Scroll n°10: 57 7/8" x 18 1/2"
Scroll n°2: 57" x 18 1/2"
Photo: Dennis Cowley
Private Collection

354
Modern Olympia (after Versace)
1997 - 2001 > oil on Gampi, 53 1/8" x 36"
Photo: Dennis Cowley
Courtesy Gallery Paule Anglim

355
Modern Olympia (after Versace)
1997 - 2001 > oil on Gampi, 45 1/4" x 18 5/8"
Photo: Dennis Cowley
Private Collection

355
Modern Olympia (after Versace)
1997 - 2001 > oil on Gampi, 47 7/8" x 23"
Photo: Dennis Cowley
Private Collection

355
Modern Olympia (after Versace)
1997 - 2001 > oil on Gampi, 51 1/4" x 32 1/2"
Photo: Dennis Cowley
Private Collection

358
Modern Olympia (after Versace)
1997 - 2001 > oil and Gampi on canvas,
100 3/16" x 38 1/8"
Photo: Dennis Cowley

358
Modern Olympia (after Versace)
1997 - 2001 > oil and Gampi on canvas,
100 3/16" x 37 1/8"
Photo: Dennis Cowley

360-361
Modern Olympia (after Manet)
1997 - 2001 > oil and Gampi on canvas,
4 panels, 73 3/8" x 148 1/16"
Photo: Dennis Cowley

362-363
Modern Olympia (after Manet)
(detail)
1997 - 2001 > oil and Gampi on canvas
Photo: Dennis Cowley

376
Untitled (flowers)
1992 > watercolor on paper,
7 panels, 70" x 42"
Photo: Dennis Cowley
Private Collection

377
Untitled (rat)
1992 > watercolor on paper,
4 panels, 47 3/4" x 39"
Photo: Dennis Cowley
Collection of Mia Feroleto

378
Untitled (Emperor's New Clothes)
1992 > watercolor on paper,
5 panels, 36" x 58"
Photo: Dennis Cowley
Collection of Steven and Nancy Oliver

379
Untitled (Cinderella)
1992 > watercolor on paper,
4 panels, 45" x 30"
Photo: Dennis Cowley

380
Untitled (pussy)
1992 > watercolor on paper,
3 panels, 22" x 29 1/4"
Photo: Dennis Cowley

381
Untitled (boy)
1993 > watercolor on paper,
5 panels, 66 3/4" x 27 1/2"
Photo: Dennis Cowley
Private Collection

382
Untitled (Grandpa Rabbit)
1992 > watercolor on paper,
8 panels, 72" x 79 1/2"
Photo: Dennis Cowley

383
Untitled (bull)
1992 > watercolor on paper, 5 panels,
2 top panels: 38 1/2" x 20 1/4"
3 bottom panels: 12 1/4" x 28 1/4"
Photo: Dennis Cowley
Collection of Nathalie Pariente

385
Subway Poster (detail)
1980 > offset lithograph
Photo: Federico Farias

387
Subway Poster (detail)
1980 > offset lithograph
Photo: Federico Farias

389
American Medical Association I (detail)
1985 > linocut on Japanese rice paper,
1 of 2 panels, 29" x 21" each
Edition size: 20
Photo: Federico Farias

390
It isn't true (detail)
1979 > offset lithograph, from *Dyspepsia Works*
Photo: Gideon Horowitz

393
Ida Applebroog
2001 > Horseshoe Lake, Sullivan County, New York
Photo: Gideon Horowitz

The voices for this book were variously compiled from some published and some commissioned pieces; we thank both the authors who kindly permitted us to use their words, and those who responded to our invitation to write about Ida.

The authors' extensive biographies often had to be edited down to an "appendix size." We owe the shortened versions used below to Martina Batan.

All texts credited as I.A. are taken from the artist's own written notes, except where otherwise indicated.

Contributors

9 Benjamin Lignel. Foreword.
Born in 1972, in France.
Benjamin Lignel first trained in philosophy and literature, then in art history, at New York University, and finally in furniture design, in London: hence his interest in the functional object, complicated by a penchant for art, and further perverted by sustained exposures to literary works, often momentous, sometimes pertinent.

10-13 Francine Prose. Introduction.
Francine Prose is the author of ten novels, most recently, *Blue Angel*, which was nominated for a 2000 National Book Award, two story collections, and a collection of novellas, *Guided Tours of Hell*.
She has written four children's books and co-translated three volumes of fiction. Her stories, reviews, and essays have appeared in *Harper's*, *Best American Short Stories*, *The New Yorker*, *The New York Times*, *The New York Observer*, *ARTnews*, and numerous other publications.
A fellow of the New York Institute for the Humanities and a 1999 Director's Fellow of the New York Public Library's Center for Scholars and Writers, she is a contributing editor of *Harper's*, *Elle* and *Bomb*, and writes regularly on art for *The Wall Street Journal*.
The winner of a Guggenheim Fellowship, a 1989 Fulbright fellowship to the former Yugoslavia, two NEA grants, and a PEN translation prize, she has taught at Harvard University, Sarah Lawrence, the Iowa Writers' Workshop, The University of Arizona, The University of Utah, the Bread Loaf, and Sewanee Writers Conferences. A film of her novel, *Household Saints*, was released in 1993.

Untitled (flowers)
1992 > watercolor on paper,
7 panels, 70" x 42"

376

63 John Cussans. "A Half-Forgotten Memory of Everyday Trauma." (part one).
An essay written for this publication.

Son of a sign painter and a geriatric nurse, born into one dimension in 1965 (York, England). Desperately seeking missing dimensions since. A part-time free-lance artist manqué, John Cussans currently lectures on critical art theory in the MFA program at Chelsea School of Art and Design, and teaches social sciences as a visiting faculty member at the Emily Carr Institute of Art and Design in Vancouver, Canada. He has exhibited work in a number of London art spaces, including Bank and the Cabinet Gallery.

68 Arthur C. Danto. "Art and Moral Dyspepsia" in *Ida Applebroog: Nothing Personal, Paintings 1987-97.*
Washington, D.C.: The Corcoran Gallery of Art; New York, New York: D.A.P./Distributed Art Publishers, 1998, pp. 41- 58.

Arthur Danto is Johnson Professor Emeritus of Philosophy at Columbia University, New York and art critic for *The Nation*.

73 John Cussans. *op.cit.* (part two).

75 John Cussans. *op.cit.* (part three).

78 Manny Farber.
Press release for *New Art Exhibit* at P. S. 1, Institute for Art and Urban Resources, 1978.

Manny Farber is an artist and Professor Emeritus of Visual Arts at the University of California, San Diego. A respected film critic, De Capo Press has released a new and expanded edition of his 1971 book, *On Negative Space: Manny Farber at the Movies*.

96 Kay Larson. "New York Reviews: Ida Applebroog."
ARTnews 77, n° 10 (December 1978), pp. 144-45.

Kay Larson specializes in writing about contemporary art issues. Her work appears in numerous publications including *The New York Times*, *New York Magazine*, *ARTnews*, and *Vogue*.

106 Kim Levin. "Voice Choice."
The Village Voice XXVI, February 18-24, 1981, p. 24.

Kim Levin is an independent critic and curator. She is a regular contributor to *The Village Voice* and the current president of the International Association of Art Critics.

109 Carrie Rickey. "Ida Applebroog at Franklin Furnace."
Flash Art, n° 90-91 (June-July 1979), p. 46.

Film critic for the *Philadelphia Inquirer*, Rickey also reviewed contemporary art and covered feminist issues while a writer at *The Village Voice* in New York.

109 Elizabeth Hess. "Rear Windows."
The Village Voice XXVI, March 4-10, 1981, p. 70.

Elizabeth Hess covered art regularly for *The Village Voice* throughout the 80's and early 90's. Her articles have appeared in *Artforum*, *Art in America*, *ARTnews* and more recently in *New York Magazine*, the *New York Observer* and *The Bark*. Hess met Ida Applebroog in the mid-70's, when they were both founding editors of *Heresies, A Feminist Magazine on Art and Politics*.

Untitled (rat)
1992 > watercolor on paper, 4 panels, 47 3/4" x 39"

112-113 Ronald Feldman, Jean Lignel, and Martina Batan. Interview. Tuesday, December 4, 2001. (part one).

Ronald and Frayda Feldman opened their uptown gallery in 1971 and moved to Soho in 1981; the first downtown exhibition was by Ida Applebroog. In 1993, Ronald Feldman was appointed by President Bill Clinton to the National Council of the Arts. Frayda Feldman is the co-editor of *Andy Warhol Prints, A Catalogue Raisonne 1962-1987.*

Jean Lignel has had several careers: once a teacher in physics and mathematics, he subsequently became the owner/director of France's fourth largest daily newspaper, *Le Progrès*, then returned to an old love, jazz piano, and founded the record company Rosebud Music. A long time collector of books, he is also the founder of la maison Red.

Martina Batan began work at Ronald Feldman Fine Arts in 1978, where she became a friend and colleague of Ida Applebroog. Her roles include curator, art dealer, and print expert, in addition to campaigner for the many artists she has met and admires.

116 Carrie Rickey. "Return to Sender." *The Village Voice* XXIII, August 14, 1978, p. 65.

119 Lucy R. Lippard. "Taking Liberties." *The Village Voice* XXVII, December 14, 1982, pp.121,136.

Lucy Lippard, author, art critic, and activist. Her many books include *From the Center: Feminist Essays on Women's Art* (New York: Dutton, 1976); *Overlay: Contemporary Art and the Art of Prehistory* (New York: Pantheon Press, 1983); *Lure of the Local: Senses of Place in a Multicentered Society* (The New Press, 1998), and *Mixed Blessings: New Art in a Multicultural America* (The New Press, 2000).

122 Lucy R. Lippard. *ibid.*

130 Robert Storr. in *Ida Applebroog*. Ulm, Germany: Ulmer Museum; Bonn, Germany: Bonner Kunstverein; Berlin, Germany: Neue Gesellschaft für bildende Kunst, 1991, pp. 38-39.

Robert Storr, an artist and writer, is Senior Curator of Painting and Sculpture at the Museum of Modern Art in New York. A contributing editor for *Art in America* since 1981, his criticism appears in *Artforum, The Village Voice, The New York Times* and other publications.

139 Linda McGreevy. "Under Current Events: Ida Applebroog's Inmate and Others." *Arts Magazine* 59, n° 2 (October 1984), pp. 128-31.

Linda McGreevy, Ph.D., is currently an Associate Professor of Art History at Old Dominion University in Virginia.

144 Linda McGreevy. *ibid.*

150 Flannery O'Connor, found in Ida Applebroog's notes.

154 Abigail Solomon-Godeau. "Ida Applebroog at Nathalie Pariente." *Art in America* 89, n° 3 (March 2001), pp. 142-43.

Professor of History of Art and Architecture at the University of California at Santa Barbara. Author of the upcoming *The Other Side of Venus: Femininity, Modernity, and Mass Culture in 19th Century France*. Solomon-Godeau recently received a J. Paul Getty Fellowship.

158 "Public Address: 'Sign on a Truck.'"
Art in America 73, n° 1 (January 1985), pp. 88-90.

160-163 András Szántó. "Gallery: Transformations
in the New York Art World in the 1980's."
Doctoral Dissertation, Columbia University, 1995.
A version of this interview, "Úgy érzem, mindig
ugyanazt a történetet mesélem; Interjú Ida
Applebrooggal," appeared in Hungarian
translation in *Új Müvészet* (Budapest),
November 1994, pp. 46-50.

András Szántó, Deputy Director of the National Arts
Journalism Program at Columbia University, writes about art,
politics, and the media.

168 Ronald Feldman, Jean Lignel, and Martina
Batan. *op.cit.* (part two).

170 Linda McGreevy. "Ida Applebroog's Latest
Paradox: Dead-Ends = New Beginnings."
Arts Magazine 60, n° 8 (April 1986), pp. 29-31.

170 Mira Schor.
"Medusa Redux - Ida Applebroog and the Spaces of Post-Modernity"
in *Ida Applebroog*. Derry, Ireland: Orchard Gallery; Dublin, Ireland:
Irish Museum of Modern Art, 1993, pp. 5-17.

Mira Schor is a painter and writer living in New York. She is the author of *Wet: On Painting, Feminism,
and Art Culture*, published by Duke University Press and the co-editor of *M/E/A/N/I/N/G: An Anthology
of Artists' Writings, Theory, and Criticism*, also published by Duke. In 1992, Schor received a
Guggenheim Fellowship in painting. She teaches in the MFA Program in Visual Art in the Fine Arts
Department of Parsons School of Design in New York City.

Untitled (Emperor's New Clothes)
1992 > watercolor on paper,
5 panels, 36" x 58"

Untitled (Cinderella)
1992 > watercolor on paper,
4 panels, 45" x 30"

177 Linda McGreevy. "Ida Applebroog's Latest Paradox..." *op.cit.*

183 Marilyn A. Zeitlin. "Happy Families"
in *Ida Applebroog: Happy Families*. Houston, Texas:
Contemporary Arts Museum, 1990, pp. 9-17.
Marilyn A. Zeitlin is Director and Chief Curator of the Arizona State University Art Museum
in Tempe. She has curated major exhibitions of the work of Francesec Torres, Sue Coe, John
Ahern, and Ida Applebroog. Zeitlin was the U.S. Commissioner for the 1995 Venice Biennale
with an exhibition of work by Bill Viola. She originated the first major exhibition of
contemporary Cuban art to tour throughout the United States.

187 Mira Schor. *op. cit.*

189 Griselda Pollock, quoted by Mira Schor. *op. cit.*

192 Mira Schor. *op. cit.*

195 Lowery S. Sims.
"Beulahland (for Marilyn Monroe): an Icon for
America" in *Ida Applebroog: Happy Families*.
Houston, Texas: Contemporary Arts Museum,
1990, pp. 23-28.
Lowery Sims is the Director of the Studio Museum in
Harlem, New York. Former curator of 20th Century Art at the
Metropolitan Museum of Art in New York, Sims most recently
contributed to *Souls Grown Deep: African American
Vernacular Art*, vol. 2, published in 2001
by Tinwood Books, Atlanta.

201 Corinne Robins. "Changing Stories."
Arts Magazine 63, n° 3 (November 1988), pp. 80-85.
Corinne Robins, art critic and poet, is the author of *The Pluralist Era: American Art 1968-81*,
and of two poetry collections, *Facing it* and *Marble Goddess with Technicolor Skins*
(Segue Books). She is a recipient of a National Endowment of the Arts Fellowship in
Criticism, a contributing editor to *American Book Review* and teaches art history at the
School of Visual Arts and art criticism at Pratt Institute in New York.

203-204 Ronald Feldman, Jean Lignel, and Martina Batan.
op. cit. (part three).

205 Mira Schor. *op. cit.*

209 Nancy Princenthal. "Ida Applebroog at Ronald Feldman."
Art in America 76, n° 2 (February 1988), p. 137.
Nancy Princenthal, an art critic, is a regular contributor to *Art in America* and *Artext*.
Her column "Artist's Book Beat" appears in *Art on Paper*.

210 Robert Storr. *op. cit.*

Untitled (pussy)
1992 > watercolor on paper,
3 panels, 22" x 29 1/4"

212 Kate Linker. "Reviews: Ida Applebroog/ Ronald Feldman Fine Arts." *Artforum* XXVI, n° 5 (January 1988), pp. 109-10.
Kate Linker writes extensively on contemporary artists, including books on Vito Acconci and Barbara Kruger.

216 Carlo McCormick. "Sympathetic Melancholia, or the Presence of Absence in Applebroog's Art" in *Nostrums*. New York, New York: Ronald Feldman Fine Arts, New York, 1989, pp. 2-5.
Carlo McCormick is a New York based writer and curator. He is Senior Editor at *Paper Magazine*, and recently organized *The LP Show*, an exhibition of record album art and design, at Exit Art in New York.

221 Max Kozloff. "The Cruelties of Affection." *Art in America* 83, n° 9 (September 1995), p. 82-87.
Max Kozloff, a New York art critic and photographer, former Executive Editor of *Artforum*, has had numerous shows in the U.S. and abroad. His latest book is *Cultivated Impasses*, a collection of essays on the waning of the avant-garde, published by Marsilio Publishers, 2000.

227 Jeffrey Kastner. "Ida Applebroog: Cubitt Street Gallery, London." *frieze*, n° 15 (March-April 1994), pp. 50-52.
Jeffrey Kastner is the author of *Land and Environmental Art (Themes and Movements)* published in 2001 by Phaidon Press, London. He writes extensively on art and culture for international publications.

228 Thomas W. Sokolowski. "This is to Show People . . ." in *Ida Applebroog: Happy Families*. Houston, Texas: Contemporary Arts Museum, 1990, pp. 19-21.
Thomas W. Sokolowski is Director of the Andy Warhol Museum in Pittsburgh and a specialist in contemporary art. While Director of the Grey Art Gallery at New York University, he mounted major exhibitions including *Success is a Job in New York: The Early Art and Business of Andy Warhol* and *Against Nature: Japanese Art in the Eighties*.

234 Amy Taubin. "Relatively True Stories." *The Village Voice* XXXV, n° 1, January 9, 1990, p. 54.
Amy Taubin is a contributing editor for *Film Comment* and *Sight and Sound* magazines. She is the author of *Taxi Driver*, published by the British Film Institute for their series on classic films.

234 Katy Deepwell. "The Menace of the Spoken Word." *Women's Art Magazine*, n° 56 (January - February 1994), pp. 22-23.
Katy Deepwell edits the international feminist journal *n. paradoxa*. She is currently a Post-Doctoral Research Fellow at the University of Ulster in Belfast, Ireland.

241 Dan Cameron. "Ida Applebroog - Ronald Feldman." *Flash Art* XXV, n° 163 (March - April 1992), pp. 113-14.
Dan Cameron is Senior Curator at the New Museum of Contemporary Art in New York. He has written about and organized exhibitions on artists David Wojnarowicz, Martin Wong, and William Kentridge among others.

Untitled (boy)
1993 > watercolor on paper, 5 panels, 66 3/4" x 27 1/2"

247 Roberta Smith. "Americana with Benign and Sinister Side by Side."
The New York Times, November 1, 1991, p. C26.
Roberta Smith is an Art Critic at *The New York Times*. She is a frequent lecturer and contributes to numerous professional journals and publications on contemporary art.

250 William Feaver. "Season's Greetings, eh."
The Observer, December 19, 1993, Review supplement, p. 9.
William Feaver has written on a wide range of artists of the 19th and 20th century. An authority on Francis Bacon, Feaver is the author of an upcoming biography of the artist to be released in conjunction with Bacon's 2002 retrospective exhibition at the Tate Modern in London.

252 Elizabeth Hess. "In the Rose Garden."
The Village Voice XXXVI, n° 47, November 19, 1991, p.100.

258 Kathleen Finley. "Ida Applebroog."
Arts Magazine 66, n° 5 (January 1992), p. 62.
Kathleen Finley is a New York based art critic.

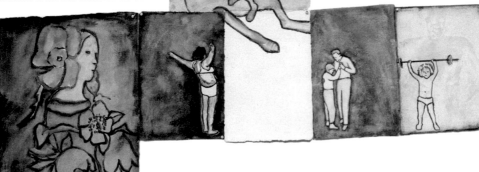

275 Patricia C. Phillips. "Ida Applebroog: Brooklyn Museum."
Artforum XXXII, n° 2 (October 1993), pp. 96-97.
Patricia C. Phillips is an independent critic. Her critical writing deals with public art, architecture, design, sculpture and the intersection of these areas. In 1997, she was appointed Dean of the School of Fine & Performing Arts at State University of New York in New Paltz.

291 David Beytelmann. "Tattle Tales, not Fairy."
An essay written for this publication.
David Beytelmann was born in Argentina in 1973; he moved to Paris in 1988 to pursue his studies in philosophy and history. He has regular jobs, but also dabbles in the black economy, while preparing a doctorate in philosophy. He likes to drink *mate*, and when applicable, to eat.

Untitled (Grandpa Rabbit)
1992 > watercolor on paper,
8 panels, 72" x 79 1/2"

312 Terrie Sultan.
"A Truth with Two Faces" in *Ida Applebroog: Nothing Personal, Paintings 1987-97.* Washington, D.C.: The Corcoran Gallery of Art; New York, New York: D.A.P./Distributed Art Publishers, 1998, pp. 4-29.
Terrie Sultan is Director of the Blaffer Gallery at the Art Museum of the University of Houston, Texas. She has organized exhibitions and authored publications featuring artists such as Ida Applebroog, Ken Aptekar, Louise Bourgeois, Petah Coyne, Kerry James Marshall, and Robert Morris among others.

312 David Beytelmann.
"Under and Ever Deeper."
An essay written for this publication.

322 Rosalyn Drexler.
in *Art Does (Not!) Exist*. Normal, Illinois: FC2, 1996, p. 86.
Rosalyn Drexler works as an artist and writer. She began her exhibition career during the Pop era of the 1960's. Drexler has several novels to her credit, and her writing appears frequently in national periodicals. Her plays are produced and performed regularly in the avant-garde theater. She is a Guggenheim Fellow.

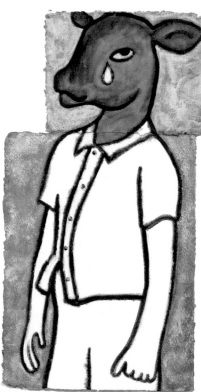

340 Charles Hall. "Best of the Bad Girls."
Art Review (December 1993 - January 1994), pp. 54-56.
Charles Hall has written on contemporary art for London-based publications, including *Art Review*, *The Guardian*, and the *Independent*.

350 Ida Applebroog, interview with Patricia Spears Jones
in "Ida Applebroog." *Bomb* 68 (Summer 1999), pp. 32-39.
Patricia Spears Jones is a poet, playwright, and author of the collection, *The Weather That Kills* (Coffee House Press, 1995) and *Mother*, a play produced by Mabou Mines in 1994. Jones has received grants from the National Endowment for the Arts, the Foundation for Contemporary Performance Art, and the New York Foundation for the Arts.

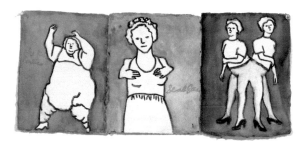

358 Grace Glueck. "Art in Review: Ida Applebroog."
The New York Times, February 1, 2002, p. E37.
Grace Glueck is a reporter and writer for *The New York Times*. She is the author of *Brooklyn: People and Places, Past and Present* (Harry N. Abrams, 1997) and *New York: The Painted City* published in 2000 by Gibbs Smith.

359 Ronald Feldman, Jean Lignel, and Martina Batan. *op.cit.* (part four).

363 Ida Applebroog, interview with Patricia Spears Jones. *op.cit.*

Untitled (bull)
1992 > watercolour on paper, 5 panels, 57 1/8" x 28 1/4"

A large number of reviews and essays has been written on Ida Applebroog's work; in addition to the previously listed references, the reader should also consult the following sources.

This collection of "further readings" was compiled by Frayda Feldman.

Selected Monographs and Solo Exhibition Catalogues

Ida Applebroog.
Essay by Thomas W. Sokolowski.
Venice, Italy: Galleria del Cavallino, 1981.

Investigations 16: Ida Applebroog.
Essay by Judith Tannenbaum.
Philadelphia, Pennsylvania: Philadelphia Institute of Contemporary Art, University of Pennsylvania, 1986.

Ida Applebroog.
Essays by Ronald Feldman, Carrie Rickey,
Lucy R. Lippard, Linda R. McGreevy, and Carter Ratcliff.
New York, New York: Ronald Feldman Fine Arts, 1987.

Ida Applebroog/Matrix 96.
Essay by Andrea Miller-Keller.
Hartford, Connecticut: Wadsworth Atheneum, 1987.

Ida Applebroog, Nostrums, Belladona.
Essay by Carlo McCormick.
New York, New York: Ronald Feldman Fine Arts, 1989.

Ida Applebroog: Happy Families, A Fifteen-Year Survey.
Essays by Marilyn A. Zeitlin, Thomas W. Sokolowski, and Lowery S. Sims.
Houston, Texas: Contemporary Arts Museum, 1990.

Ida Applebroog.
Essay by Bert Winther.
Tokyo, Japan: Seibu, Seed Hall, 1990.

Ida Applebroog: Bilder.
Essays by Brigitte Reinhardt, Annelie Pohlen, Robert Storr, Carla Schulz-Hoffmann.
Ulm, Bonn, and Berlin, Germany: Ulmer Museum, Bonner Kunstverein, and Neue Gesellschaft für bildende Kunst, 1991.

Ida Applebroog.
Essay by Mira Schor.
Derry, Ireland: Orchard Gallery; Dublin, Ireland: Irish Museum of Modern Art, 1993.

Ida Applebroog: Nothing Personal, Paintings 1987-1997.
Essays by Terrie Sultan, Arthur C. Danto, and Dorothy Allison.
Washington, D.C.: The Corcoran Gallery of Art; New York, NY: D.A.P./Distributed Art Publishers, 1998.

Selected Books and Group Exhibition Catalogues

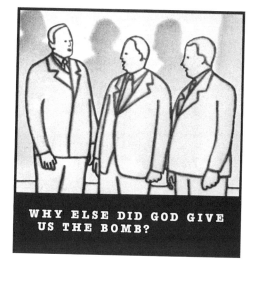

WHY ELSE DID GOD GIVE US THE BOMB?

1984 - The Show.
Edited by Sean Elwood. New York, New York: Ronald Feldman Fine Arts, 1984.

1993 Biennial Exhibition Whitney Museum of American Art.
Essays by Elisabeth Sussman, Thelma Golden, John G. Hanhardt, Lisa Phillips. New York, New York: Whitney Museum of American Art in association with Harry N. Abrams, Inc., 1993.

A Boat of Diversity: The Tokyo International Forum Art Collection.
Tokyo, Japan: The Tokyo Metropolitan Government Bureau of Citizens and Cultural Affairs, 1996.

American Narrative/Story Art: 1967-1977.
Essay by Paul Schimmel. Houston, Texas: Contemporary Arts Museum, 1977.

An American Renaissance: Painting and Sculpture Since 1940.
Essay by Sam Hunter. Fort Lauderdale, Florida: Museum of Art, 1987.

An International Survey of Recent Painting and Sculpture.
Essay by Kynaston McShine. New York, New York: The Museum of Modern Art, 1984.

Art and Feminism.
Edited by Helena Reckitt. New York, New York: Phaidon Press, 2001.

Bellamy, Peter. **The Artist Project: Portraits of the Real Art World/New York Artists 1981-1990.**
New York, New York: IN Publishing Company, 1991.

Brown, Betty Ann, Arlene Raven and Kenna Lane. **Exposures, Women and Their Art.**
Pasadena, California: New Sage Press, 1989.

But is it Art? The Spirit of Art as Activism.
Edited by Nina Felshin. Seattle, Washington: Bay Press, Inc., 1994.

Chadwick, Whitney. **Women, Art and Society.**
London, England: Thames & Hudson, 1997.

Contemporary Art and Multicultural Education.
Edited by Susan Cahan and Zoya Kocur. New York, New York: The New Museum of Contemporary Art, 1996.

Devil on the Stairs: Looking Back on the Eighties.
Essays by Robert Storr, Judith Tannenbaum, and Peter Schjeldahl. Philadelphia, Pennsylvania: Institute of Contemporary Art, 1991.

Directions '83.
Essay by Phyllis D. Rosenzweig. Washington, D.C.: Hirshhorn Museum and Sculpture Garden, Smithsonian Institution Press, 1983.

Documenta 8.
Essay by Carter Ratcliff. Kassel, Germany, 1987.

Domestic Tales.
Essay by Helaine Posner. Amherst, Massachusetts: University Gallery, University of Massachusetts, 1984.

Enstice, Wayne and Melody Peters. **Drawing: Space, Form and Expression.**
New York, New York: Prentice Hall, 1990.

Guggenheim Museum: A to Z.
Edited by Nancy Spector. New York, New York: The Solomon R. Guggenheim Museum, 1992.

Humor and Rage.
Essays by Mireia Sentís, Steve Cannon, and Lucy R. Lippard. Barcelona, Spain: Fundacio Caxia Catalunya, 2001.

Invisible/Visible.
Essays by Judy Chicago and Debra Frankel. Long Beach, California: Long Beach Art Museum, 1972.

Lippard, Lucy R. **The Pink Glass Swan: Selected Feminist Essays on Art.**
New York, New York: The New Press, 1995.

Making Their Mark: Women Artists Move into the Mainstream, 1970-1985.
Essays by Catherine C. Brawer, Ellen G. Landau, Thomas McEvilley, Ferris Olin, Randy Rosen, Calvin Tomkins, Marcia Tucker, and Ann-Sargent Wooster. Cincinnati, Ohio: The Cincinnati Art Museum, 1989.

Morality Tales: History Painting in the 1980s.
Essay by Thomas W. Sokolowski. New York, New York: Grey Art Gallery, New York University, 1987.

New Narrative Painting.
Essay by Robert Littman. Long Island City, New York: P.S. 1, Institute for Art and Urban Resources, 1985.

Phillips, Lisa. **The American Century: Art & Culture 1950-2000.**
New York, New York: Whitney Museum of American Art and W.W. Norton, 1999.

Power of Feminist Art: The American Movement of the 1970s, History & Impact.
Edited by Norma Broude and Mardy D. Garrard. New York, New York: Harry Abrams, Inc., 1996.

Prospects: Selected Works from the Collection and Possible Acquisitions.
Essay by Carla Schulz-Hoffmann. Munich, Germany: Bayerische Staatsgemäldesammlungen, 1991.

Schor, Mira. **Wet: On Painting, Feminism, and Art Culture.**
Durham, North Carolina: Duke University Press, 1996.

Wye, Deborah. **Committed to Print: Social and Political Themes in Recent American Art.**
New York, New York: Museum of Modern Art, 1988.

Word As Image: American Art 1960-1990.
Essay by Dean Sobel. Milwaukee, Wisconsin: Milwaukee Art Museum, 1990.

Subway Poster (detail)
1980 > offset lithograph

Selected Periodicals

Before 1981

Larson, Kay. "New York Reviews: Ida Applebroog."
ARTnews 77, n° 10 (December 1978), pp. 144-45.

Kingsley, April. "Art."
The Village Voice XXIV, March 3, 1979, p. 72.

Saunders, Wade. "Ida Applebroog at Ellen Sragow."
Art in America 67, n° 3 (May/June 1979), p. 144.

1981

Casademont, Joan. "Ida Applebroog - Ronald Feldman
Fine Arts."
Artforum XIX, n° 9 (May), pp. 72-73.

Cavaliere, Barbara. "Ida Applebroog."
Arts Magazine 55, n° 10 (June), p. 35.

Nadelman, Cynthia. "New York Reviews: Ida Applebroog."
ARTnews 80, n° 6 (Summer), pp. 246-48.

1982

Brenson, Michael. "Art People: Sculpture 'Speaks Out' at
Downtown Landmark."
The New York Times, November 12, p. C25.

Levin, Kim. "Voice Choice."
The Village Voice XXVII, November 23, p. 85.

Zimmer, William. "Applebroog at Ronald Feldman."
Art Gallery Scene (December 14).

1983

Brach, Paul. "Ida Applebroog at Ronald Feldman."
Art in America 71, n° 2 (February), pp. 139-40.

Linker, Kate. "Reviews: Ida Applebroog."
Artforum 21, n° 6 (February), p. 80.

Muchnic, Suzanne. "Review: La Cienega Area."
The Los Angeles Times, February 18.

Norklun, Kathi. "Pick of the Week."
Los Angeles Weekly, February 25-March 3.

Silverthorne, Jeanne. "Review Directions 1983."
Artforum 22, n° 2 (October), p. 79.

1984

Cohen, Ronny. "Ida Applebroog: Her Books."
The Print Collector's Newsletter 15, n° 2 (May/June), pp. 49-51.

Glueck, Grace. "Ida Applebroog."
The New York Times, October 26, p. 29.

McGreevy, Linda. "Sugar and Spice."
Portfolio Magazine (July 31).

Smith, Roberta. "Exercises for the Figure."
The Village Voice XXIX, November 20, p. 120.

Sokolowski, Thomas W. "Silences: Recent Work of Ida
Applebroog."
The Chrysler Museum Bulletin 14, n° 8 (August).

Zeitlin, Marilyn A. "Ida Applebroog 'Silences.'"
VCU Today, November 27-December 1.

1985

Gambrell, Jamey. "Ida Applebroog at Feldman."
Art in America 73, n° 1 (January), pp. 141-42.

Phillips, Deborah. "Ida Applebroog/Ronald Feldman Fine Arts."
ARTnews 84, n° 2 (February), p. 141.

1986

Bohn, Donald Chant. "Investigations 1986."
The New Art Examiner 14, n° 2 (October), p. 53.

Cameron, Dan. "Report from the Front."
Arts Magazine 60, n° 10 (June), pp. 86-93.

Cotter, Holland. "Ida Applebroog."
Arts Magazine 60, n° 8 (April), p. 143.

Gill, Susan. "Ida Applebroog/Ronald Feldman."
ARTnews 85, n° 4 (April), pp. 154-55.

Morgan, Susan. "And That's the Way It Is..."
Artscribe International, n° 58 (June/July), pp. 48-49.

Raven, Arlene. "Ida Applebroog."
The New Art Examiner 14, n° 1 (September), p. 57.

Van Sicien, Bill. "Art that Beats Like the Big City That
Inspired It."
The Providence Sunday Journal, January 19, p. H4.

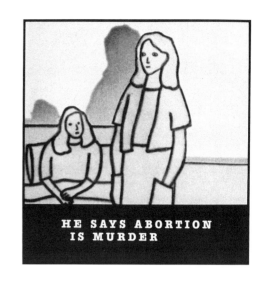

He Says Abortion Is Murder

1987

Cohen, Jon. "The District Line."
Washington City Paper, March 27.

Cyphers, Peggy. "Culture and Nature."
Cover (November).

Damsker, Matt. "Ida Applebroog/Enigmatic and Alive: A 'Generic Artist' Prods Conscience of Modern Society."
The Hartford Courant, September 18, pp. B1, B4.

Hess, Elizabeth. "Beyond Domestic Agony."
The Village Voice XXXII, November 10, p. 101.

Loughery, John. "Ida Applebroog."
Arts Magazine 62, n° 4 (December), p. 106.

Zimmer, William. "Retrospective of Ida Applebroog at the Wadsworth Atheneum."
The New York Times (Connecticut edition), November 1, p. CN36.

1988

Bass, Ruth "Ordinary People."
ARTnews 87, n° 5 (May), pp. 51-54.

Heartney, Eleanor. "Ida Applebroog."
ARTnews 87, n° 1 (January), pp. 151-52.

Princenthal, Nancy. "Political Prints: An Opinion Poll."
The Print Collector's Newsletter XIX, n° 2 (May-June), p. 44.

Schwendenwien, Jude. "Social Surrender: An Interview with Ida Applebroog."
Real Life, n° 17/18 (Winter), pp. 40-44.

1989

Fox, Catherine. "Evil's Witness: Artist Ida Applebroog Depicts a Grim World."
The Atlanta Constitution, September 25, pp. B1, B2.

Hess, Elizabeth. "Shock Gallery."
The Village Voice XXXIV, n° 45, November 7, p. 103.

Kozik, KK. "Ida Applebroog."
Cover (November), p. 15.

Zed, Xenia. "Interview: Ida Applebroog."
Art Papers 13, n° 5 (September/October), pp. 30-33.

1990

Harris, Melissa. "Tell Me, Does Your Condition Have a Name?" *Interview* (February), p. 36.

Heartney, Eleanor. "Ida Applebroog and Beth B at Feldman." *Art in America* 78, n° 1 (January), pp. 160-61.

Johnson, Patricia C. "'Happy Families' exhibit sophisticated, unsettling."
Houston Chronicle, March 5, pp. 1D, 20D.

Nesbitt, Lois E. "Ida Applebroog."
Artforum XXVIII, n° 5 (January), p. 36.

Roberts, Ann. "Not So Happy Families."
Public News, March 7, p. 10.

1991

Burkhart, Dorothy. "Emptiness, Loss of Identity Fill *De-Persona* Exhibit."
San Jose Mercury News, May 5.

"Goings on about Town."
The New Yorker (May 27).

Piguet, Phillippe. "Ida Applebroog: Galerie Langer-Fain."
ArtPress 156 (March), p. 102.

Volk, Carol. "Anatomy of Culture."
Art & Antiques VII, n° 9 (November), p. 31.

1992

"Museum and Dealer Catalogues - Ulmer Museum: Ida Applebroog."
The Print Collector's Newsletter XXII, n° 6 (January/February), p. 217.

Pohlen, Annelie. "Ida Applebroog: Ulmer Museum Ulm."
Flash Art XXV, n° 163 (March/April), p. 145.

Wulffen, Thomas. "Reviews."
Forum International, n° 14 (September/October), p. 100.

Subway Poster (detail)
1980 > offset lithograph

387

1993

Baker, Kenneth. "Contemporary Painting Celebrated in D.C." *San Francisco Chronicle*, November 7, pp. 46-47.

Bonetti, David. "Gallery Watch - Women front and center in local shows." *San Francisco Examiner*, April 23, p. D17.

Barbara MacAdam. "Scrooge Goes Minimal." *ARTnews* 92, n° 10 (December), p. 26.

Richard, Paul. "What's Wrong with This Picture?" *The Washington Post*, October 31, pp. G2, G4.

Russell, John. "The Corcoran Gives New Meaning to 'Biennial.'" *The New York Times*, November 21, p. 39.

1994

Archer, Michael. "What's in a Prefix?" *Art Monthly*, n° 173 (February), pp. 3-5.

Fox, Marilyn. "Monkey Business." *Reading Eagle*, April 17, p. F2.

Lovelace, Carey. "'Yagona' in Fiji and Breakfast in Derry." *ARTnews* 93, n° 9 (November), p. 147.

Schjeldahl, Peter. "Form and Discontent." *The Village Voice* XXXIX, May 17, p. 90.

1995

"Distinguished Artist Award for Lifetime Achievement." *College Art Association News* 20, n° 2 (March/April), pp. 7-8.

McClelland, Suzanne. "Lauren Szold, Jill Baroff, Ida Applebroog." *Bomb*, n° 51 (Spring), pp. 52-57.

1996

Brooks, Susan. "Ida Applebroog." *NY Soho* 5 (December), p. 34.

Cotter, Holland. "Ida Applebroog." *The New York Times*, December 13, p. C30.

Diehl, Carol. "Birds, Beads & Banner Stones." *ARTnews* 95, n° 7 (Summer), pp. 76-84.

1997

Protzman, Ferdinand. "Ida Applebroog's Tabula Nervosa." *The Washington Post*, May 17, p. H21.

Rowlands, Penelope. "San Francisco: Renovation and Innovation." *ARTnews* 96, n° 2 (February), p. 55.

1998

Frankel, David. "Preview: Ida Applebroog: Paintings, 1987-1997." *Artforum* XXXVI, n° 5 (January), p. 35.

Johnson, Ken. "Not So Innocent After All: Works With a Sweetly Nasty Streak." *The New York Times*, May 8, p. E31.

Jones, Joyce. "Applebroog: Unmasking Untidy Truths." *The Washington Post Weekend*, May 1, pp. 72-73.

Lewis, Jo Ann. "Applebroog's Obscure Irreverence." *The Washington Post*, April 5, p. G12.

Risatti, Howard. "Ida Applebroog." *Artforum* XXXVII, n° 1 (September), pp. 159-60.

"29 Are Chosen for Fellowships from the MacArthur Foundation." *The New York Times NATIONAL*, June 2, p. A16.

Weil, Rex. "Ida Applebroog: Corcoran Gallery of Art." *ARTnews* 97, n° 6 (June), p. 129.

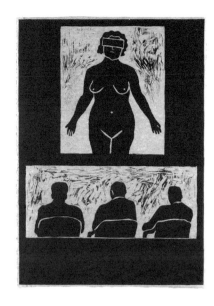

1999

Bernstein, Susan. "This is Personal."
Atlanta Jewish Times, February 12, p. 46.

Cullum, Jerry. "Ida Applebroog."
ARTnews 98, n° 5 (May), p. 172.

DeSouza, Cedric. "Ida Applebroog."
New Art Examiner 27, n° 8 (April), pp. 55-56.

Danto, Arthur C. "Correspondence School Art."
The Nation, March 29, pp. 30-34.

"People: 1998 in Review."
Art in America 87, n° 8 (August), p. 47.

2001

Attias, Laurie. "Ida Applebroog."
ARTnews 100, n° 3 (March), pp. 165-66.

"Ida Applebroog."
The New Yorker (May 21), p. 19.

Johnson, Ken. "Ida Applebroog Early Works."
The New York Times, May 25, p. E29.

Levin, Kim. "Ida Applebroog."
The Village Voice XXXXV, May 29, p. 80.

Pollack, Barbara. "How Can You Think
About Making Art at a Time Like This?"
ARTnews 100, n° 10 (November), pp 148-49.

2002

Bakke, Erik. "Ida Applebroog."
NY Arts 7, n° 6 (February), p. 26.

"Ida Applebroog."
The New Yorker (February 11), p. 13.

Levin, Kim. "Ida Applebroog."
The Village Voice XLVI, February 5, p. 85.

Robinson, Walter. "Weekend Update."
artnet, January 16.

American Medical Association I
(detail)
1985 > linocut on Japanese rice paper

Publications by the Artist

The 'I am Heathcliff', Says Catherine Syndrome.
Heresies n° 2 (May 1977), pp. 118-24.

American Medical Association, a project by Ida Applebroog.
Artforum XXIII, n°8 (April 1985), pp. 57-59.

A Christmas Carol.
San Francisco, California: Arion Press, 1993.
Edition size: 200 copies

Intermissions.
in *Ida Applebroog: Are You Bleeding Yet?*
Brooklyn, New York: la maison Red, 2002.

The artist kindly agreed to create a series of narrative
moments for this book. They appear throughout and
were conceived as a continuous "story."
They are "Intermissions," meant to suggest another
storyline where there are already so many.

Galileo Works

A set of 10 self-published books, 1977
Edition size: 500 copies
Dimensions: W - 6 3/16" H - 7 3/4"
Photos: Yasuo Minagawa
These books were mailed in the following order:

IT IS MY LUNCH HOUR, September 10, 1977
SAY SOMETHING, October 1, 1977
I'M NOT YOUR SON, October 22, 1977
IT DOESN'T SOUND RIGHT, November 26, 1977
WHERE DO I COME FROM?, December 31, 1977
I OVERDO IT, January 14, 1978
SOMETIMES A PERSON NEVER COMES BACK, February 11, 1978
I CAN DO ANYTHING, March 25, 1978
THE LIFEGUARDS ARE CARRYING A STILL BODY
OUT OF THE WATER, April 15, 1978
End., May 6, 1978

see pp. 68-69

It isn't true (detail)
1979 > offset lithograph from *Dyspepsia Works*

Dyspepsia Works

A set of 11 self-published books, 1979
Edition size: 500 copies
Dimensions: W - 6 3/16" H - 7 3/4"
Photos: Gideon Horowitz
These books were mailed in the following order:

SURE I'M SURE, September 15, 1979
YOU'LL SEE, October 13, 1979
BUT I WASN'T THERE, November 10, 1979
NOW THEN, December 8, 1979
I PRETEND TO KNOW, January 5, 1980
LOOK AT ME, January 26, 1980
THE SWEET SMELL OF SAGE, February 16, 1980
IT ISN'T TRUE, March 22, 1980
YOU WHAT?, April 12, 1980
I FEEL SORRY FOR YOU, May 3, 1980
End., May 17, 1980

see pp. 102-03

Blue Books

A set of 7 self-published books, 1981
Edition size: 500 copies
Dimensions: W - 6 3/16" H - 7 3/4"
Photos: Gideon Horowitz
These books were mailed in the following order:

I CAN'T, September 7, 1981
IT'S VERY SIMPLE, September 30, 1981
STOP CRYING, October 19, 1981
I MEAN IT, November 13, 1981
UNTITLED, December 14, 1981
SO?, January 3, 1982
End., January 23, 1982

see pp. 116-17

Public Collections

Addison Gallery of American Art Phillips Academy, Andover, Massachussetts
Arizona State University Art Museum Tempe, Arizona
Australia National Gallery Sydney, Australia
Bayerische Staatsgemäldesammlungen Munich, Germany
Chase Manhattan Bank New York, New York
Cincinnati Museum of Art Cincinnati, Ohio
Corcoran Museum of Art Washington, D.C.
Denver Art Museum Denver, Colorado
Graphische Sammlung Albertina Vienna, Austria
Metropolitan Museum of Art New York, New York
Miami Art Museum Miami, Florida
Milwaukee Museum of Art Milwaukee, Wisconsin
Munson-Williams-Proctor Arts Institute Utica, New York
Museum of Modern Art New York, New York
New Museum of Contemporary Art New York, New York
New School University New York, New York
Northern Illinois University Art Museum Dekalb, Illinois
Pushkin State Museum Moscow, Russia
San Francisco Museum of Modern Art San Francisco, California
Sarah Moody Gallery of Art University of Alabama, Tuscaloosa, Alabama
Solomon R. Guggenheim Museum New York, New York
Tokyo International Forum Tokyo, Japan
Ulmer Museum Ulm, Germany
Wadsworth Atheneum Hartford, Connecticut
Weatherspoon Art Gallery University of North Carolina, Greensboro, North Carolina
Whitney Museum of American Art New York, New York
Williams College Museum of Art Williamstown, Massachusetts

Grants and Awards

Artist's Fellowship. National Endowment for the Arts, 1980
Creative Artists in Public Service Program. New York Council on the Arts, 1983
Artist's Fellowship. National Endowment for the Arts, 1985
John Simon Guggenheim Fellowship. 1990
Lifetime Achievement Award. College Art Association, 1995
Honorary Doctorate. New School/Parson School of Design, 1997
MacArthur Foundation Fellowship. 1998

Ida Applebroog
2001 > Horseshoe Lake, Sullivan County, New York

Biography

1929	born in the Bronx, New York
1947-50	New York State Institute of Applied Arts and Science
1966-68	School of Art Institute of Chicago
since 1974	lives and works in New York

Index of Works

and for the record

Font
Akzidenz Grotesk
Paper
Job parilux 150gr
Valopaque 45gr
Printing
Offset (CTP) stochastic
Music
Egberto Gismonti and The Avalanches

Printed by Deux-Ponts (Grenoble), May 2002

Available through D.A.P./Distributed Art Publishers, Inc.
155 Sixth Avenue, 2nd Floor, New York, N.Y. 10013
t. 212.627.1999 f. 212.627.9484